Photo Ark
Wonders

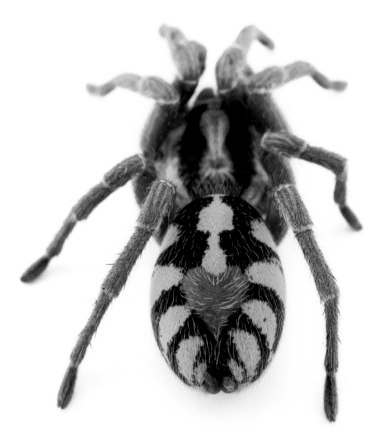

To my parents, John and Sharon Sartore.
In me, their sense of wonder
is alive and well.

Northern rosella, *Platycercus venustus* (LC)

In the hilly woodlands along Australia's northern coast, this brilliantly colored parrot whistles from its perch and chatters softly as it feeds on the seeds of eucalyptus, acacia, and other trees.

PREVIOUS PAGE:
Pumpkin patch tarantula, *Hapalopus* sp. "Colombia" (NE)

This orange-and-black dwarf tarantula has not yet been formally described by science. Native to the Pacific coast of Colombia, its common name refers to the patterns on its abdomen.

Photo Ark

CELEBRATING DIVERSITY IN THE ANIMAL KINGDOM

Wonders

JOEL SARTORE

NATIONAL
GEOGRAPHIC

WASHINGTON, D.C.

Sand cat, *Felis margarita harrisoni* (LC)

Living in the Sahara and other extreme desert environments isn't challenge enough for the world's smallest wildcat. Hunting at night with superb hearing and smell, it catches and consumes venomous vipers and spiders.

Green keel-bellied lizard, *Gastropholis prasina* (NT)

This vivid green lizard lives in the forests, woodlands, and coastal thickets of Kenya and Tanzania. Secretive and active only during the day, it spends much of its time in trees, perching on small branches.

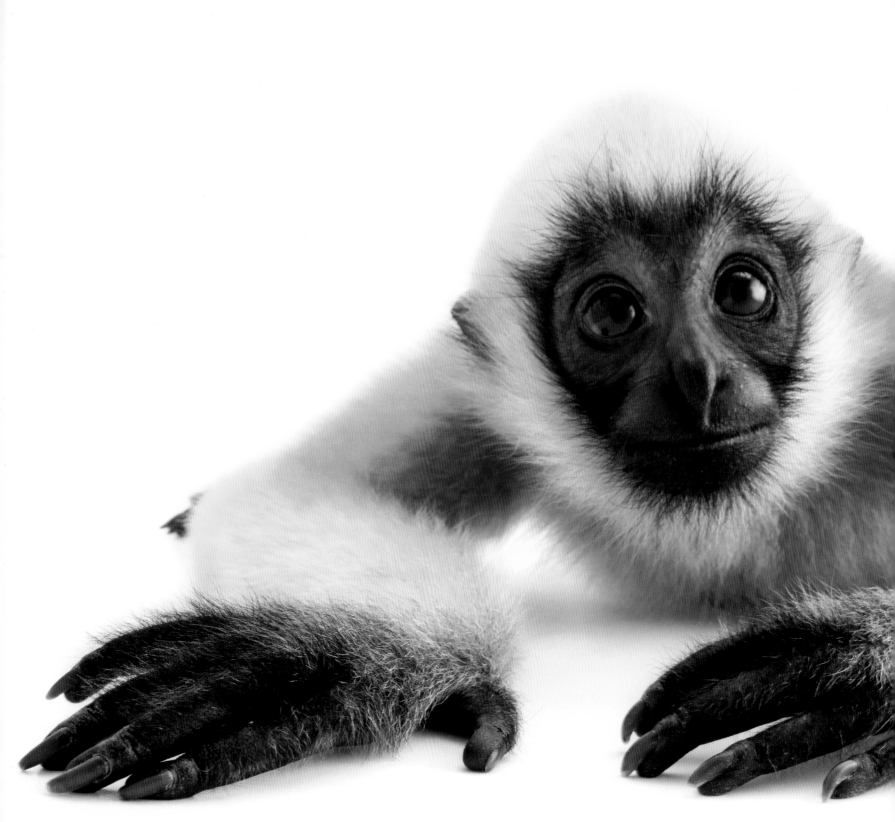

Northern white-cheeked gibbon, *Nomascus leucogenys* (CR)

As this male infant grows, its fur will change to black, and it will learn how to socialize, play, groom itself, and search for food. Those large, hooked hands are just one feature of a body built for life in the trees.

| CONTENTS |

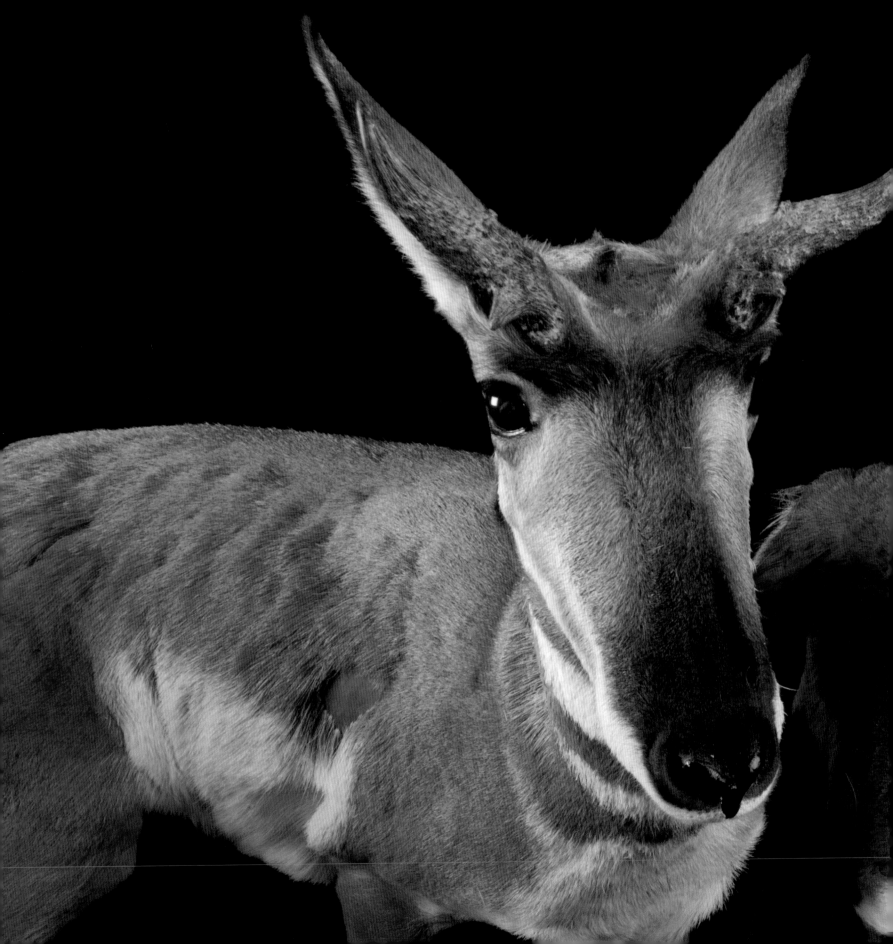

Peninsular pronghorn, *Antilocapra americana peninsularis* (CR)

Sprinting across the treeless plains and deserts of western North America at speeds up to 60 miles an hour, the pronghorn is the Western Hemisphere's fastest mammal. Young pronghorns can outrun a human just a few days after birth.

Mosshead warbonnet, *Chirolophis nugator* (NE)

This striking fish lives in coastal areas of the eastern Pacific, from the Aleutian Islands to Southern California. It belongs to the prickleback family of fish, so named for their dorsal fins' spiny rays.

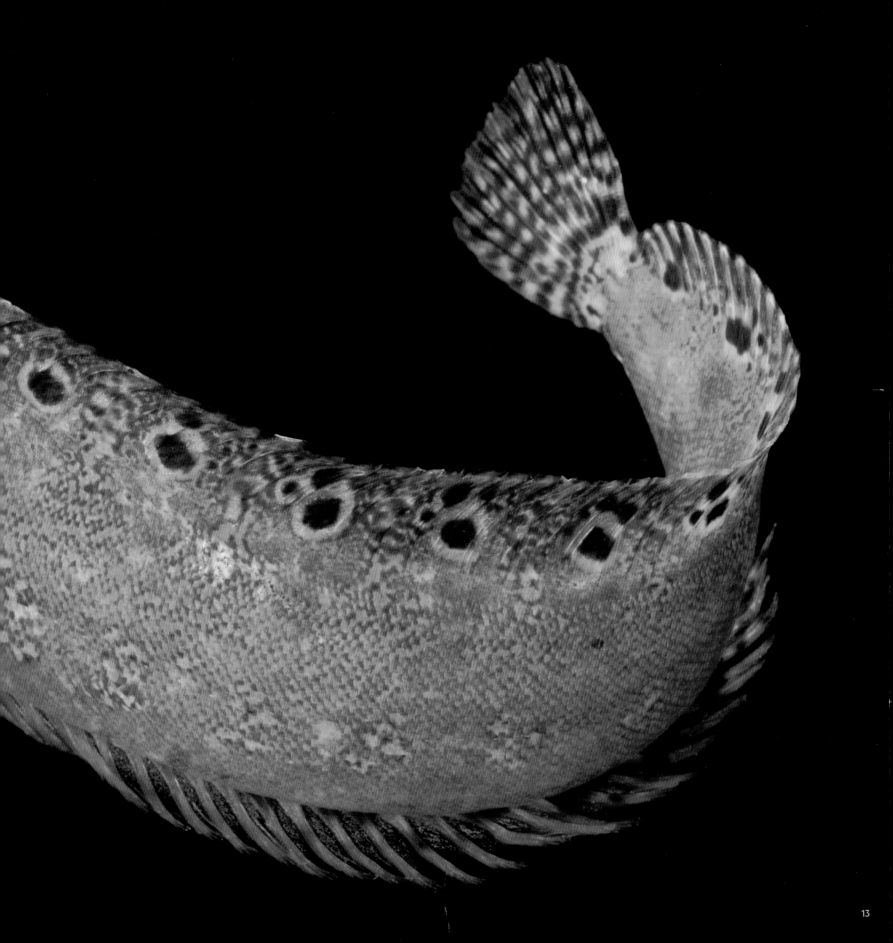

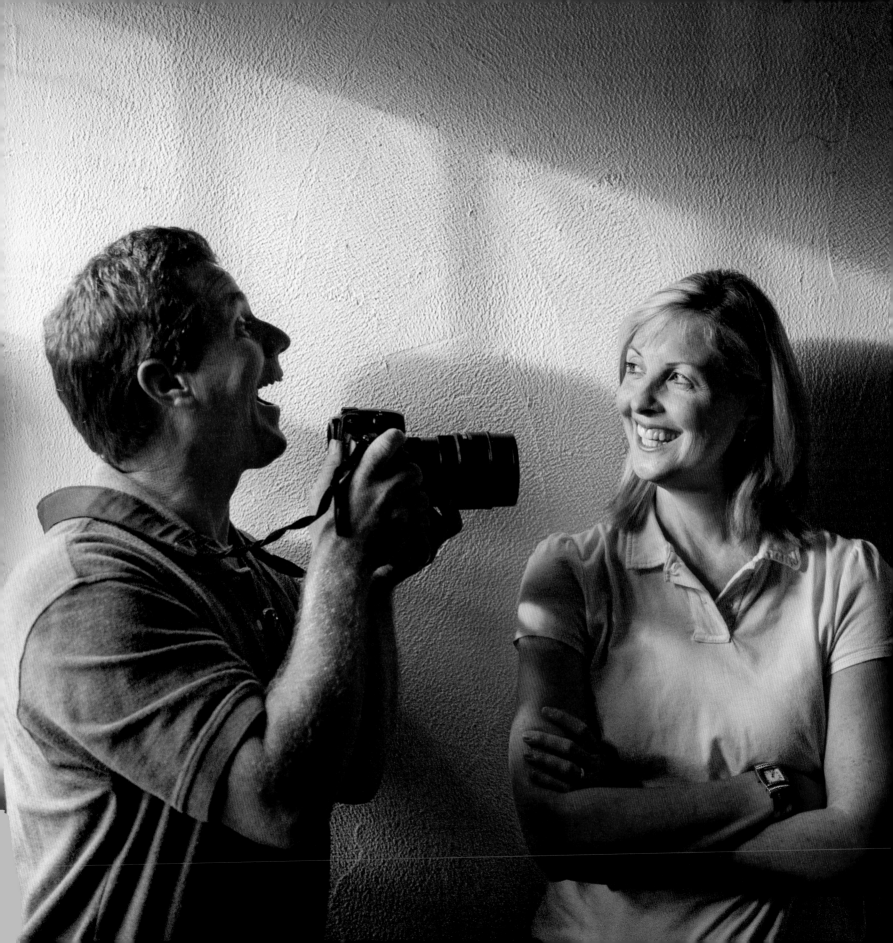

| INTRODUCTION |

I n September 2005, while I was on assignment for *National Geographic* magazine, my wife said she was going to stop pleading with me to come home. She wasn't angry, just sad and resigned to the fact that if I didn't leave Alaska right then, our marriage might end.

I remember exactly where I was at that moment: talking to her on a pay phone in the lobby of a cheap motel in the village of Kaktovik, with a terrible storm beating on the tin roof. There were so many leaks that the lobby television had just shorted, catching fire before the rain put it out and filling the room with acrid smoke. I closed my eyes and concentrated, but it was hard to hear Kathy between the howling wind and distance between us.

I asked her to just hold on. I was there to cover life on Alaska's North Slope, and local subsistence hunters had only brought in one whale for butchering so far. Plus I'd spent a lot

OPPOSITE: Kathy Sartore has remained tolerant of her type A husband for 36 years. Since the Photo Ark began, she's allowed into her home a woodchuck, opossum (with six babies), albino porcupine, beaver, four coyote puppies, and more than 700 bees, spiders, moths, flies, and wasps.

JOEL HAS ALWAYS BEEN THIS WAY. I'VE KNOWN THAT SINCE WE WERE DATING IN COLLEGE. WHATEVER HE WORKS ON, IT TAKES OVER HIS LIFE. HE'S LIKE A GOOD BIRD DOG. IF YOU TELL HIM TO HUNT, THAT'S ALL HE DOES, WITH A SINGULAR FOCUS, UNTIL THE JOB IS DONE.

KATHY SARTORE

of time and money to be there. I went on and on defending my absence, and when I finished, all she said was this: "You've always got great excuses, Joel. I'm not saying you have to quit your job. I'm only saying that if you continue to be gone more than you're home, I don't want any part of this. It's your choice now."

I flew home the following day. It was one of the best decisions I ever made.

I met Kathy when we were both 21. I immediately recognized how grand she was in every way, and I proposed soon after, before

I'VE GOTTEN TO BOTTLE-FEED A BABY JAGUAR IN THE DOMINICAN REPUBLIC AND FLY IN A HELICOPTER UP THROUGH A RAINFOREST CANYON IN MOZAMBIQUE. THE BEST HAS BEEN SEEING HOW OTHER CULTURES CARRY ON AND HOW PEOPLE LIVE AROUND THE WORLD.

COLE SARTORE

someone else did. As we'd say in Nebraska, I'd "married up": She was smarter than me, statuesque with long blond hair. Plus she thought I was funny, which was about all I had going for me at the time.

And believe it or not, her warning shot to call me home that stormy day eventually created the Photo Ark.

I got back home to Lincoln, where Kathy and our three young children, Cole, Ellen, and Spencer, were waiting. The youngest was just two at the time. I chose them over my work, and we agreed to set a new path forward that we could live with.

Six weeks later, Kathy found a tumor in her right breast. It was large, it was cancer, and she'd be in for it: nine months of chemo followed by radiation. I learned how to take care of someone so sick she couldn't speak at times. But also how to be a father, how to run the house, and how to accept lasagna that various friends brought over.

Many times that winter, when she and Spencer were napping, I'd wander around our historic but drafty house and look at the art on the walls and the books on the shelves. There were Audubon prints depicting birds he knew were going to completely vanish. There were paintings by George Catlin and photographs by Edward Curtis, offering visual depictions of Native people who also were threatened with extinction.

All three men gave their lives to creating not just a visual record of loss but also a loving celebration of what had been. Could I do the same for all the species I'd met over the years, especially the ones who never have their stories told because they're deemed too insignificant to matter? Could my work save some of them at least—the minnows, sparrows, frogs, and even snails?

If Kathy got better, this would be my path forward.

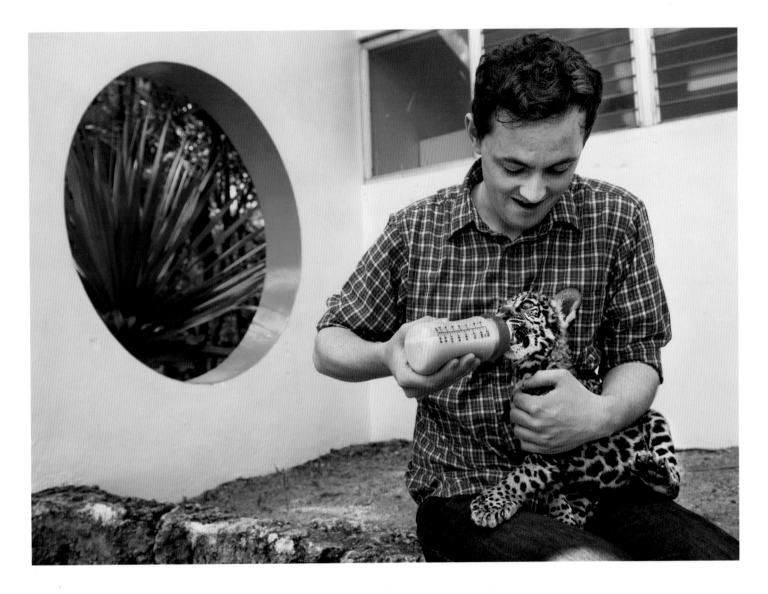

And get better she did. She's still just fine to this day, and we've been married 36 years now. I'm gone a lot, but for a much better cause, plus these days she says she needs the break, as I can be hard to live with.

When it comes to their feelings about the Photo Ark, she and the kids admire the mission, but they'd prefer not to get sucked into the "vor-tex," as they've named it. And yet for years, all have helped the cause tremendously, though at times with resentment.

Son Cole, now 27, likes to travel but really has to bite his tongue when we're spending days on the road together. "Having constant difficulty finding a balance between having a dad and having a dad as my employer, it's very difficult sometimes," Cole says. When asked about his funniest memory connected to the Photo Ark, he replies, "Nothing is coming to

me." But then he adds, "How I spend money and consume resources, and operate in my daily life . . . every element of life is tied to nature in my mind. The Photo Ark isn't just pretty pictures, it's a guide to living sustainably. Seeing these creatures up close and personal makes one realize what's at stake."

Ellen, now 23, has mixed feelings as well. "I know that it was necessary, but that doesn't mean it was pleasant. Five people in a Prius with eight-foot rolls of paper riding over our heads on an eight-hour drive isn't my idea of family fun. Carrying everything from the airport to truck to our basement, then reversing the process the next time he was leaving . . . Really, really not fun at all.

"But the Photo Ark has and will continue to affect the way I conduct myself and how I live," she continues. "I shop smart, I try to conserve energy and water whenever I can, and I have a job that doesn't contribute to the destruction of Earth. It's helped things fall into place for me, and I can't imagine why that wouldn't continue for the rest of my life."

OPPOSITE: Ellen Sartore is a clotheshorse who loves her dad and his mission but not the actual work itself. Here, she's smiling during a break on an insect shoot in western Iowa. She's a pretty good actress.

> **I MOVE EARTHWORMS ON THE SIDEWALK BACK INTO THE GRASS. I PUT BUGS OUTSIDE IF THEY FIND THEIR WAY INTO MY HOUSE. I HAVE A SMALL POLLINATOR GARDEN. IN SHORT, GROWING UP AROUND THE PHOTO ARK INFLUENCED WHO I AM AND HOW I INTERACT WITH THE WORLD.**
>
> ELLEN SARTORE

Son Spencer is 17 now. He's the least likely to follow in my footsteps, but he has played a part in the Photo Ark just as much as everyone else in the family. Worst moments? "There are a lot of those," he says. "Probably when we were in the Czech Republic, when we had to stay several nights in a zoo's rhino barn that was superhot and smelly. The rhino ran her horns across the bars all night long. We thought it was a ceiling fan that was hitting an iron pipe, but it wasn't."

And finally, Kathy: She's learned to live with it, but that doesn't mean she loves it. "Everything

else in life gets pushed to the back behind the Photo Ark," she says. "And I mean everything. Any house maintenance, life events, meals, sleeping, all of it. Joel always has the most fabulous reasons, and you can't argue with them; it all needs done immediately or else the species could go extinct."

ABOVE: The last child living at home, Spencer Sartore is now the one saddled with the task of loading photo gear in and out of the Sartore house, much to his chagrin.

Unfortunately for my entire family, I've been sticking close to home since the pandemic hit, but I've still managed to shoot more than a thousand species. Mainly insects, but they count most of all in the scheme of things. We're over 11,250 species now, and climbing.

All along, the one question I think about most is still this: Why do the project at all? It'll take until I die, or nearly so, to reach my goal of

photographing every species in human care. Meanwhile, the human population continues to expand exponentially.

Today, from my kitchen table on a cold January morning, here's the best answer I can come up with: Big things can have small beginnings. When we care about the least among us, it can lead to broader environmental thinking, from consumer spending to saving rainforests. So when we save other species, we're actually saving ourselves.

Besides, sparing some mouse or little brown toad is simply the right and noble thing to do. There's no money in it, just the satisfaction of doing the right thing as gauged by someone who simply can't stand the thought of living in a world that's being diminished daily.

To me at least, none of this is too burdensome—this invitation for us to pause, and marvel, and act, before a prairie wind carries that rare bird's soft song away for the very last time, or the mountain stream loses that native trout that has continued to glow brilliant red and gold even through the most violent of storms.

It's easy to rally support for the tiger and the zebra. They are big, beautiful, and famous.

IT'S NO FUN HAULING ALL HIS GEAR IN, THEN BACK OUT AGAIN THE NEXT TIME HE HEADS TO THE AIRPORT. I DON'T LIKE HIS 50-POUND DUFFLE BAGS, NOT ONE LITTLE BIT. THE PHOTO ARK IS A LOT OF WORK, BUT IT'S FOR A GOOD CAUSE, I GUESS.

SPENCER SARTORE

But how to get folks excited about the long-beaked echidna and the harvest mouse, the crayfish and the spider monkey, even the forests they live in? In degree of difficulty, that's Mount Everest.

But enough rest for now. It's time to get moving, and do all we can, with what we've got, right this minute.

We keep climbing.

EDITOR'S NOTE: A special thanks to Kathy, Cole, Ellen, and Spencer Sartore for so generously sharing their thoughts and memories for this book.

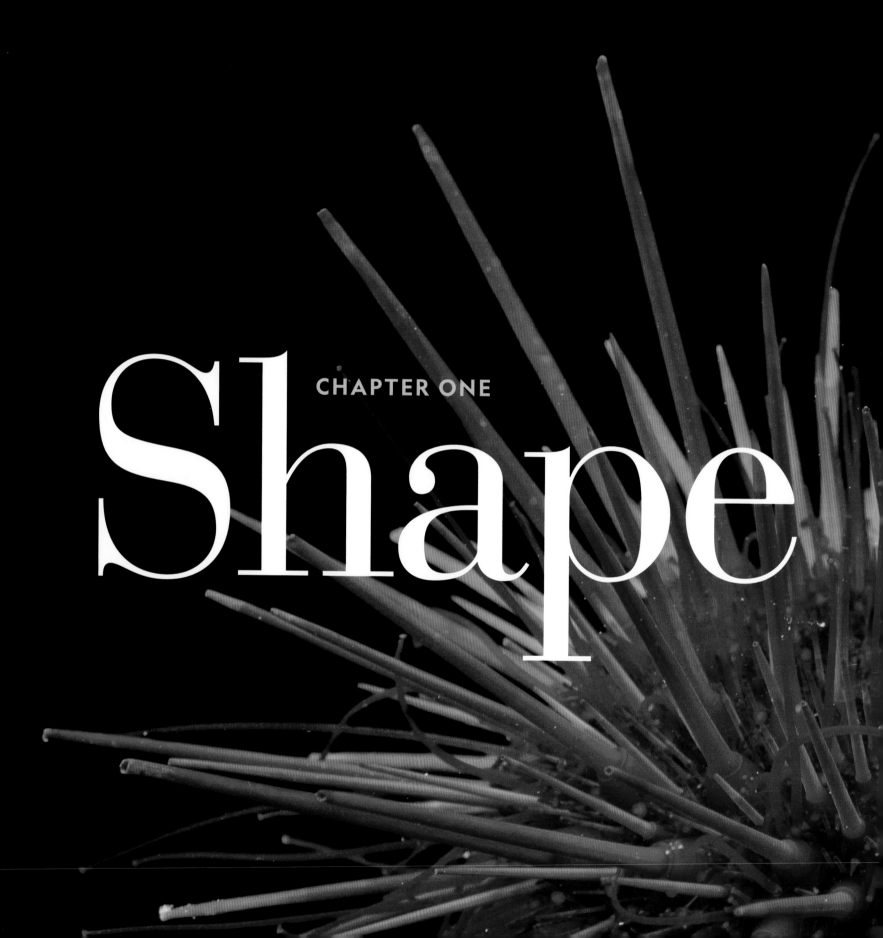

CHAPTER ONE

Shape

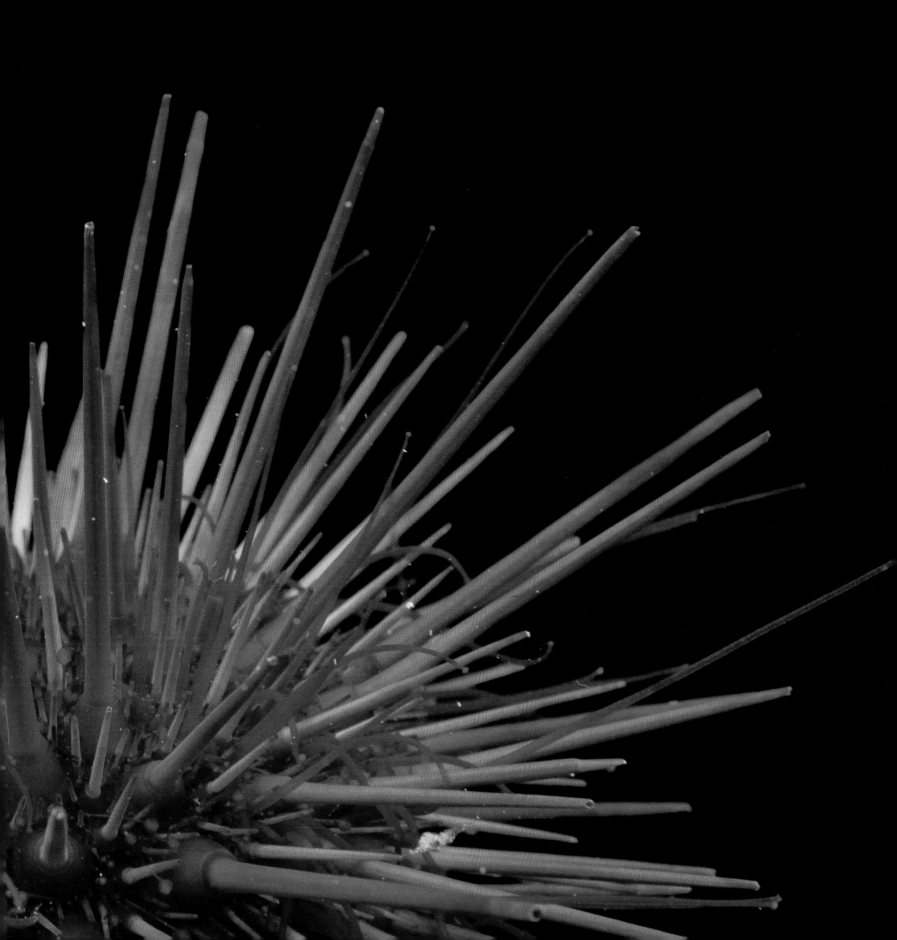

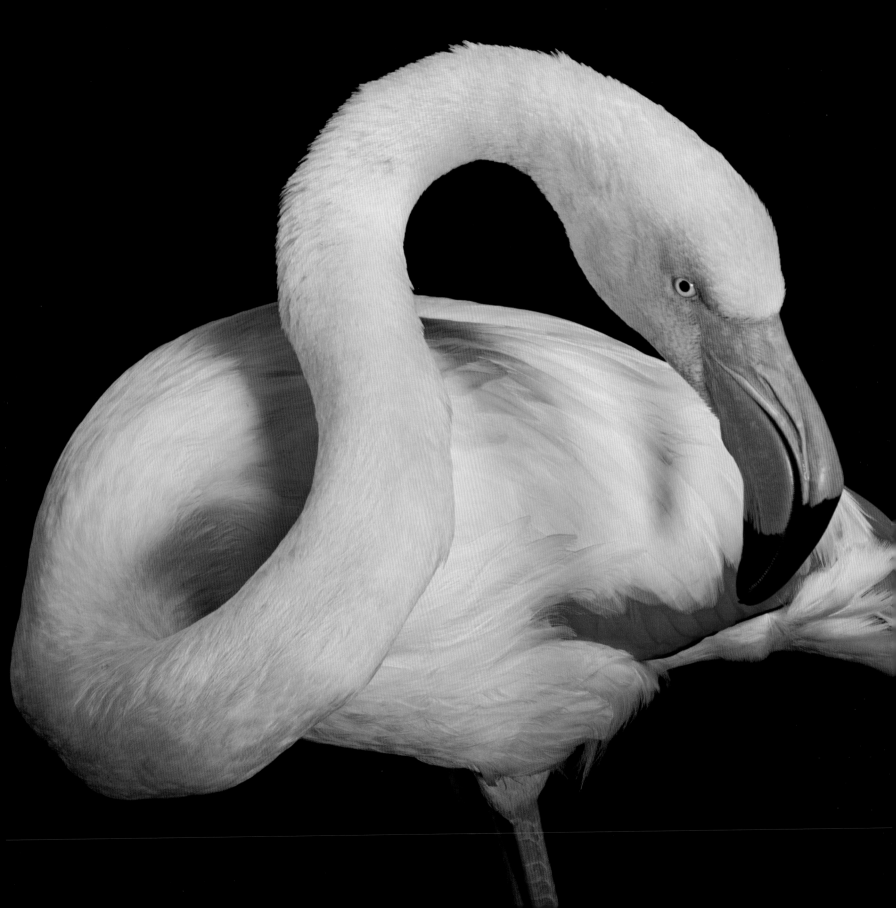

Silhouette

Graceful curves or sharp projectiles, reaching tall or squatting down, all stretched out or rolled up into a ball: Shape defines the creature.

Some shapes serve to dissemble: the papery mantis that looks like a leaf or the monkey whose fur puffs up bigger than its frame might warrant. The frogfish is so lumpy, if it didn't move, it would look like a chunk of coral. Other shapes respond to circumstances: the sprung legs of the jerboa, which must leap from predators, or the long beak of the giant ibis, best for fishing in marshes.

Some shapes we know in an instant, like the signature giraffe head, knobs and lips atop a slender neck, or the elegant wings of the luna moth. Then some shapes defy comprehension, like the massive bulk of a giant softshell turtle or the lazy flow of anemone tentacles, wafting in ocean currents.

Shape so defines the creature that some animals survive by being champion shapeshifters. The hermit crab—unlike its kin confined by a hard carapace—adapts to many a found container, moving into some abandoned seashell by taking the shape it requires. The moray eel curls tightly into underwater cracks and crevices until it darts out and glides through the water, its full-length ribbon of a body unfurled.

Shape, a primal characteristic, unites the unexpected and distinguishes each creature from all others. We know many animals by their shapes—and by their shapes we learn more about them. ▪

OPPOSITE: Greater flamingo, Phoenicopterus roseus (LC)
PREVIOUS PAGES: Purple sea urchin, *Strongylocentrotus purpuratus* (NE)

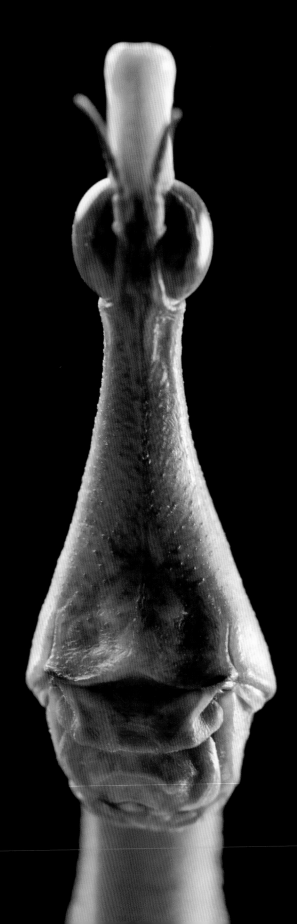

Giant jumping stick, *Stiphra* sp. (NE)

Bulging eyes on an alien head give this South American
insect a panoramic view of its rainforest home. With sticklike,
angular legs, this close relative of grasshoppers leaps
through the air—and onto the next tasty leaf to munch.

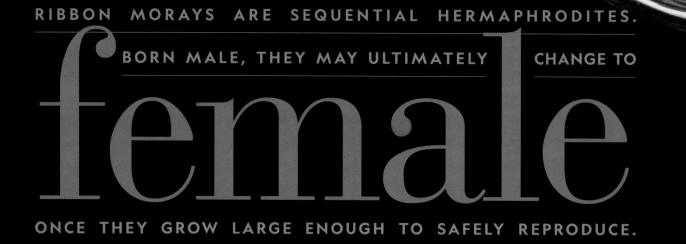

RIBBON MORAYS ARE SEQUENTIAL HERMAPHRODITES.
BORN MALE, THEY MAY ULTIMATELY CHANGE TO

female

ONCE THEY GROW LARGE ENOUGH TO SAFELY REPRODUCE.

Ribbon moray eel, *Rhinomuraena quaesita* (LC)

This juvenile eel's huge nostrils and barbel-studded lower jaw
make it easily recognizable in the reefs of the Pacific Ocean.
Eels change from male to female during their lifetimes. As they
change, so does their color; females are completely yellow.

Red-handed tamarin, *Saguinus midas* (LC)

Glowing fur and long, curved claws show off the hands and feet of this acrobatic primate. But they are more than adornment: The tamarin's remarkable joints can absorb the impact of a 60-foot jump from a tree branch to the ground.

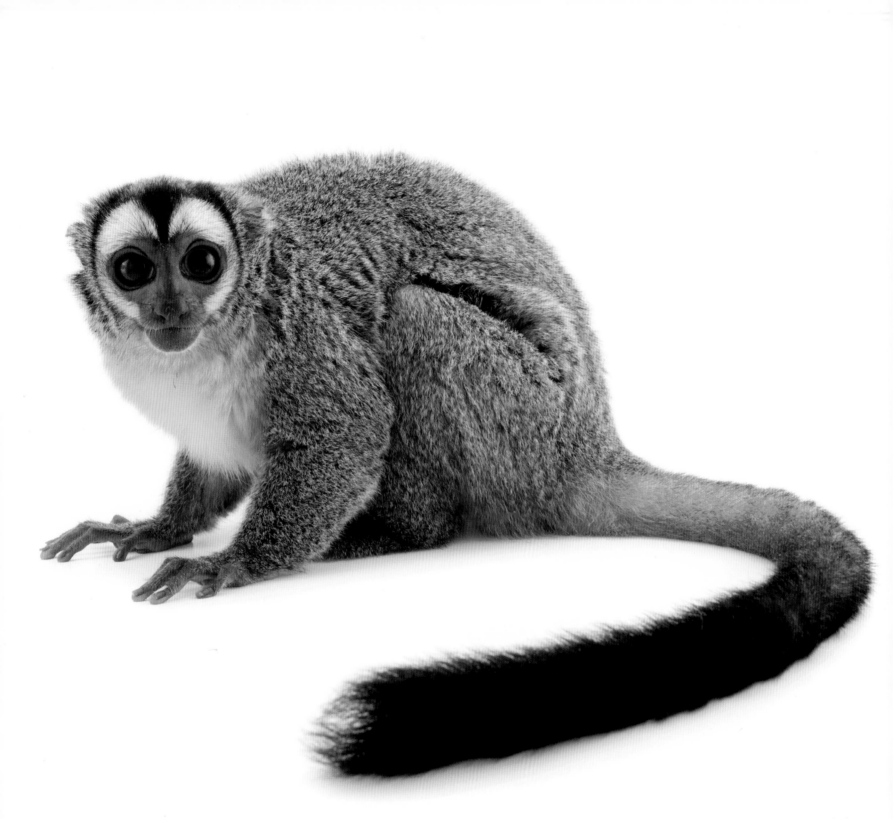

Three-striped night monkey, *Aotus trivirgatus* (LC)

Guided by dark, owl-like eyes and using their long tails for
balance, these nocturnal monkeys of the Amazon leap from
tree to tree to find food. They follow the same route each
time, having memorized the way on bright, moonlit nights.

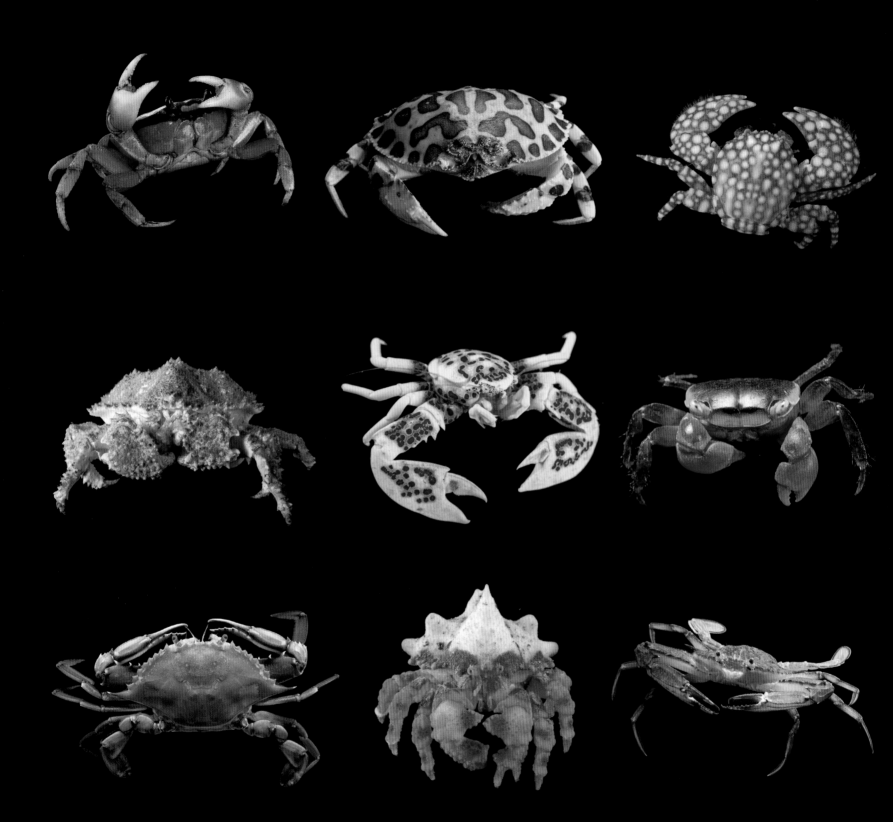

The world's roughly 10,000 species of crabs include tiny critters only an inch long and giants measuring 12 feet from tip to tip. Often living in or near water, crabs (and their claws) come in nearly every color of the rainbow. **TOP ROW, L TO R:** Halloween crab, *Gecarcinus lateralis* (NE); Calico crab, *Hepatus ephelit-icus* (NE); Spotted porcelain crab, *Porcellana sayana* (NE); **CENTER ROW, L TO R:** Brown box crab, *Lopholithodes foraminatus* (NE); Porcelain anemone crab, *Neopetrolisthes maculatus* (NE); Red apple crab, *Metasesarma aubryi* (NE); **BOTTOM ROW, L TO R:** Lesser blue crab, *Callinectes similis* (NE); Puget Sound king

crab, *Lopholithodes mandtii* (NE); Swimming crab, *Achelous xantusii* (NE);
TOP ROW, L TO R: Vampire crab, *Geosesarma dennerle* (NE); Purple marsh crab,
Sesarma reticulatum (NE); Speckled swimming crab, *Arenaeus cribrarius* (NE);
CENTER ROW, L TO R: Pygmy rock crab, *Glebocarcinus oregonensis* (NE); Heart

crab, *Phyllolithodes papillosus* (NE); Striped shore crab, *Pachygrapsus crassipes* (NE); **BOTTOM ROW, L TO R:** Red mangrove crab, *Pseudosesarma moeshi*
(NE); African rainbow crab, *Cardisoma armatum* (NE); Sheep crab, *Loxorhynchus grandis* (NE)

Cantor's giant softshell turtle, *Pelochelys cantorii* (EN)

This bulky freshwater turtle may not win any beauty contests, but it's perfectly suited to a life spent buried in mud. The turtle's taxonomic family dates back 140 million years, but today this species, native to Southeast Asia, is at risk of extinction.

The Forgotten One

We were at a zoo in Malaysia, eyeing a goldfish pond beneath the stairs in the lobby of the reptile building, when my colleague Pierre de Chabannes spotted a ring in the mud as big as a manhole cover. "Let's pry this up and see what it is," he said. I didn't know what Pierre was up to, but I found a broom in a janitor's closet. As I wedged it under the ring, Pierre caught a quick glimpse of a huge, muddy, dripping creature. He immediately identified the animal as a Cantor's giant softshell turtle—an extremely rare reptile, and possibly the only one of its kind in a zoo. We learned later that a fisherman had donated it some 15 years before. But most of the zoo staff had no idea it was there. They'd never seen it. They just knew all their goldfish kept disappearing. ∎

Painted frogfish, *Antennarius pictus* (NE)

Resembling a misshapen strawberry, the frogfish uses its
globular body to blend in with sponge and coral neighbors.
Found in reefs from East Africa to Hawaii, it can change color—
cream, pink, yellow, red, brown—to match its surroundings.

Florida false coral, *Ricordea florida* (NE)

Is it a coral? An anemone? Neither: This resident of swift-
moving, shallow coastal waters is something in-between—
a morph. It clings to rocky areas or dead coral and feeds
using the bubble-like tentacles that cover its body.

Rothschild's giraffe, *Giraffa camelopardalis rothschildi* (NT)
OPPOSITE: Reticulated giraffe, *Giraffa camelopardalis reticulata* (EN)

With its long neck, stuck-out ears, and fuzzy ossicones atop its head, the giraffe is one of the animal kingdom's most familiar faces. When resting at night, it remains standing, arching its neck to place its head on a hind leg.

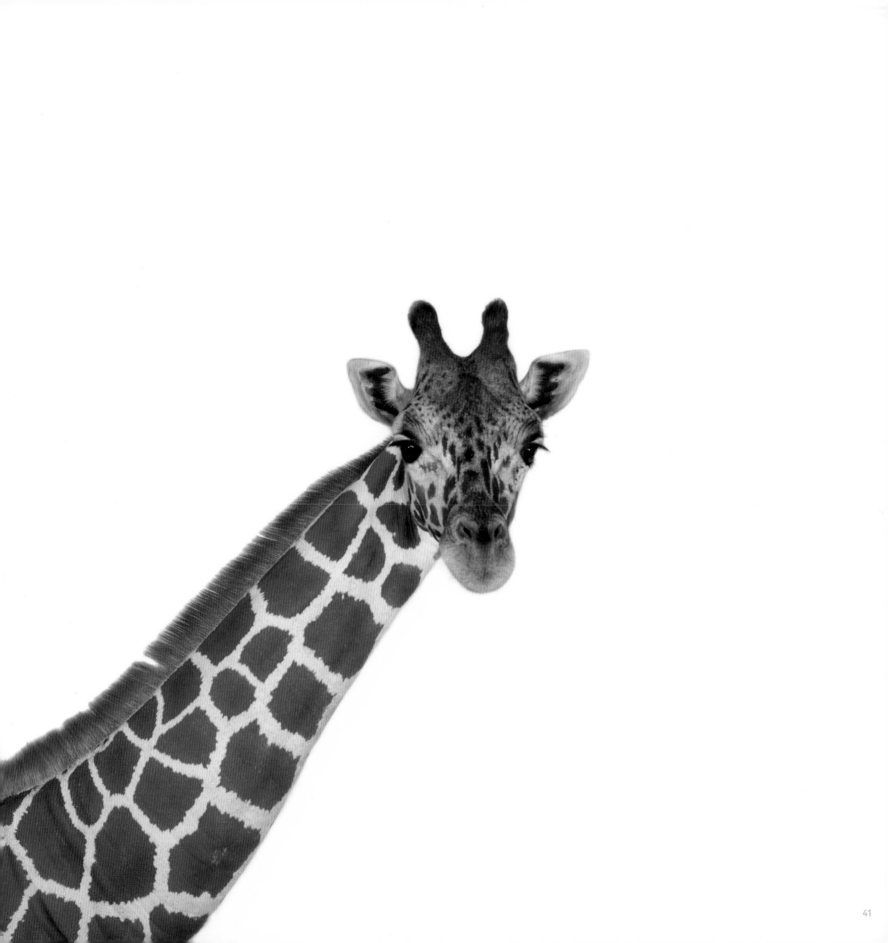

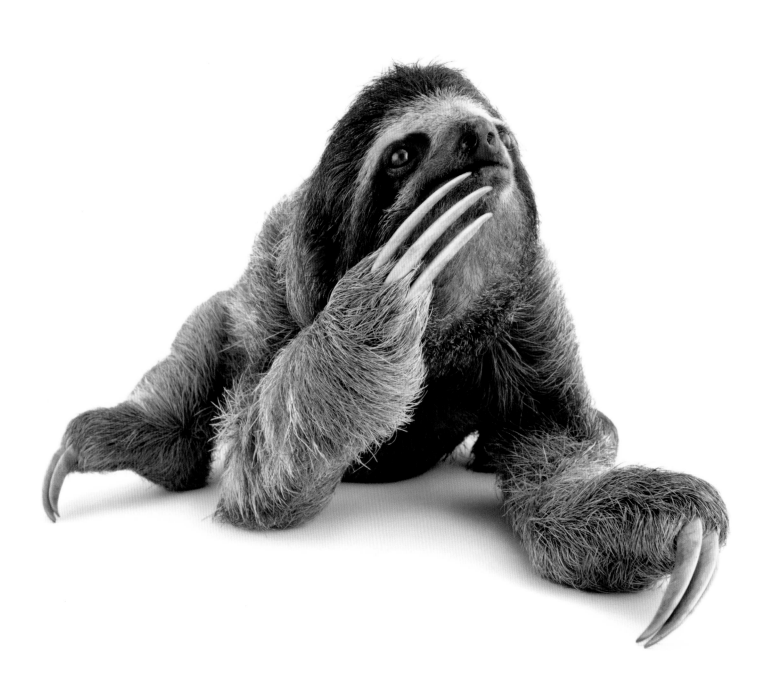

Brown-throated three-toed sloth, *Bradypus variegatus* (LC)

Don't be fooled by the claws: This languid tree dweller of Central
and South American rainforests is benign, napping up to 16 hours
a day. Its arms are twice as long as its legs, and its long claws allow it
to climb trees and hang from limbs without slipping.

River cooter, *Pseudemys concinna* (LC)

During mating season across the species' range in the
southeastern United States, a male will caress a female's face
and shell with his elongated claws.

TENRECS ARE THE ONLY MAMMALS THAT COMMUNICATE BY STRIDULATION. THEY CREATE ULTRASONIC SOUNDS BY RUBBING AN ORGAN HOLDING SPECIAL **quills,** MAKING SOUND THROUGH FRICTION—A HABIT THAT IS MORE COMMONLY FOUND IN CRICKETS.

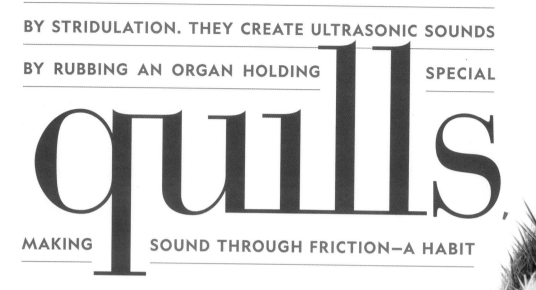

Lowland streaked tenrec, *Hemicentetes semispinosus* (LC)

This small but scrappy mole-like animal native to Madagascar may look cuddly, but it has a rather fearsome way of deploying its spiny quills: If a female is not ready to mate, she'll stick her quills into the male's genitals.

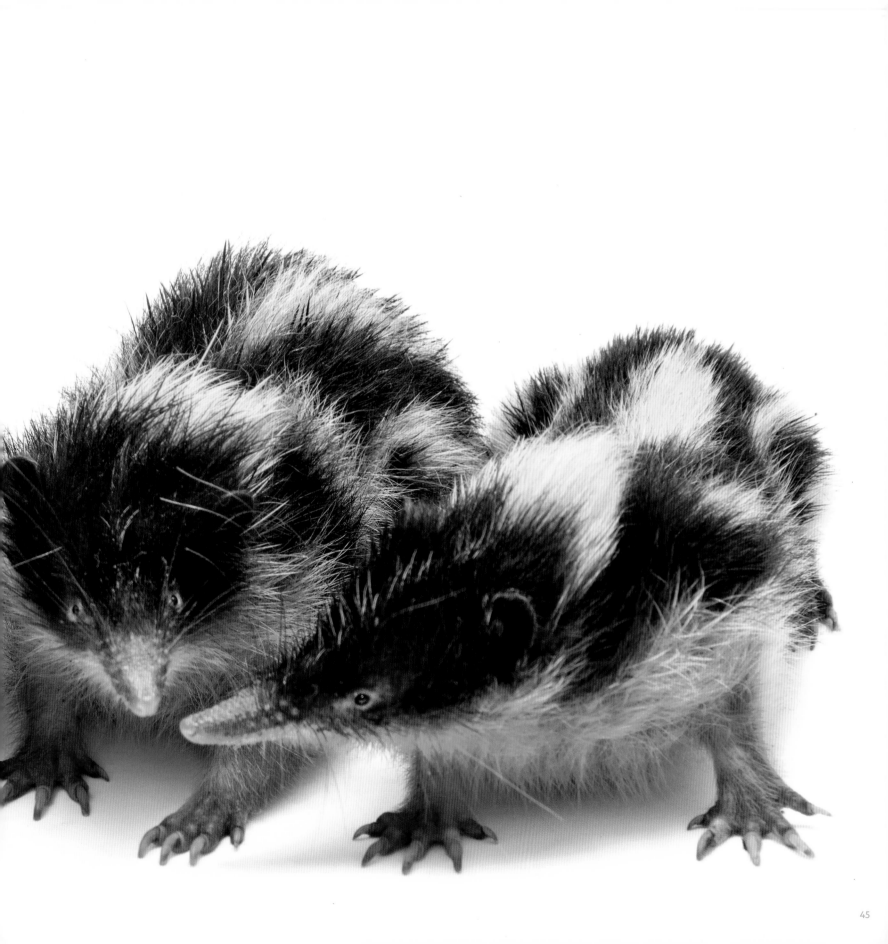

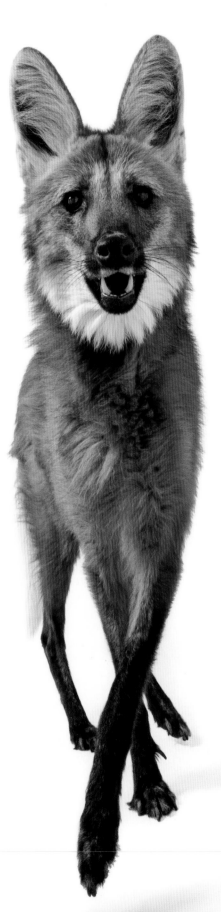

Maned wolf, *Chrysocyon brachyurus* (NT)

Slender, lanky legs help this wolf lope in search of prey amid
the tall grasses and scrub forests of central South America.
Everything about it seems stretched: long muzzle, upright
ears, even hind legs that are longer than its front legs.

Gerenuk, *Litocranius walleri* (NT)

By rearing up on spindly legs and craning its long neck, the gerenuk of East Africa can reach tasty tree leaves that are out of range for most antelopes. One individual was found to have 80 different species of plants in its stomach.

Barred eagle-owl, *Bubo sumatranus strepitans* (LC)

Slanted ear tufts of buff and brown feathers fluff out from the head of this large owl. Found in Malaysia and parts of Indonesia, these eagle-owls are thought to mate for life and will spend many years at the same nesting site.

Horned marsupial frog, *Gastrotheca cornuta* (EN)

This rare frog of Central American rainforests has hornlike
triangular skin flaps above its golden eyes. But that's not all:
Eggs develop in a pouch on the mother's back and hatch out
as fully formed froglets rather than tadpoles.

Giant clam, *Tridacna gigas* (VU)

The world's largest mollusk tips the scales at an average weight of 440 pounds and can grow up to four feet long. A colorful, dotted, wavy mantle protrudes from its scalloped shell; no two clams have the same coloration.

The Longest Day

My daughter, Ellen, took off a semester from college to travel with me. We ended a grueling swing through the Philippines at a marine reserve to shoot photos of giant clams. That morning I had unwisely eaten several scoops of room-temperature corned beef hash. By the afternoon, I was as sick as I'd ever been, in a marine lab with one toilet with a tank that took 20 minutes to refill. I was miserable. I curled up on the cool tile floor as the staff brought out the clams one at a time. Ellen would place a clam in the display tank and rouse me. I'd get up, take the photos, and return to the fetal position. There were only four clams, but it felt like a lifetime. By evening I felt better. But now Ellen will only travel with me if I leave my camera at home. ∎

Cat Ba langur, *Trachypithecus poliocephalus* (CR)

A heart-shaped face, perfectly round eyes, and a cone-shaped shock of golden fur give this langur an arresting visage. This is one of the rarest primates in the world; only a few dozen survive on the island of Cat Ba in Vietnam.

Hispaniolan solenodon,
Solenodon paradoxus paradoxus (LC)

Those formidable incisors aren't just sharp:
They're also deadly. One of the only venomous
mammals on Earth, the solenodon—meaning
"slotted tooth"—injects its prey with lethal saliva
through grooves in its pointy lower teeth.

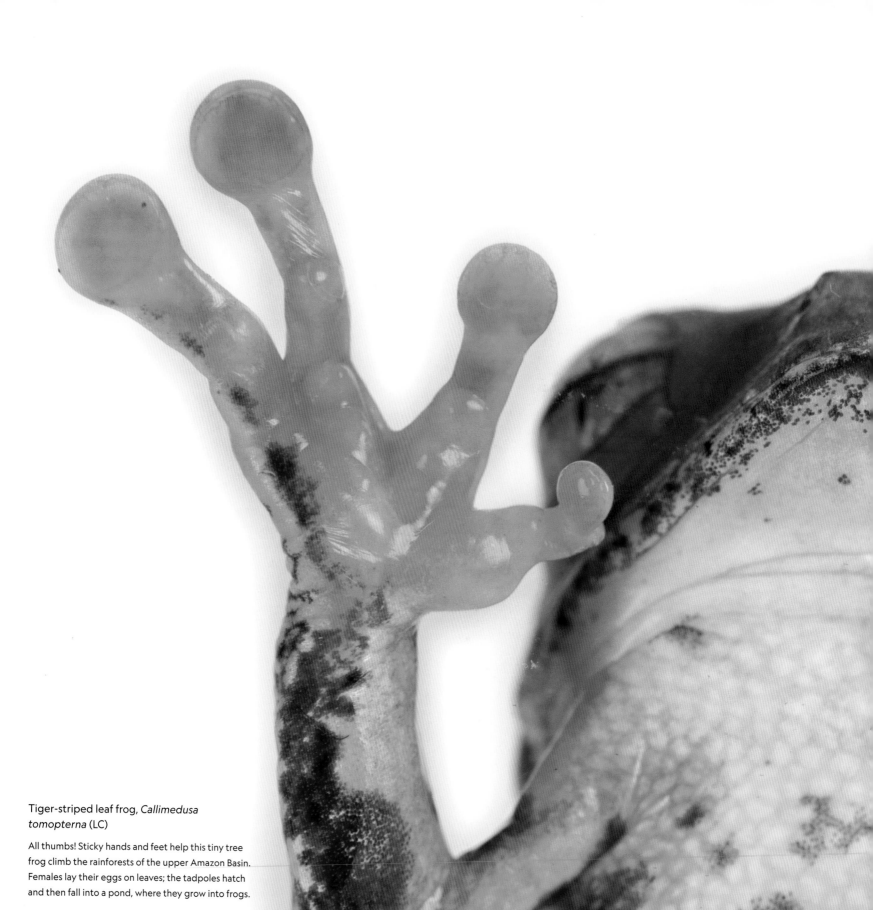

Tiger-striped leaf frog, *Callimedusa tomopterna* (LC)

All thumbs! Sticky hands and feet help this tiny tree frog climb the rainforests of the upper Amazon Basin. Females lay their eggs on leaves; the tadpoles hatch and then fall into a pond, where they grow into frogs.

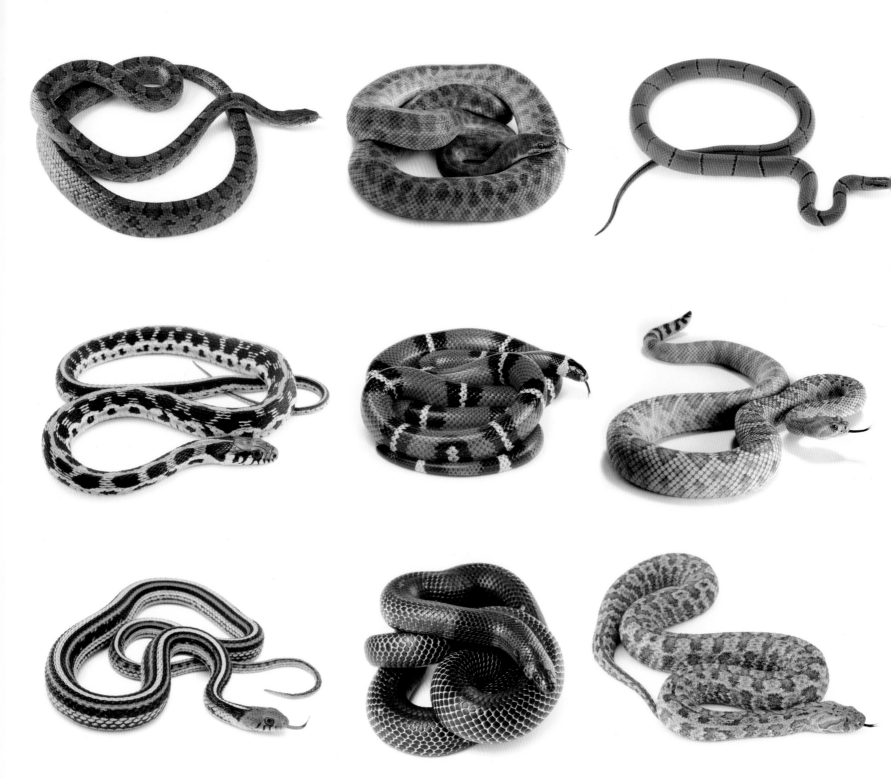

Snakes are cold-blooded and covered in scales, with forked tongues and a preference for swallowing their prey whole. Only 200 or so of the world's 3,000 species of snakes are venomous enough to kill or seriously harm a human. **TOP ROW, L TO R:** Red corn snake, *Pantherophis guttatus* (LC); Stimson's python, *Antaresia stimsoni* (LC); Red bamboo snake, *Oreocryptophis porphyraceus laticinctus* (NE); **CENTER ROW, L TO R:** Eastern blackneck garter snake, *Thamnophis cyrtopsis ocellatus* (LC); Sinaloan milk snake, *Lampropeltis polyzona* (NE); Santa Catalina Island rattlesnake, *Crotalus catalinensis* (CR); **BOTTOM ROW, L TO R:** San Francisco garter snake, *Thamnophis sirtalis tetrataenia* (LC);

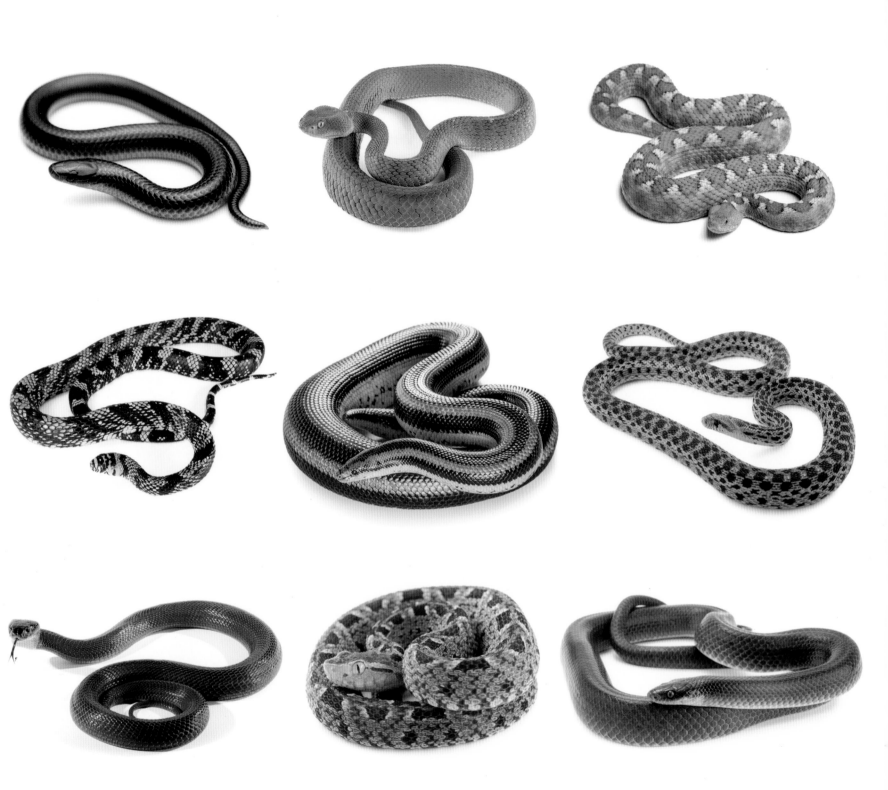

Ecuadorian milk snake, *Lampropeltis micropholis* (NE); Turanian viper, *Macrovipera lebetina turanica* (NE); **TOP ROW, L TO R:** Midwest worm snake, *Carphophis amoenus helenae* (LC); Large-eyed pit viper, *Trimeresurus macrops* (LC); Eastern long-nosed viper, *Vipera ammodytes meridionalis* (LC); **CENTER ROW, L TO R:** Mexican tiger rat snake, *Spilotes pullatus mexicanus* (LC); Rosy boa, *Lichanura trivirgata trivirgata* (LC); San Diego gopher snake, *Pituophis catenifer annectens* (LC); **BOTTOM ROW, L TO R:** Red spitting cobra, *Naja pallida* (NE); Terciopelo, *Bothrops asper* (NE); Neu-wied's false boa, *Pseudoboa neuwiedii* (LC)

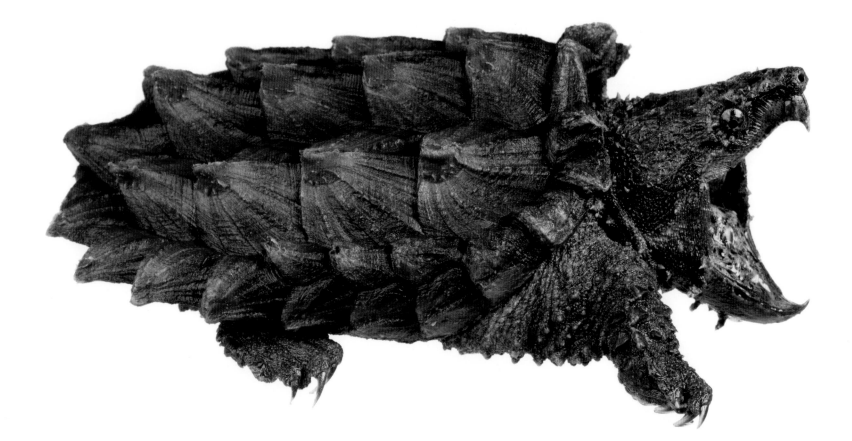

Alligator snapping turtle, *Macrochelys temminckii* (VU)

Spiked scales and a sharp beak give this freshwater turtle
of the southeastern United States a fierce and primitive
appearance. Using its wormlike tongue as a lure, it mostly
eats fish—but can also take down raccoons and armadillos.

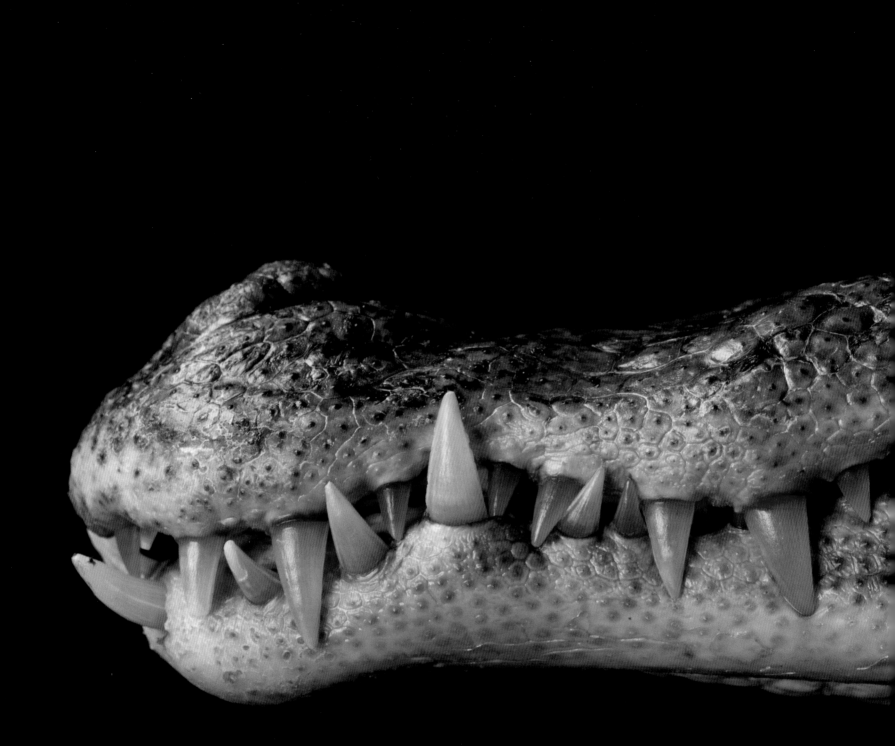

Spectacled caiman, *Caiman crocodilus crocodilus* (LC)

Birds, mammals, fish, lizards, snails, crabs, insects, carrion—
native to rivers and wetlands of Latin America and parts of
the Caribbean, this crocodile gobbles more than a hundred
varieties of prey with its powerful jaws and fearsome teeth.

SMALL, FLIGHTLESS BIRDS RELATED TO EMUS AND OSTRICHES,
KIWIS ARE KNOWN FOR THEIR REMARKABLE NOSES. THEY HAVE

nostrils

ON THE TIPS OF THEIR BEAKS THAT THEY USE TO SNIFF

OUT PREY, SUCH AS EARTHWORMS, BURIED IN THE GROUND.

North Island brown kiwi, *Apteryx mantelli* (VU)

Found only on the North Island of New Zealand, the
kiwi's stout body performs a remarkable reproductive
feat: Females lay one massive egg that constitutes
about 15 percent of their body weight.

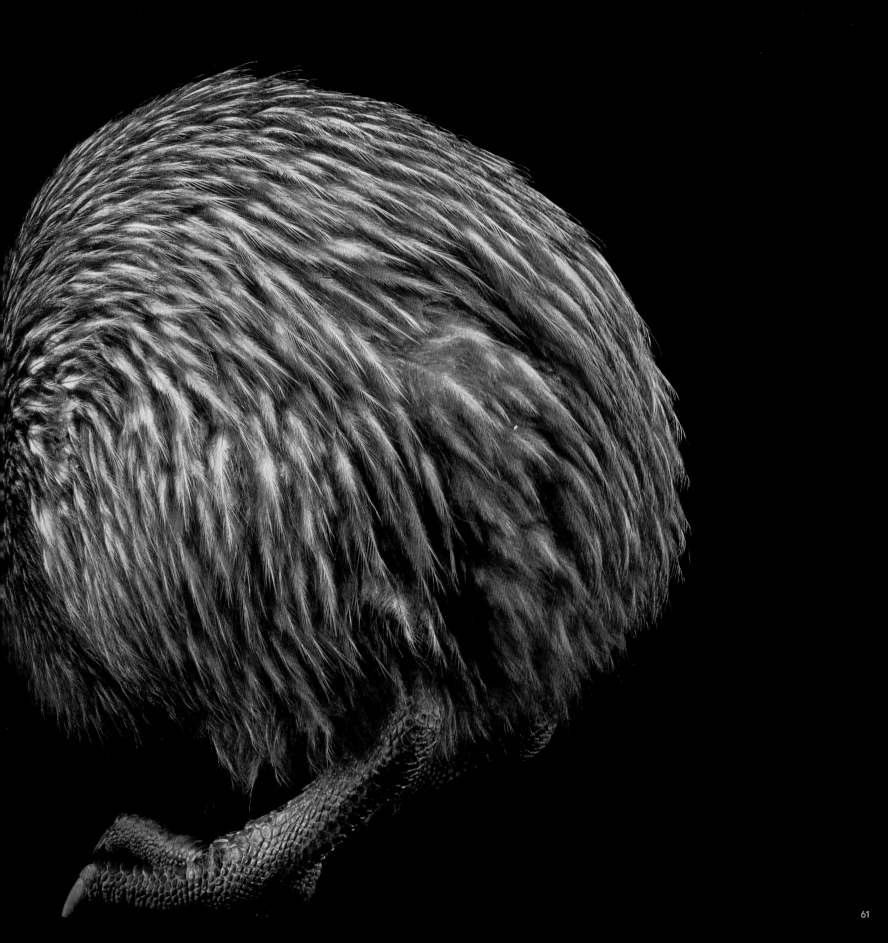

Ground beetle larva, *Dicaelus* sp. (NE)

The larva of this ground beetle burrows its long body
through soil to feast on other insects by crushing them
with its pincerlike mouth. Found in eastern North America,
adults typically live under rocks and logs.

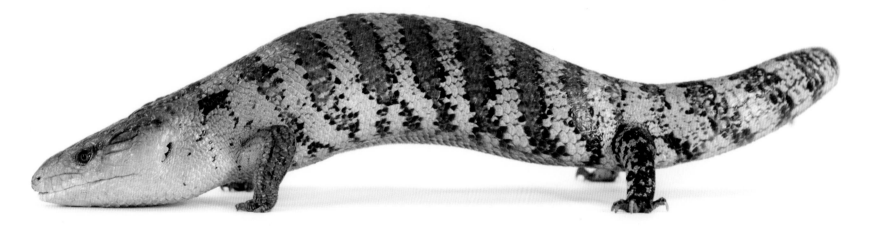

Eastern blue-tongued skink, *Tiliqua scincoides scincoides* (LC)

Like a striped cylinder with short legs, this native of Australia
rarely waddles far from the hollow logs where it lives.
Skinks can puff themselves up and hiss if confronted; in a
pinch, a skink can also lose its tail and grow another.

Bluespotted fantail ray, *Taeniura lymma* (NT)

This ray's tail, tipped with two venomous spines, is nearly as long as its oval-shaped body. Because baby rays emerge from egg sacs while still inside their mothers, their tails are soft and encased in skin; only later do they harden.

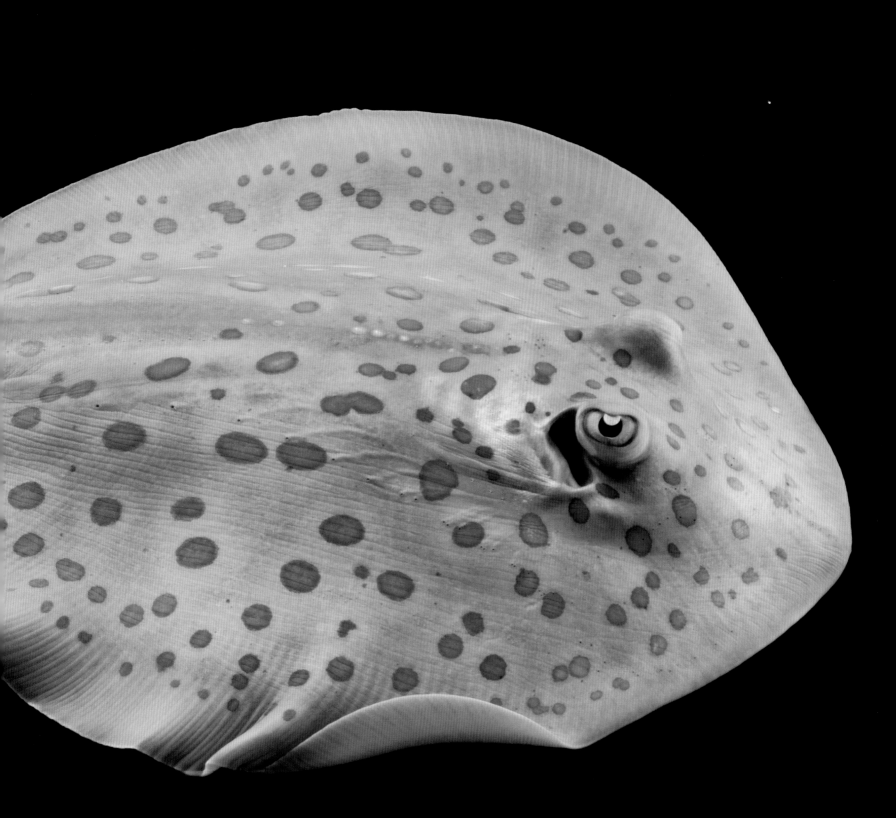

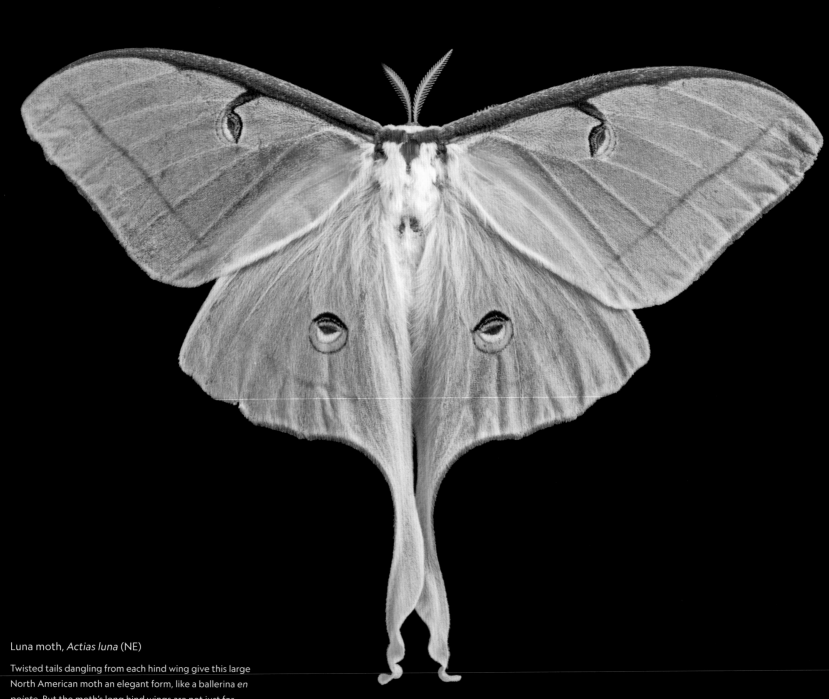

Luna moth, *Actias luna* (NE)

Twisted tails dangling from each hind wing give this large
North American moth an elegant form, like a ballerina *en
pointe*. But the moth's long hind wings are not just for
looks: They may confuse bats seeking the moths as prey.

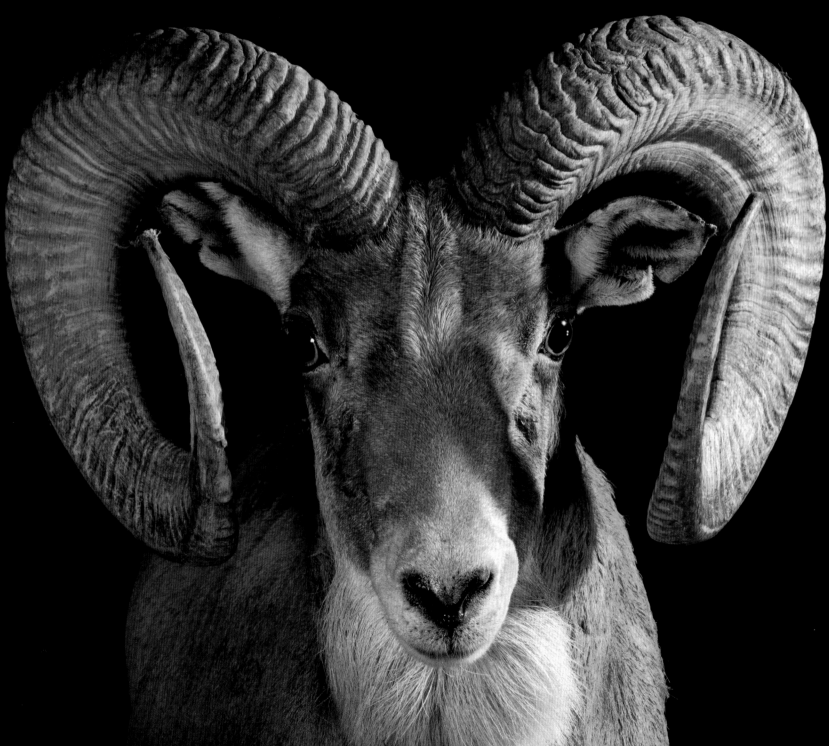

Transcaspian urial, *Ovis vignei arkal* (VU)

A wild sheep of Central Asia, the urial has huge, corrugated horns that frame its face in spectacular spirals. Rams spar with one another to determine dominance: They rear up on their hind legs, lunge forward, and lock horns in a formidable crash.

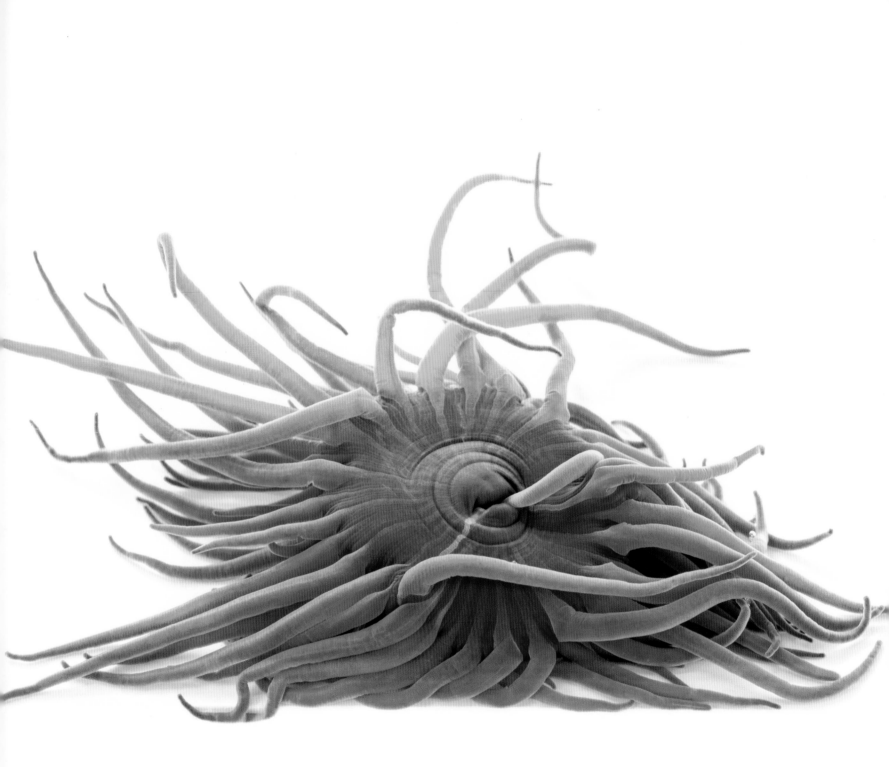

Mediterranean snakelocks sea anemone, *Anemonia viridis* (LC)

Resembling an unruly platter of pasta, this anemone of the Atlantic Ocean and Mediterranean Sea uses more than 200 sticky, stinging tentacles to find and consume prey—sea snails, fish, prawns—too large for other anemones to tackle.

Rajah Brooke's birdwing, *Trogonoptera brookiana* (LC)

Broad, straight wings marked with flashes of electric green give this butterfly the look of a sleek jet plane set to go. Found only in Thailand, Malaysia, and Indonesia, it is a strong flier capable of crossing a river in just a few wingbeats.

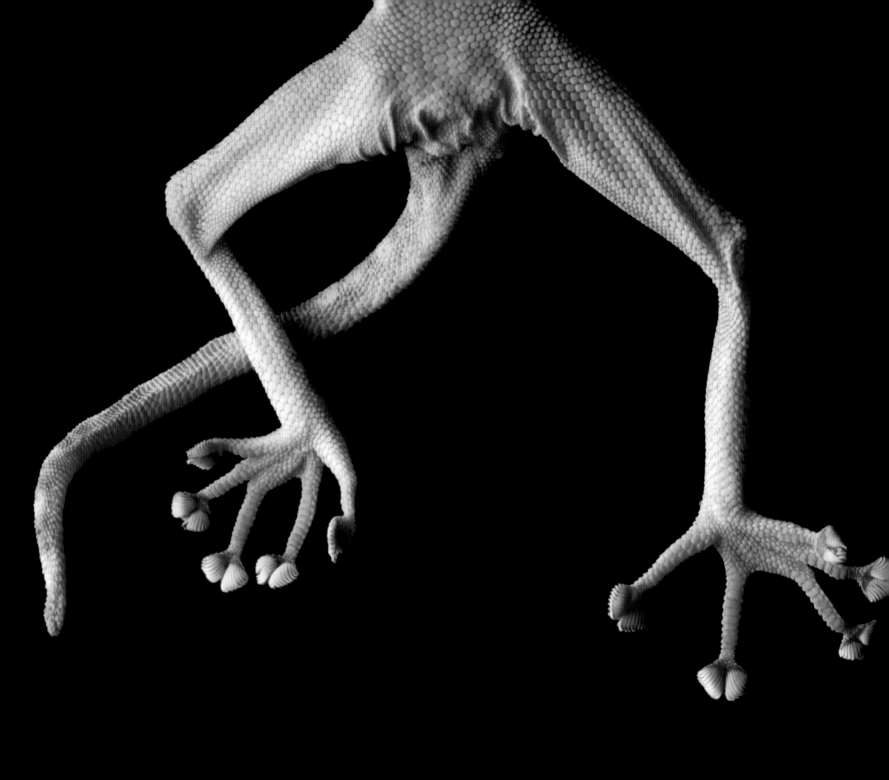

Hasselquist's fan-footed gecko, *Ptyodactylus hasselquistii* (NE)

Feet like these are a must for a creature that spends its life darting
among and clinging to the sheer faces of steep rocks. It lives amid the
boulders and dry areas of North Africa and West Asia.

Greater bulldog bat, *Noctilio leporinus* (LC)

These bats fly low and fast above water, using echolocation to detect small fish. Raking their talonlike hind claws along the surface, they hook a fish, chew it up right away, store the pulp in their cheek pouches, and keep on hunting.

Giant ibis, *Thaumatibis gigantea* (CR)

The world's largest ibis is striking in size, appearance, and rarity. It lives a secretive life in the lowland forests of Southeast Asia, foraging in secluded pools with its long, curved bill for worms, eels, frogs, and other food.

A World Away

Cambodia was my first stop on a trip through Southeast Asia. I was there to photograph the only giant ibis in captivity, and I was excited. But my father was dying. He had Alzheimer's. I felt fairly certain he didn't know who I was anymore. But on my last visit to see him, just before the trip, he called me by my name for the first time in years. He said, "Joel, I'd like you to rest." Leaving him really tore me up. But we had 20 stops lined up at zoos all across Southeast Asia, and he'd been hanging on for months, so I went, assuming he'd be there when I returned. We got the photos of the ibis. I flew next to Malaysia, and that evening I got word that my father had died. It felt like I'd been kicked in the stomach. Still does. I get to travel the world, but there's a high price. ■

Wunderpus, *Wunderpus photogenicus* (LC)

With a scientific name that nods to its marvelous shape and colors, this octopus of the Indo-Pacific region can change its colors or patterns to either blend in with its surroundings or mimic lionfish and other venomous creatures.

Tropical huntsman spider, *Heteropoda boiei* (NE)

This hunter doesn't need a web; fast legs and strong jaws are its tools for catching cockroaches and other prey. Its flattened body—good for sliding into tiny cracks and crevices—is about an inch long, and its legs grow up to five inches.

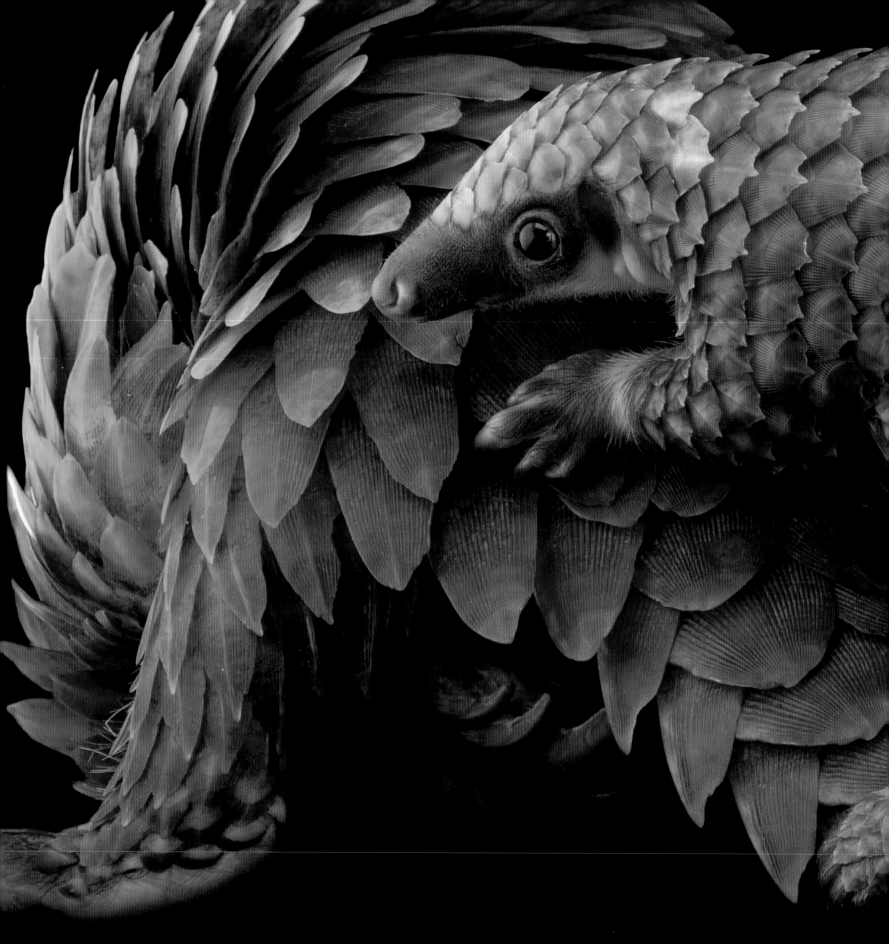

White-bellied tree pangolin, *Phataginus tricuspis* (LR)

With its sharp scales, tiny head, and long tail, this pangolin of equatorial
Africa is among the world's most unusual mammals. It is also among the
most vulnerable: Pangolin populations are plummeting, their scales
erroneously believed to have medicinal effects.

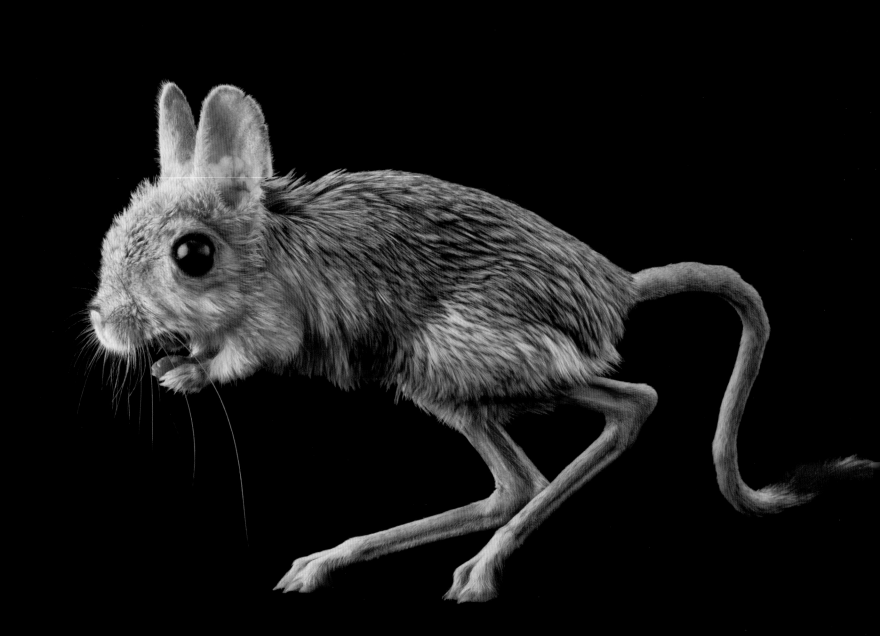

Greater Egyptian jerboa, *Jaculus orientalis* (LC)

With hind legs more than four times the length of its tiny arms, and a long, curvy tail for balance, the jerboa is built for jumping. Its only defense from predators is to spring three feet in the air and across distances up to nine feet.

Black-sided meadow katydid, *Conocephalus nigropleurum* (NE)

Those long legs aren't just for jumping through tall grass. By rubbing a hind leg against a wing, this colorful katydid of the northern United States produces a signature sound of summer nights: *tick, tick, tick,* followed by a shuffling trill.

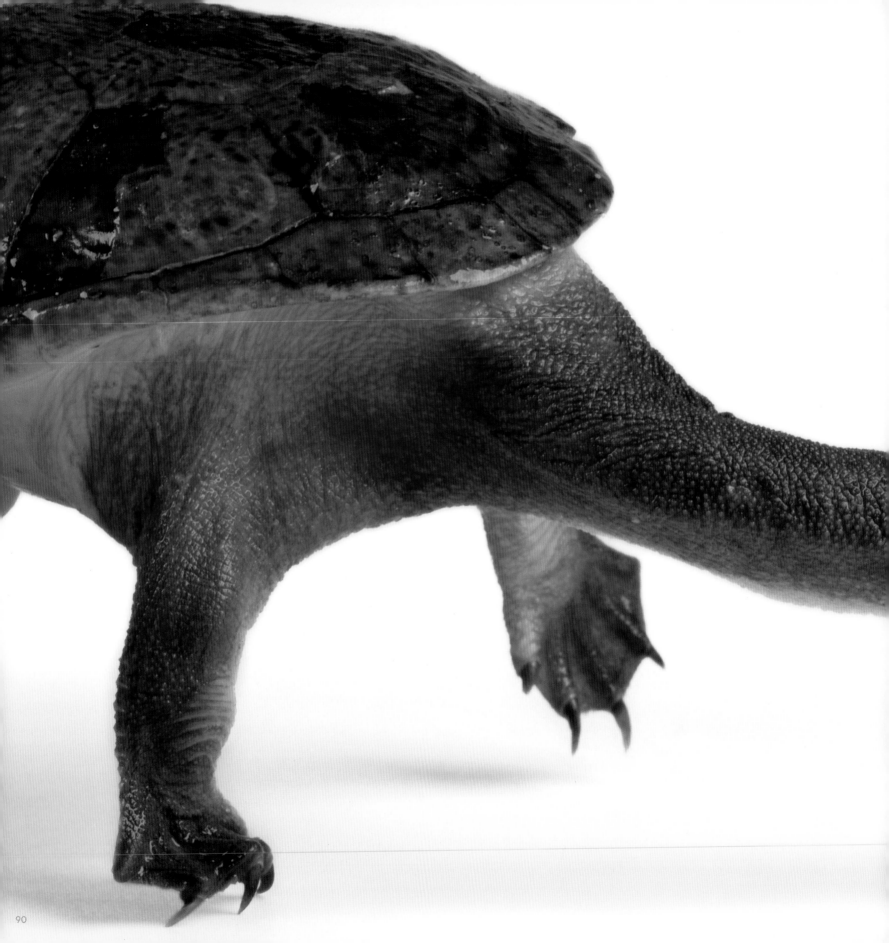

THE HEAD AND NECK OF THE SIEBENROCK'S SNAKE-NECKED TURTLE ARE ROUGHLY

equal

TO ONE HALF THE LENGTH OF ITS OUTER SHELL.

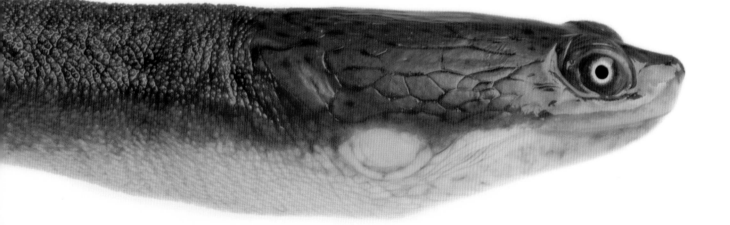

Siebenrock's snake-necked turtle,
Chelodina rugosa (NT)

This gangly Australian turtle likes to hide in mud and ambush
fish, frogs, and other prey. If threatened, the turtle doesn't pull
its head straight back into its shell; it curls its long neck around
the side of its dinner plate–size carapace.

Miller's saki, *Pithecia milleri* (VU)

If disturbed, this rare South American monkey puffs
up its coarse fur like a hood. Scientists know little
about the species; although it vocalizes
in grunts, chirps, and whistles,
it can be silent when sneaking
away from researchers.

Ringed seal, *Pusa hispida hispida* (LC)

This portly Arctic seal can dive as deep as 300 feet in the frigid water and stay submerged for 45 minutes. With its front claws, it carves breathing holes in the ice—allowing the seal to venture farther from shore ice than other seals.

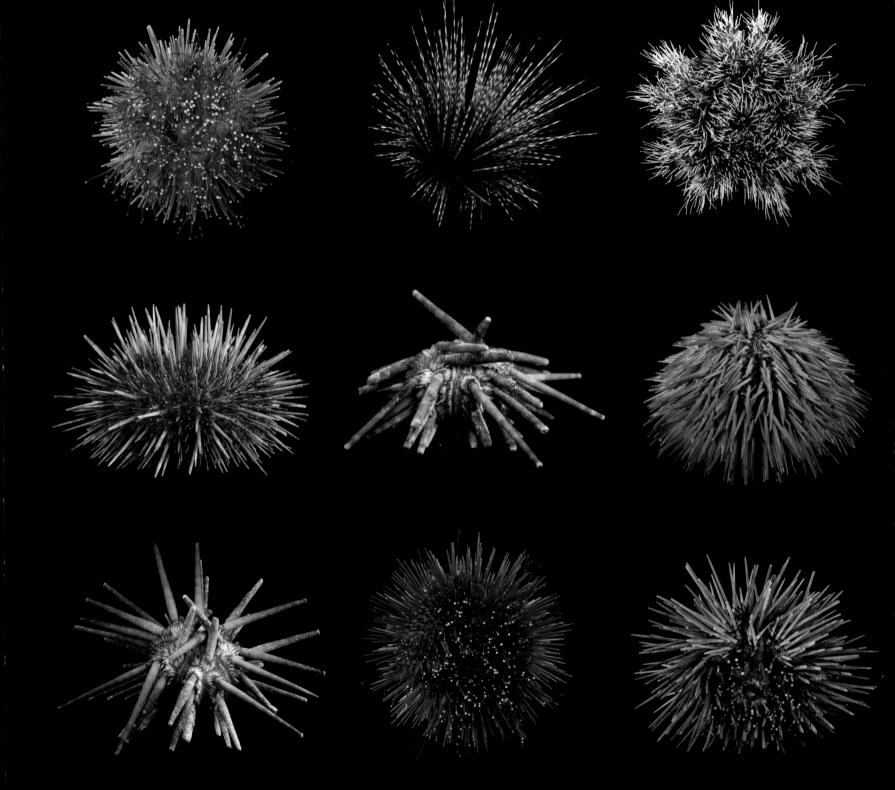

Some 700 species of sea urchins are found in the world's oceans. Their long, venomous spines protect them from predators like sea otters, help them move around, and even aid in detecting light. **TOP ROW, L TO R:** Brown sea urchin, *Paracentrotus lividus* (NE); Double-spined urchin, *Echinothrix calamaris* (NE); Cake urchin, *Tripneustes gratilla* (NE); **CENTER ROW, L TO R:** Short-spined sea urchin, *Heliocidaris erythrogramma* (NE); Slate pencil urchin, *Heterocentrotus mamillatus* (NE); Variegated sea urchin, *Lytechinus variegatus* (NE); **BOTTOM ROW, L TO R:** Slate pencil urchin, *Eucidaris thouarsii* (NE); Black sea urchin, *Arbacia lixula* (NE); Atlantic purple sea urchin, *Arbacia punctulata* (NE)

Flower urchin, *Toxopneustes pileolus* (NE)

Although it looks like a fuzzy flower, this sea urchin is one of the world's most dangerous: Its stalklike spines can inject a highly toxic venom into skin, sometimes causing death.

Indian elephant, *Elephas maximus indicus* (EN)

Curling trunk, flapping ears, massive feet, knowing eyes:
The elephant's form is expressive and familiar. Female Indian
elephants care intensely for their young. They shelter calves
with their bodies and touch and rub them to provide comfort.

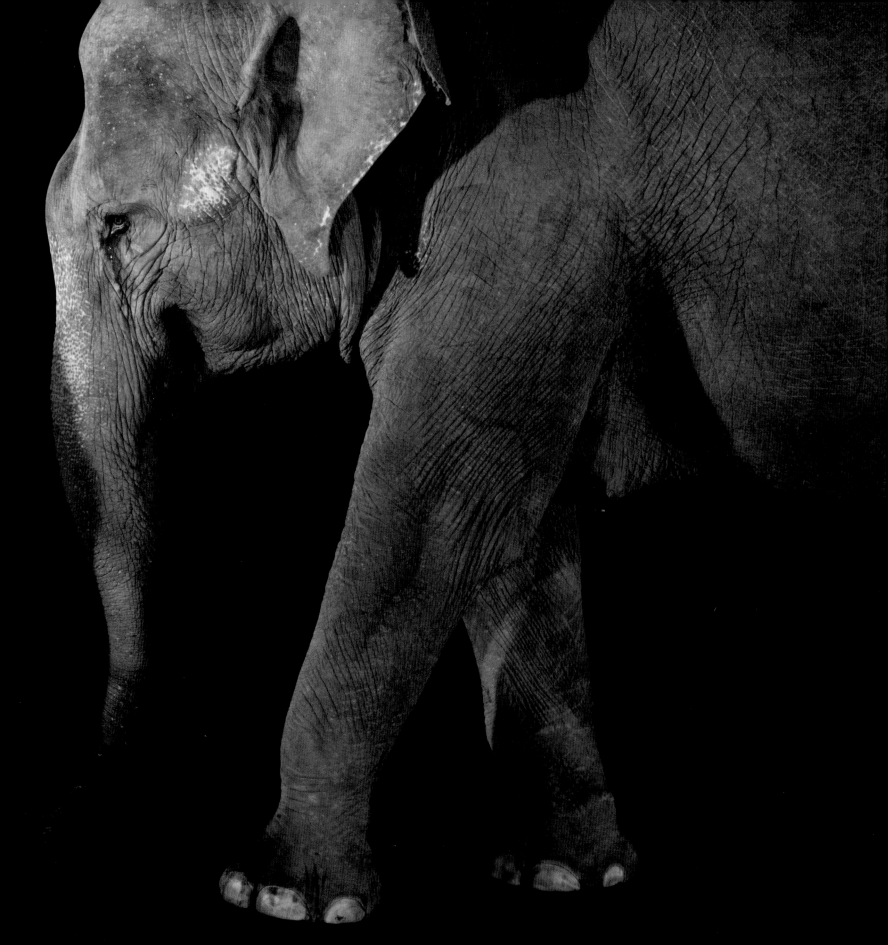

Giant red hermit crab, *Petrochirus diogenes* (NE)

As juveniles, these large crabs search for vacant shells. Sometimes they luck out and find a queen conch, a knobbed whelk, or, in this case, a glass ornament. But if housing is scarce, crabs may seek out a recently deceased snail to take its shell.

Lesser Malayan chevrotain, *Tragulus kanchil klossi* (LC)

One of the world's smallest hoofed mammals, this tiny resident of Southeast Asia's forests can be as small as 18 inches tall. If threatened, the chevrotain—also known as the lesser mousedeer—will freeze in place and stamp its slender hind legs.

Don't Look Up

It's never the bears or lions that get you. It's always the little guys. In Uganda, I had just exited a cave filled with 100,000 Egyptian fruit bats when I took off my glasses and a respirator I had worn as a precaution. At that very moment, the bats streamed out of the cave in an ammonia-laced gust of wind. I glanced up, just for a second, and caught a juicy dollop of fresh guano directly in my left eye. It was hot, and it burned. I knew right away this was a "wet contact," potentially more dangerous than a bite. Back at camp, I called the Ugandan arm of the U.S. Centers for Disease Control and Prevention. There was a long pause on the other end of the line, and then: "You shouldn't have gone in there. Marburg circulates in that cave." The Marburg virus causes a terrible, messy death—like Ebola, only faster. I immediately flew home to Nebraska and quarantined in an attic bedroom for three weeks. On Day 22, with no sign of sickness, I finally emerged. But that one look up could have killed me. ◼

Egyptian fruit bat, *Rousettus aegyptiacus* (LC)

Roosting by the dozens or the thousands, these bats are found across Africa, the Arabian Peninsula, and the eastern Mediterranean to northern India. After breeding season, females gather in nursing colonies to give birth to and rear their pups, while males form bachelor colonies elsewhere.

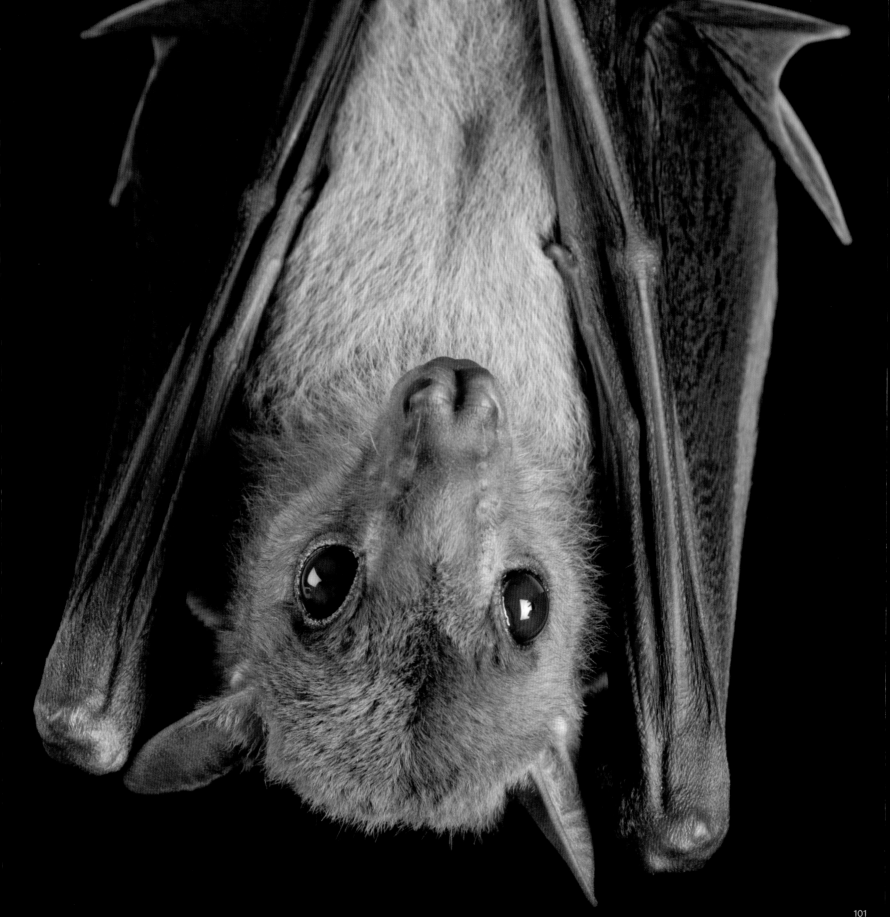

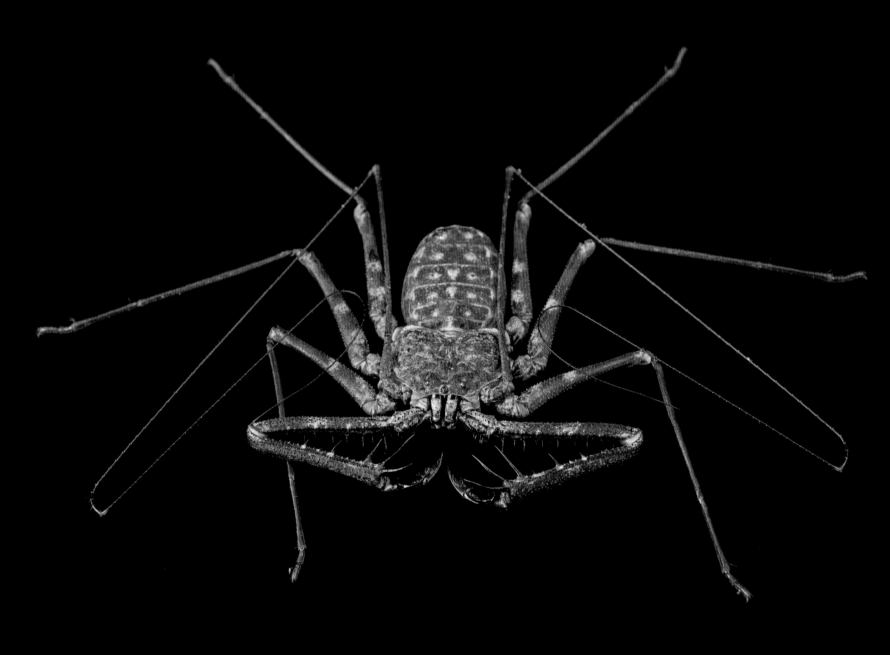

Tanzanian whip scorpion, *Damon medius* (NE)

Without the arching, fearsome tail of its venomous cousins, this harmless scorpion of Kenya and Tanzania looks more like a spider. Its name nods to its extralong front legs, which act as feelers when the scorpion moves around at night.

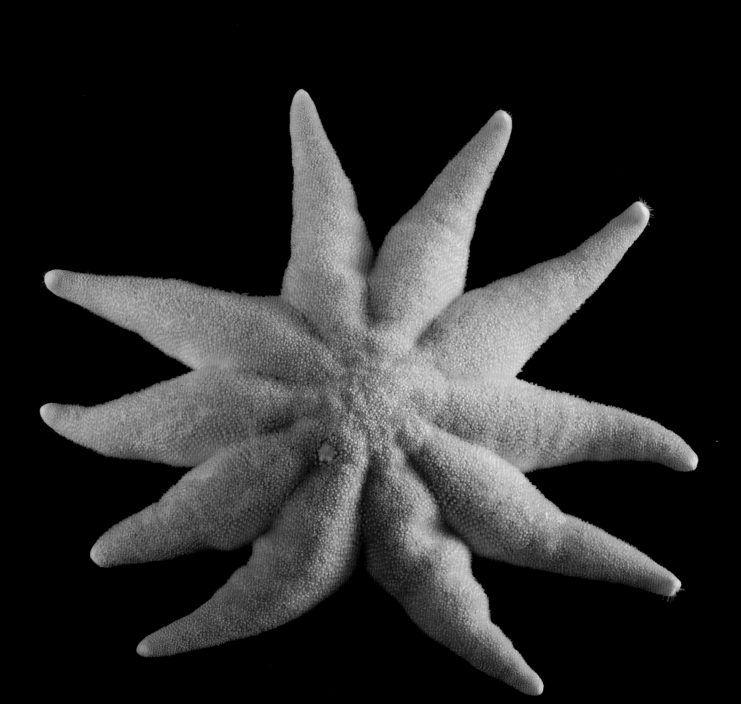

Smooth sun star, *Solaster endeca* (NE)

This sea star, commonly found across the North Atlantic, may
be smoother than others, but its surface is actually quite rough.
With its nine or 10 arms often pointing up, as though curious,
the sea star sports colors of cream, orange, pink, or purple.

Whooper swan, *Cygnus cygnus* (LC)

When a flock of whooper swans is readying for takeoff, individual swans will repeatedly pump their heads and long necks, flap their wings, and call out to build excitement. Then, the synchronized flock—often numbering several dozen birds—lifts off all at once.

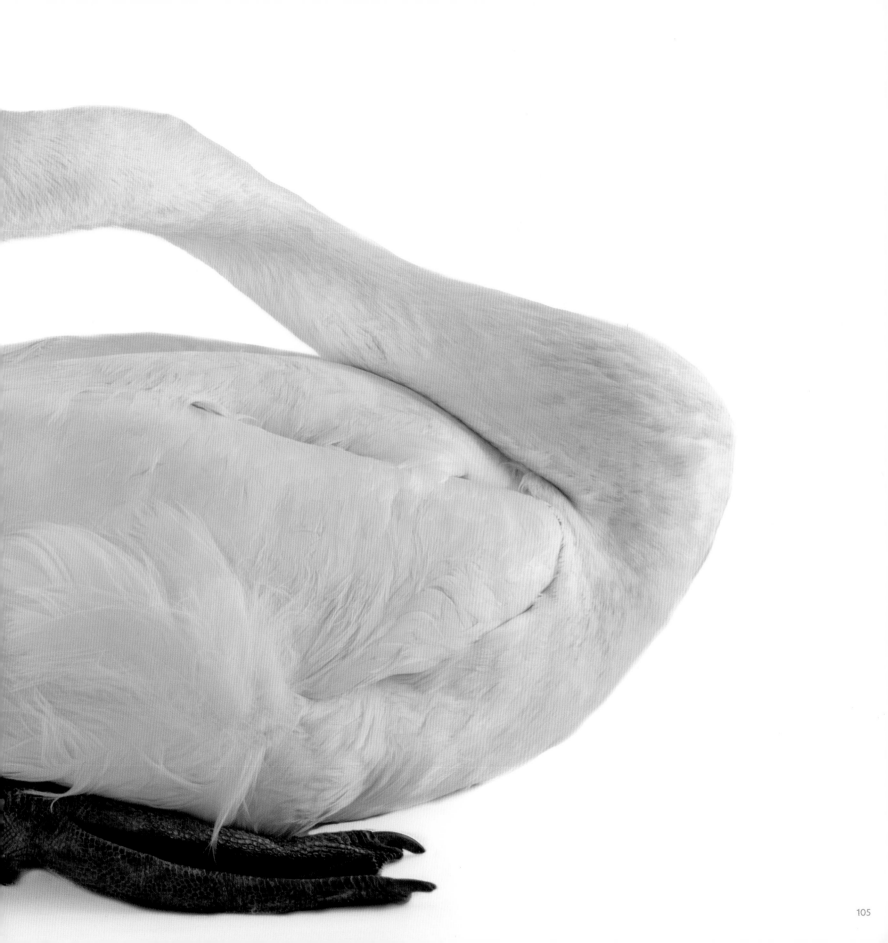

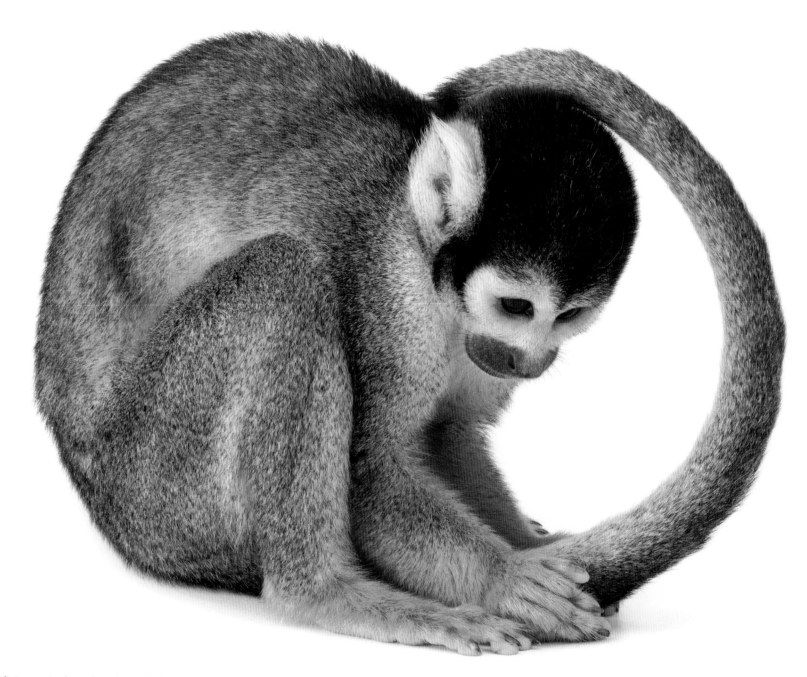

Bolivian squirrel monkey, *Saimiri boliviensis* (LC)

That long tail looks perfect for acrobatic jumps between tree branches. But this small monkey of the Amazon rainforest prefers to walk or run. It lives in large groups of up to 75 to 100 and often associates with other primates.

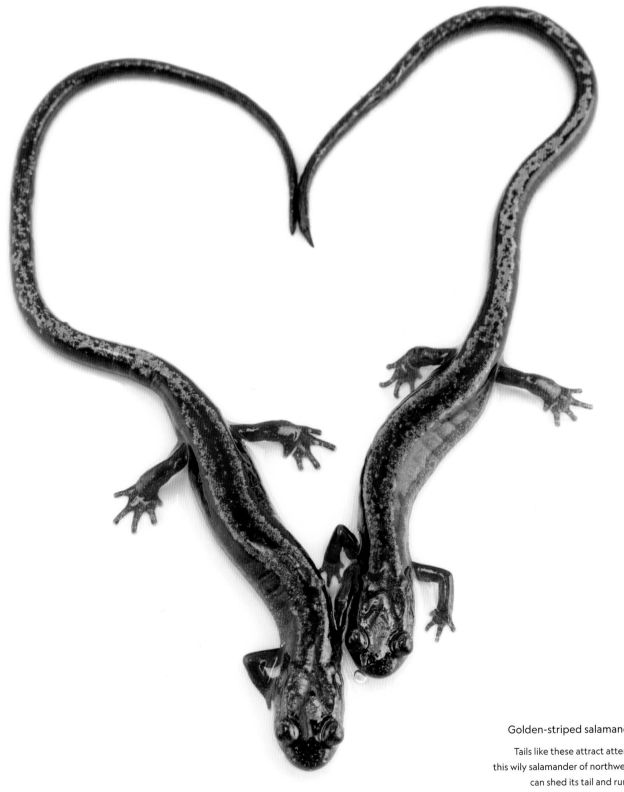

Golden-striped salamander, *Chioglossa lusitanica* (VU)

Tails like these attract attention. But if a predator grabs hold, this wily salamander of northwestern Spain and northern Portugal can shed its tail and run away—while the tail, wiggling for a few more minutes, distracts the attacker.

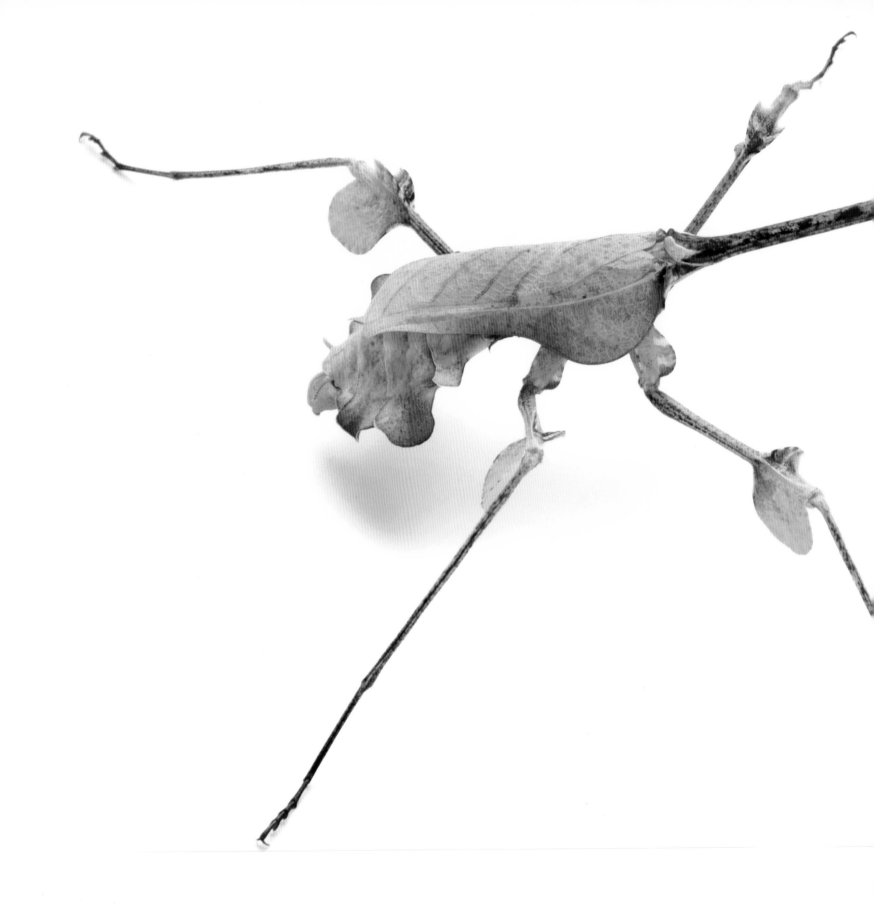

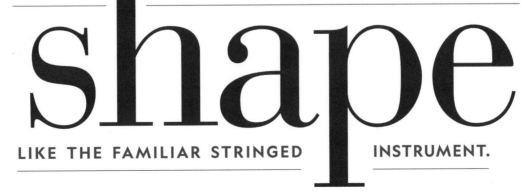

Violin mantis, *Gongylus gongylodes* (NE)

This shy mantis of India and Sri Lanka sits and waits for its preferred prey to zoom past; it can grab a fly from midair. When nymphs emerge from their egg cases, known as ootheca, they resemble miniature versions of adult mantises.

THE VIOLIN MANTIS IS NAMED FOR ITS LONG, SLENDER THORAX CONNECTING TO ITS WIDE AND LEAFY ABDOMEN, THUS GIVING THIS INSECT A

shape

LIKE THE FAMILIAR STRINGED INSTRUMENT.

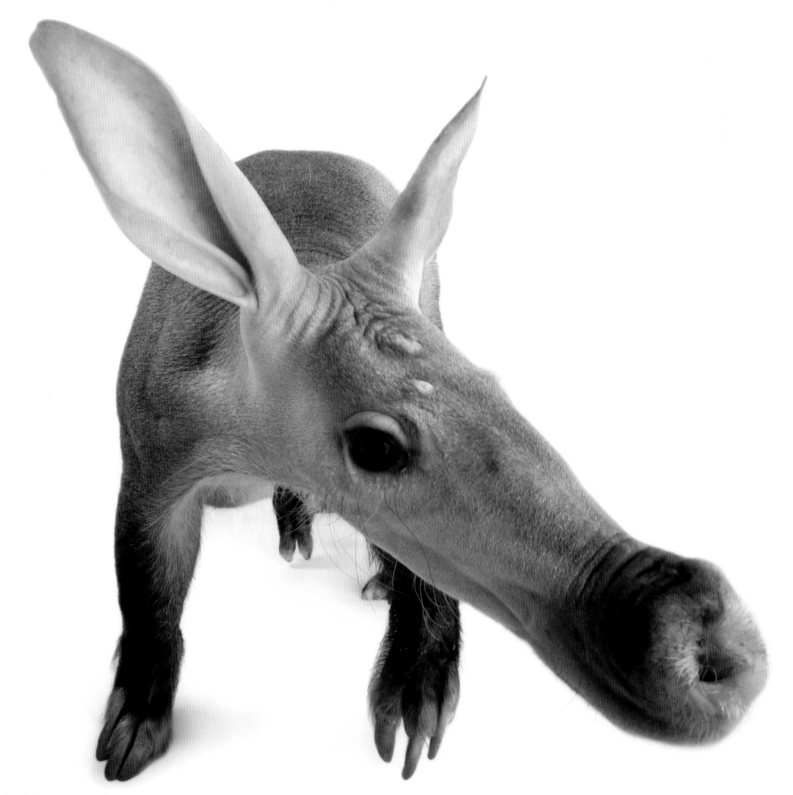

Aardvark, *Orycteropus afer* (LC)

The aardvark's snout is a marvel. It contains a labyrinth of nine to 10 thin bones—more than any other mammal—and joins forces with a long, sticky, wormlike tongue to extract termites, aardvarks' favorite food, from large, earthen mounds.

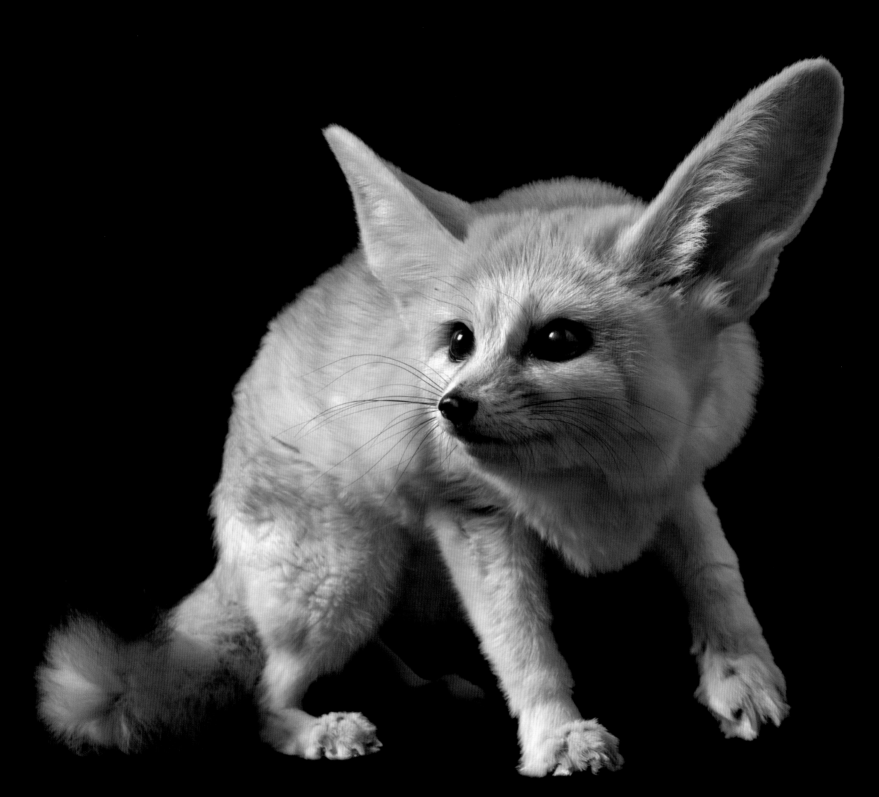

Fennec fox, *Vulpes zerda* (LC)

This desert fox's enormous ears help it stay cool and locate prey moving beneath the sand. The foxes are so well adapted to their hot, dry environments that they rarely need to drink; they get water from their prey or surrounding plants.

Chestnut-eared araçari, *Pteroglossus castanotis castanotis* (LC)

With the help of a massive bill that looks like a cross between a serrated knife and a giant crab claw, this member of the toucan family feasts on fruit—and often hangs upside down in a tree to get it.

CHAPTER TWO

Pattern

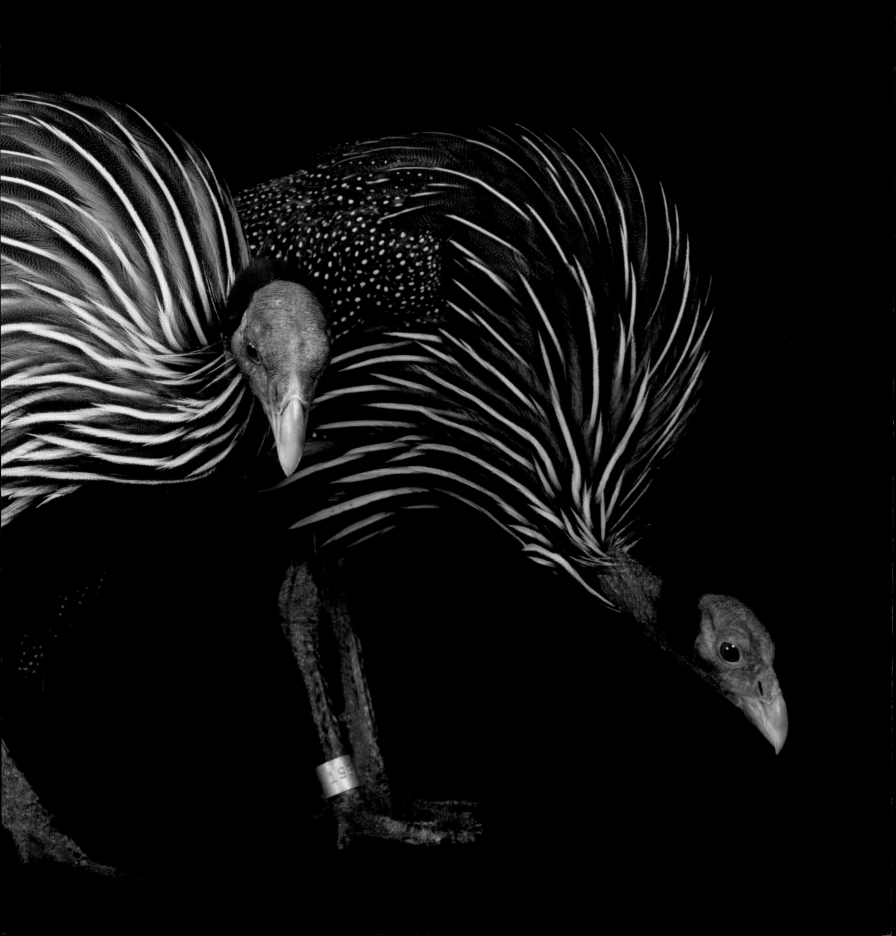

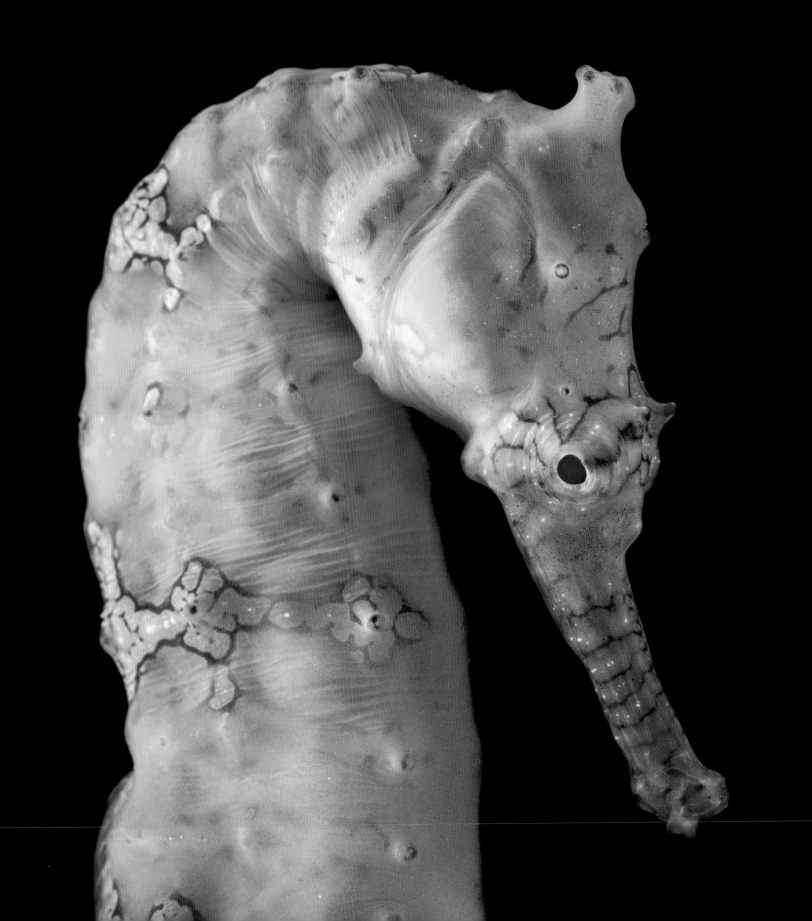

Spots & Stripes

Some like it bold; some like it subtle. Some show off and others blend in. Some of our favorite animals are known for their patterns. What's a tiger, or a zebra, without its stripes?

Some patterns pit color against color. Birds seem to win the prize. The paradise tanager, the red-crested turaco, the green twinspot, and of course the macaw: All wear colors with abandon, reds and greens and blues side by side in vibrant designs. Angelfish glow as if neon underwater. Chameleons get to change their hues. Poison dart frogs dare to clothe themselves in the most unnatural of blues and yellows—effective in discouraging predators, experts presume. In the world of animal wardrobes, all these guys are show-offs.

Other patterns borrow from the background, strategies for blending in and staying unseen. The chain catshark's murky mottling mirrors shifting patterns of dark and light on the ocean floor. Splitfins shimmer like sunlight on water. Wood turtle shells sport elegant mosaics, picking up earth tones of the leaf litter where they scuttle. A grass mouse striped like the stubble it calls home, a fish and a katydid as speckled as the leaves that fall around them, a whip snake's scales as green as the rainforest vines it winds through—all adopt patterns from the environments they inhabit.

The animal kingdom offers patterns in abundance. Some we interpret to have a purpose, but others seem arbitrary shapes and colors combined with abandon, nature's artistry. ■

OPPOSITE: West Australian seahorse, *Hippocampus subelongatus* (DD)
PREVIOUS PAGES: Vulturine guineafowl, *Acryllium vulturinum* (LC)

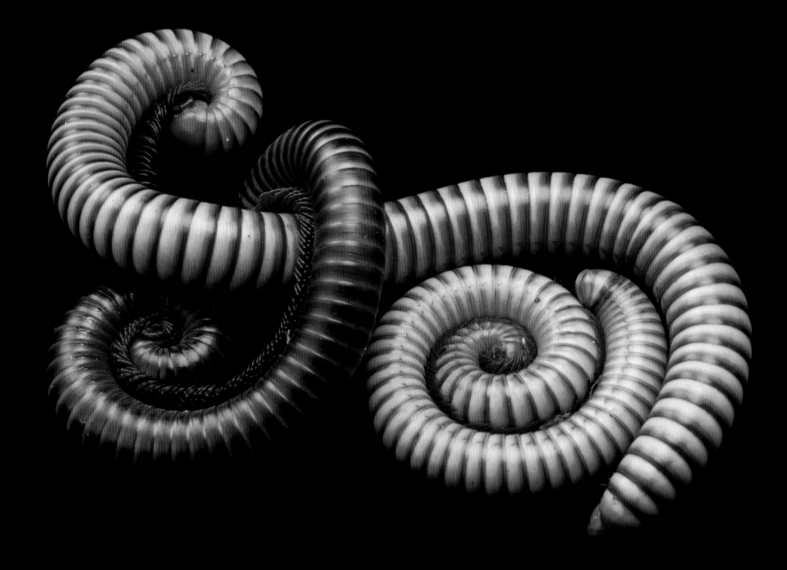

Sonoran desert millipede, *Orthoporus ornatus* (NE)

This millipede of the American Southwest has a hardy exoskeleton
colored orange, tan, brown, black, or yellow with dark stripes.
That tough exterior, along with its reclusive lifestyle deep in
the dirt, enables it to live more than 10 years.

Veiled chameleon, *Chamaeleo calyptratus* (LC)

A striking mosaic of turquoise, green, and gold scales defines
this chameleon, found near the border between Saudi Arabia
and Yemen. If startled, the creature will curl into a tight fetal
position and remain that way for quite some time.

Honeycomb moray, *Gymnothorax saxicola* (LC)

This eel's smooth, muscular body is covered in spots that provide camouflage as it lurks on the sea's sandy bottom. Like a bit of contrast trim on a fashionable jacket, a black-and-white dorsal fin completes the look.

Common murre egg, *Uria aalge* (LC)

This seabird's egg is made for life on the edge. On a cliff above the sea, a female lays one egg—its pear-like shape providing stability—recognizable to parents by its color (brown, green, or blue) and its stripes, speckles, or spots (black, brown, or lilac).

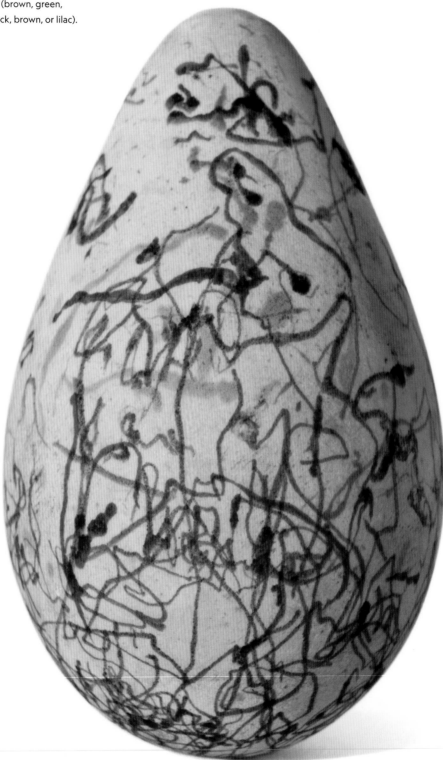

Striped hyena, *Hyaena hyaena hyaena* (NT)

The smallest of the true hyenas, this animal has stripes that help
it move stealthily through scrub and tall grasses as it scavenges.
Legend and superstition hold the hyenas as grave robbers or
magical beings; in reality, many are timid and quiet.

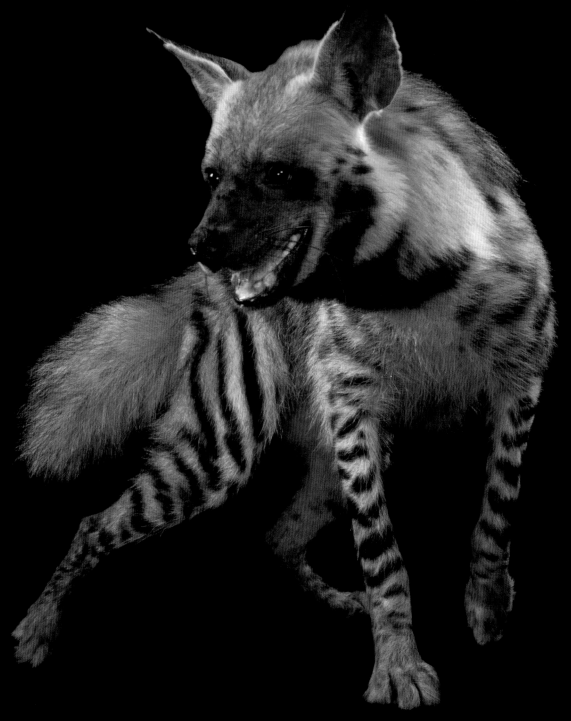

Tigers Prefer Prada

I was all set up for a shoot at Colorado's Cheyenne Mountain Zoo. The only thing missing was the cat, who had no interest in posing. Turns out, tigers may be kings of the jungle, but they won't walk onto my backgrounds unless they feel comfortable. We threw out meat for him; surely that would do the trick. But this beast was impervious to bribery. Over and over again, he'd carefully stretch a paw from his spot outside the background, grab the meat, and slink away to eat it. We did this for four hours. The tiger took a nap; I wondered if we needed a more enticing treat, like an intern. Finally, one of the keepers remembered that enrichment activities with the tigers occasionally involved whiffs of perfume. So someone fetched a bottle of Prada fragrance and sprayed a little on the background. The tiger sauntered right in and sprawled out on the cloth. We got our picture. ■

Sumatran tiger, *Panthera tigris sumatrae* (CR)

With its white mane, reddish brown coat, and black velvet stripes, this wildcat of the tropics flaunts one of the best known patterns in the animal kingdom. It is the smallest of the eight subspecies of tigers that are historically recognized.

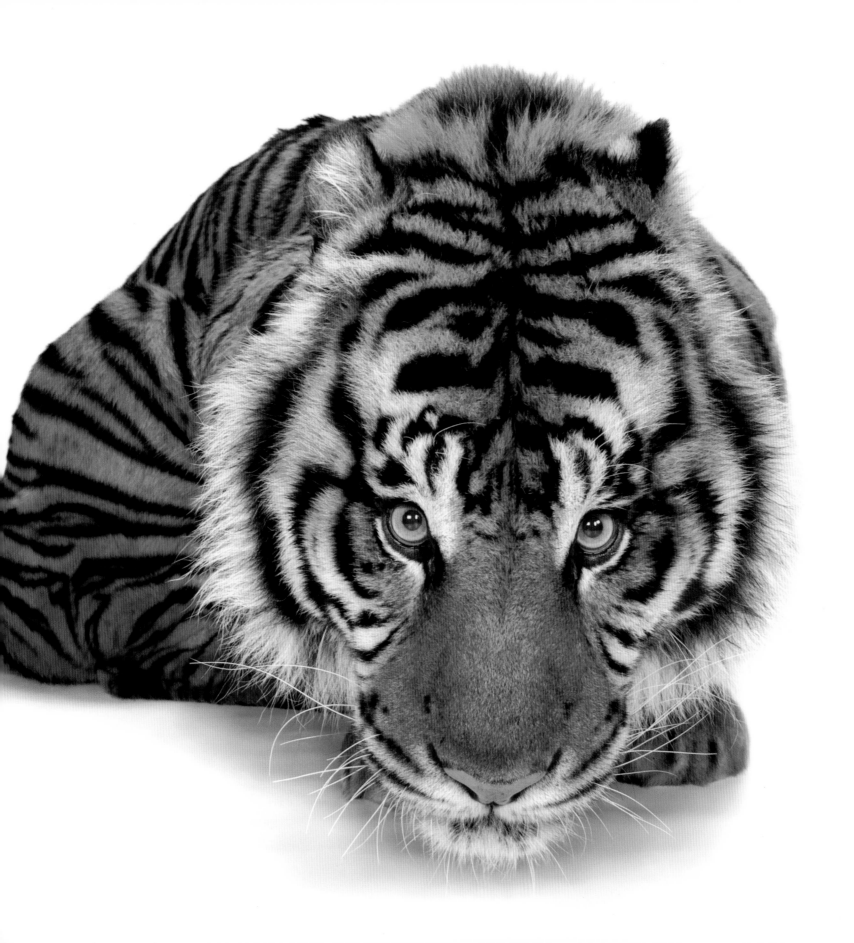

The animal kingdom loves a smart black-and-white getup. The contrast of light and dark helps animals stand out, blend in, or send a signal to would-be predators. **TOP ROW, L TO R:** Western spotted skunk, *Spilogale gracilis gracilis* (LC); Question mark cockroach, *Therea olegrandjeani* (NE); Carnaby's black cockatoo, *Zanda latirostris* (EN); **CENTER ROW, L TO R:** Clown knifefish, *Chitala ornata* (LC); Malayan tree nymph, *Idea lynceus* (NE); Frosted flatwoods salamander, *Ambystoma cingulatum* (VU); **BOTTOM ROW, L TO R:** Snow leopard, *Panthera uncia* (VU); Snowy owl, *Bubo scandiacus* (VU); Eastern Florida terrapin,

Malaclemys terrapin tequesta (VU); **TOP ROW, L TO R:** Black-necked swan, *Cygnus melancoryphus* (LC); Black phantom tetra, *Hyphessobrycon megalopterus* (LC); Black-and-white ruffed lemur, *Varecia variegata* (CR); **CENTER ROW, L TO R:** Malayan krait, *Bungarus candidus* (LC); Horntail, *Urocerus albicornis* (NE);

Black ocellaris clownfish, *Amphiprion ocellaris* (NE); **BOTTOM ROW, L TO R:** Xingu River ray, *Potamotrygon leopoldi* (DD); Spotted nutcracker, *Nucifraga caryocatactes* (LC); Rusty-spotted genet, *Genetta maculata* (LC)

Paradise tanager, *Tangara chilensis paradisea* (LC)

In paradise, even the tiniest filaments of a feather are radiant: This songbird of South America's humid forests has plumage of midnight black feathers with swatches of luminous blue and green.

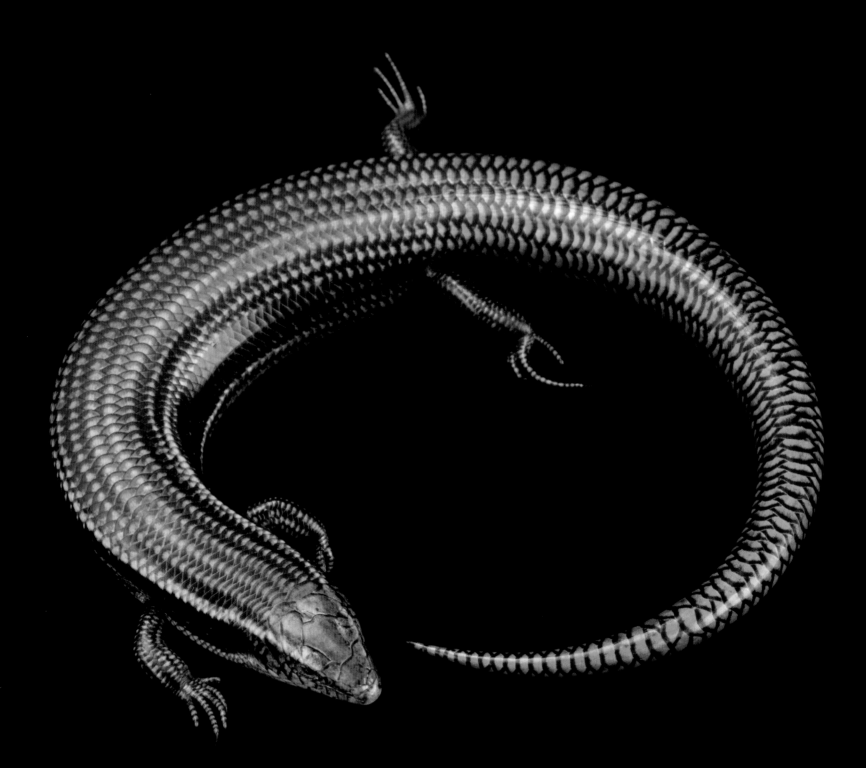

Gran Canaria skink, *Chalcides sexlineatus sexlineatus* (LC)

With its brown front and blue rear joined in a latticework of dark
marks, this little reptile seems torn between wanting to sunbathe
on a rock or dip its tail in the sea. In reality, it lives in meadows,
stone walls, sandy shores, or woodlands.

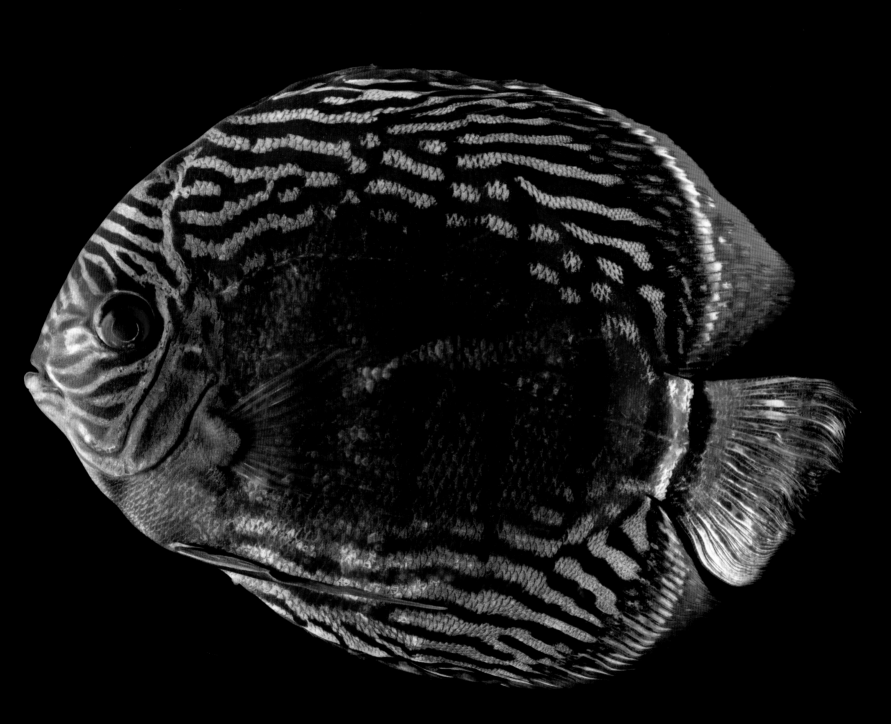

Blue discus, *Symphysodon aequifasciatus* (NE)

Swathed in undulating stripes of black and blue, with a dash
of bright red on its dorsal fin, this colorful six-inch fish is native
to the warm freshwater habitats of the lower Amazon Basin,
particularly in flooded forests.

THE CHAIN CATSHARK IS A NOCTURNAL OCEAN

DWELLER THAT CAN EXUDE A BIOFLUORESCENT

GLOW. IN THE DARK DEPTHS, ITS SKIN EMITS A

green

LIGHT VISIBLE TO OTHER CATSHARKS.

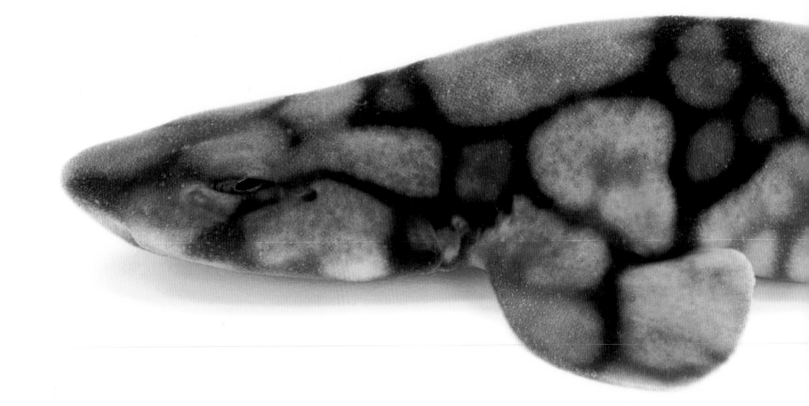

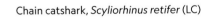

Chain catshark, *Scyliorhinus retifer* (LC)

Blending into the sea bottom with its dark chain-link markings,
this small shark of the western Atlantic Ocean—from Massachusetts
to Nicaragua—hangs out, mostly motionless, moving only to
capture the occasional squid or small fish.

Chital, *Axis axis* (LC)

Rows of white spots give this deer of India and Sri Lanka a
fawnlike appearance, even when fully grown. Its name is
derived from the Sanskrit word *citrala,* meaning "spotted";
the cheetah's name has a similar origin.

Marbled lungfish, *Protopterus aethiopicus mesmaekersi* (DD)

Lungfish, so named for their ability to breathe air, have swum the world's waterways for 400 million years—long before the first dinosaurs. This species is native to central and eastern Africa, including the Nile and Congo river systems.

Cicada, *Cicadoidea* sp. (NE)

Of the world's 3,000 species of cicadas, some appear every
year; others emerge from the ground to mate only every
decade or two. Several ancient cultures regarded these
insects as powerful symbols of rebirth because of their unusual
life cycles.

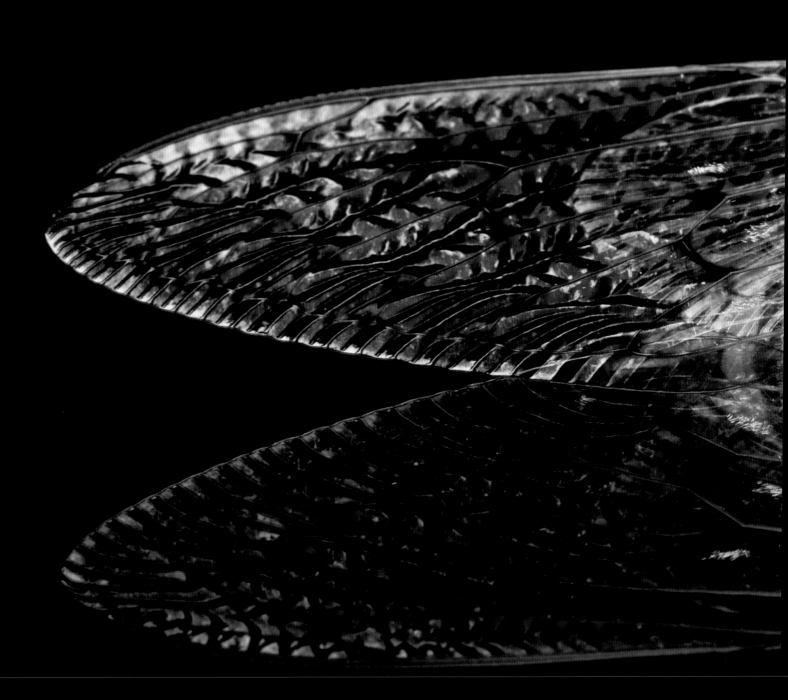

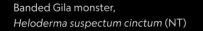

Banded Gila monster,
Heloderma suspectum cinctum (NT)

This speckled native of the southwestern United States
and northern Mexico can eat more than a third of its body
weight in one feeding—a necessary indulgence in arid
regions where regular meals are scarce.

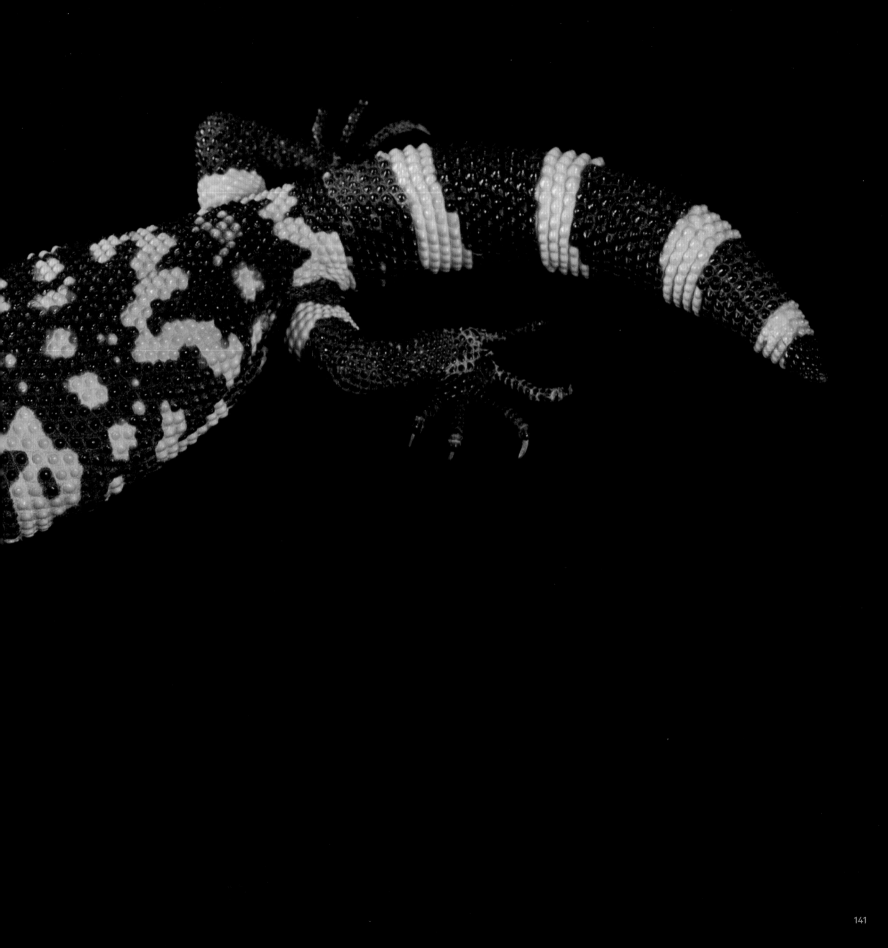

As this Australasian python grows, it changes color—sometimes as quickly as overnight—from yellow or red to bright green, blending into the rainforest where it lives. The vertical slits in its golden eyes are typical of nocturnal hunters.

Red-eyed tree frog, *Agalychnis callidryas* (LC)

Huge, bright red irises can be a form of self-defense: By abruptly popping open its eyes and startling an approaching predator, this Central American tree frog gains a few precious seconds to hop away to safety.

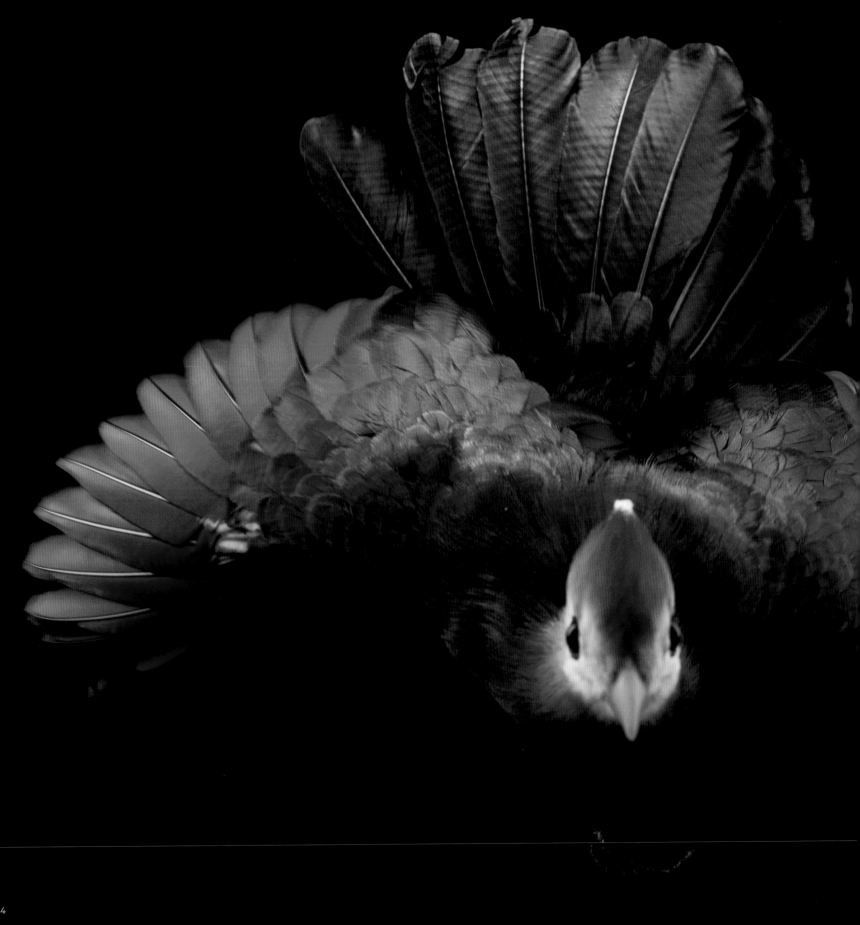

FROM PIGMENTS TO THEIR PHYSICAL STRUCTURE, MANY THINGS

GIVE COLOR TO BIRD FEATHERS. BUT ONLY TURACO FEATHERS

CONTAIN TURACIN AND TURACOVERDIN, PIGMENTS RICH IN

copper

THAT CREATE SUCH BRIGHT RED AND GREEN HUES.

Fried egg jellyfish, *Cotylorhiza tuberculata* (NE)

Looking just like an egg sunny-side up, this jellyfish of the Mediterranean Sea floats in open water and close to the shore, always near the surface. The yolk-like orange bump on the bell contains algae that live symbiotically inside the jellyfish.

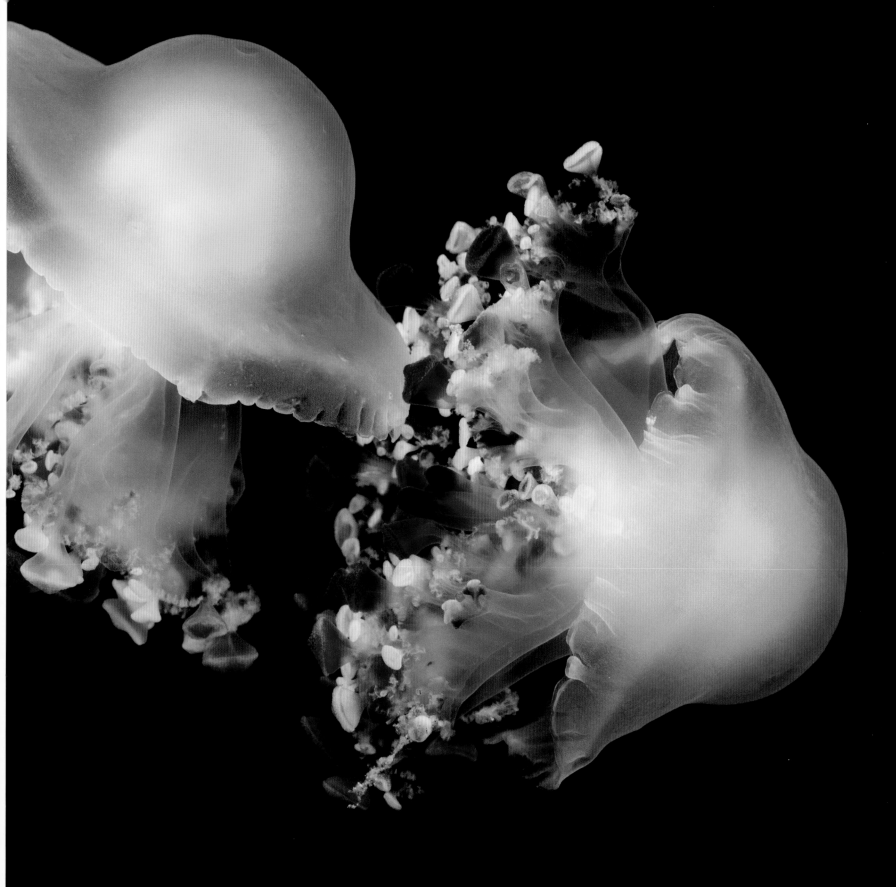

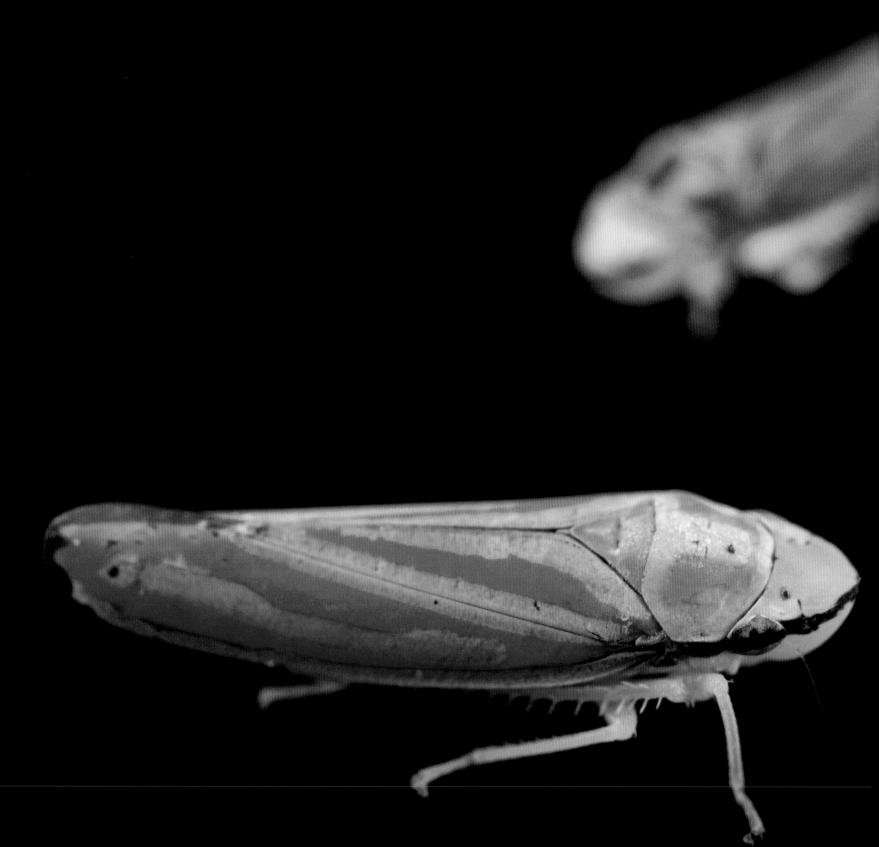

Insects Among Us

For a picture of alien life, look no farther than your backyard. Insects are interesting, ferocious, relentless in their way, and vital to our existence. They make the world's ecosystems go round. Without them, life as we know it wouldn't be possible. When the pandemic hit, I realized that although I couldn't travel anywhere, it gave me the chance to document insects, which are underrepresented in the Photo Ark and yet so essential to life. I'll never run out of them. Within 20 miles of my Nebraska home, I've photographed 700 species: leafhoppers, fish flies, tiger beetles, scarab beetles in every color of the rainbow, and lots and lots of spiders—not insects but closely related. The goal is to hit 1,000. I used to collect bugs as a kid, so this is like a return to childhood. I've traveled the world looking for animals. It turns out hundreds were in my backyard the whole time. ■

Candy-striped leafhopper, *Graphocephala coccinea* (NE)

This insect's striped jacket resembles a delicious sweet. Found from Canada to Panama, it belongs to a group of leafhoppers known as sharpshooters: As it sucks sap from leaves, it expels excess liquid in droplets with a forceful *pop*.

Amazon leaffish, *Monocirrhus polyacanthus* (NE)

Top-notch camouflage makes this Amazonian fish a
stealthy predator. Looking just like a dead leaf, it captures
disproportionately large prey—even some fast-swimming
ones—that are up to two-thirds its body length.

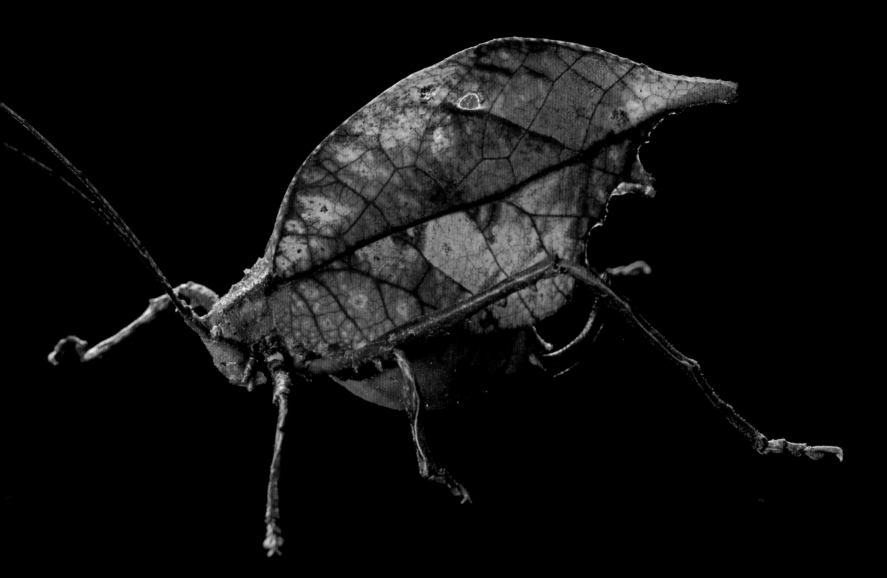

Leaf katydid, *Typophyllum* sp. (NE)

Like this species, a great many katydids—also called bush crickets—use camouflage to mimic the leaves scattered in their surroundings. Katydids live on every continent except Antarctica; thousands of species have been identified.

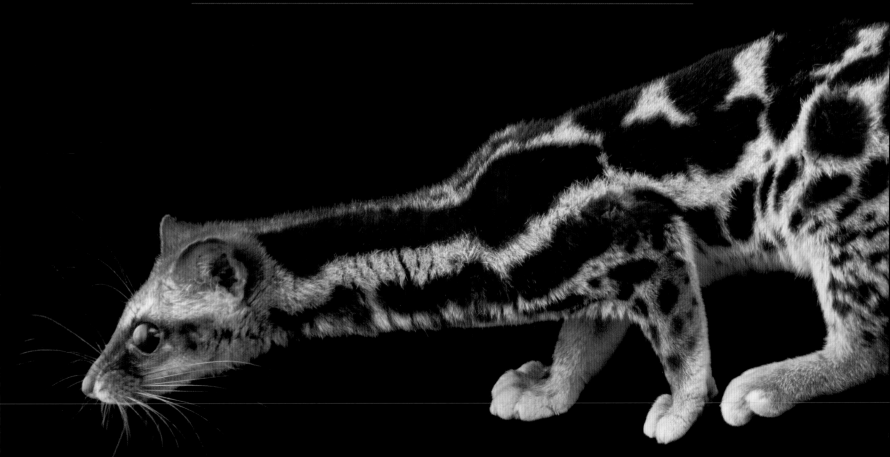

THE BANDED LINSANG IS A SOLITARY, NOCTURNAL ANIMAL THAT SLINKS AFTER ITS PREY. CAMOUFLAGED BY ITS SPECKLED COAT, IT WEAVES LIKE A snake THROUGH THE TREES IN ITS FOREST HOME.

Banded linsang, *Prionodon linsang* (LC)

A coat of dark spots, stripes, and rings provides excellent
cover for this secretive tree dweller as it sneaks up on its
prey of squirrels, birds, or lizards. This rare civet is native to
Indonesia, Malaysia, Thailand, and Myanmar.

Meso-American slider, *Trachemys venusta venusta* (NE)

Scientists who discovered this freshwater turtle found its striking patterns and colors so beautiful that they gave it a name derived from the Latin *venustus,* meaning "like Venus." It lives in Mexico, Central America, and northwestern Colombia.

Lady Amherst's pheasant, *Chrysolophus amherstiae* (LC)

In the hilly forests of southwestern China and northern Myanmar, the brilliant, scalloped plumage of this pheasant stands out. The male's tail feathers are long and resplendent, making it a popular ornamental bird in the West.

Libyan striped weasel, *Ictonyx libycus* (LC)

With a loping gait like a mongoose and a foul-smelling
self-defense strategy similar to that of North American skunks,
this small mammal thrives across much of north Africa. If a squirt
from its anal glands doesn't deter assailants, the weasel plays dead.

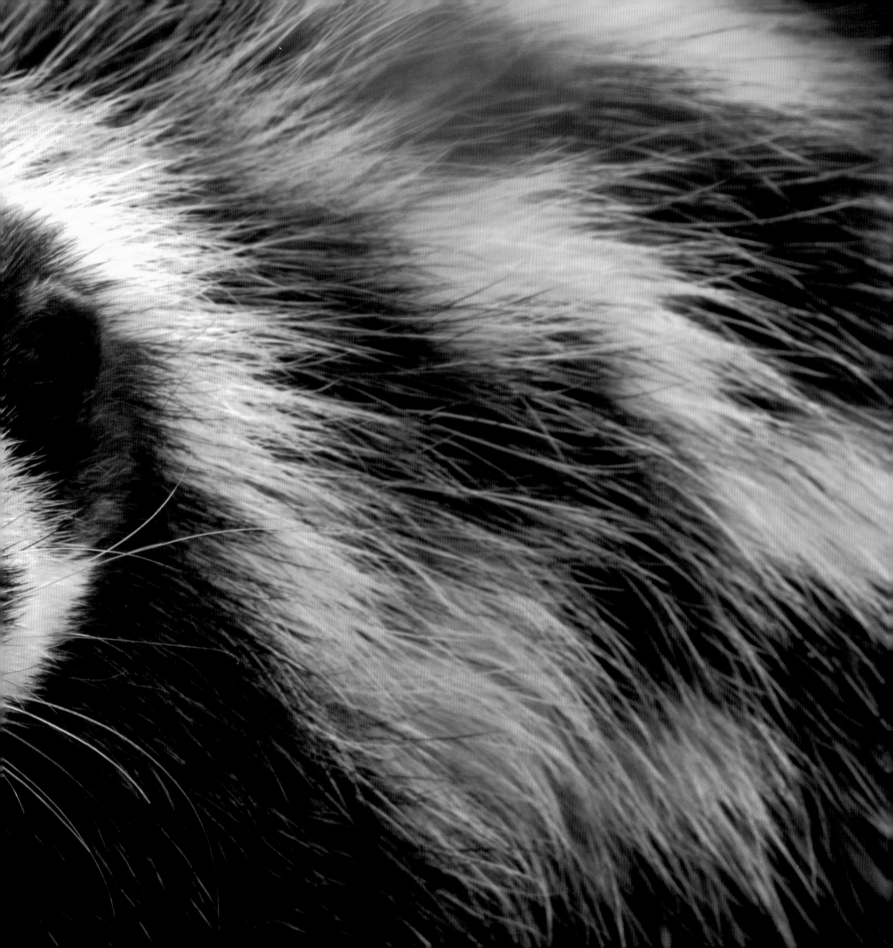

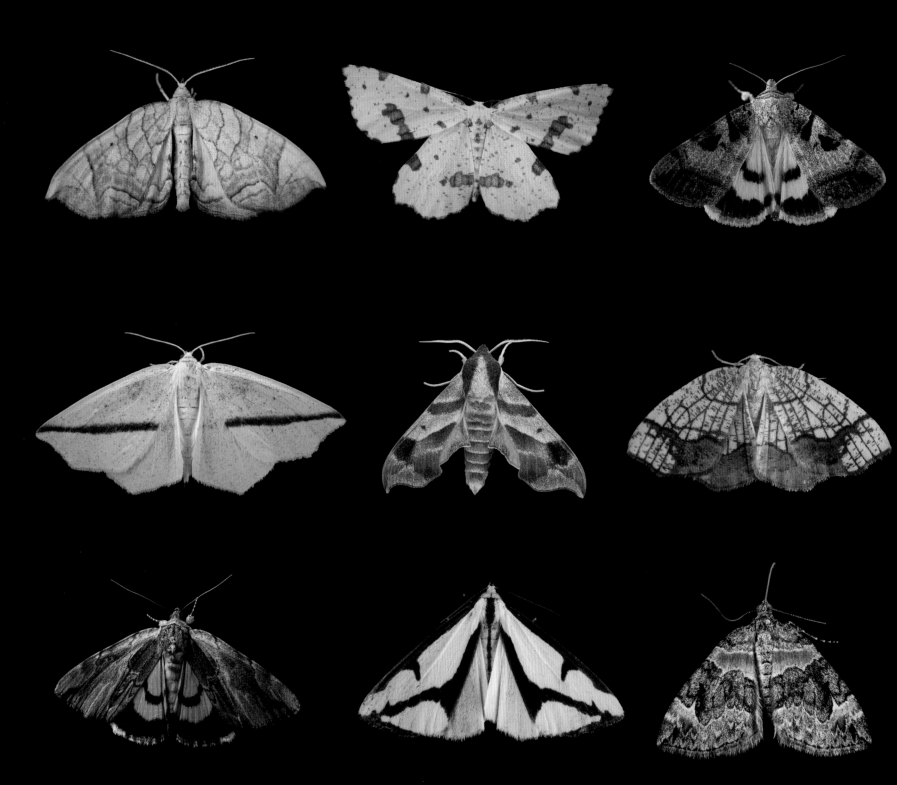

At least 150,000 species of moths flutter about our night skies—and porch lights. Their colorful, complex patterns are often meant to fool predators. **TOP ROW, L TO R:** Grapevine looper, *Eulithis* sp. (NE); False crocus geometer moth, *Xanthotype urticaria* (NE); Whitney's underwing moth, *Catocala whitneyi* (NE); **CENTER ROW,** **L TO R:** Yellow slant-line, *Tetracis crocallata* (NE); Virginia creeper sphinx, *Darapsa myron* (NE); Horned spanworm moth, *Nematocampa resistaria* (NE); **BOTTOM ROW,** **L TO R:** Ultronia underwing, *Catocala ultronia* (NE); LeConte's haploa moth, *Haploa lecontei* (NE); Orange-barred carpet moth, *Dysstroma hersiliata* (NE)

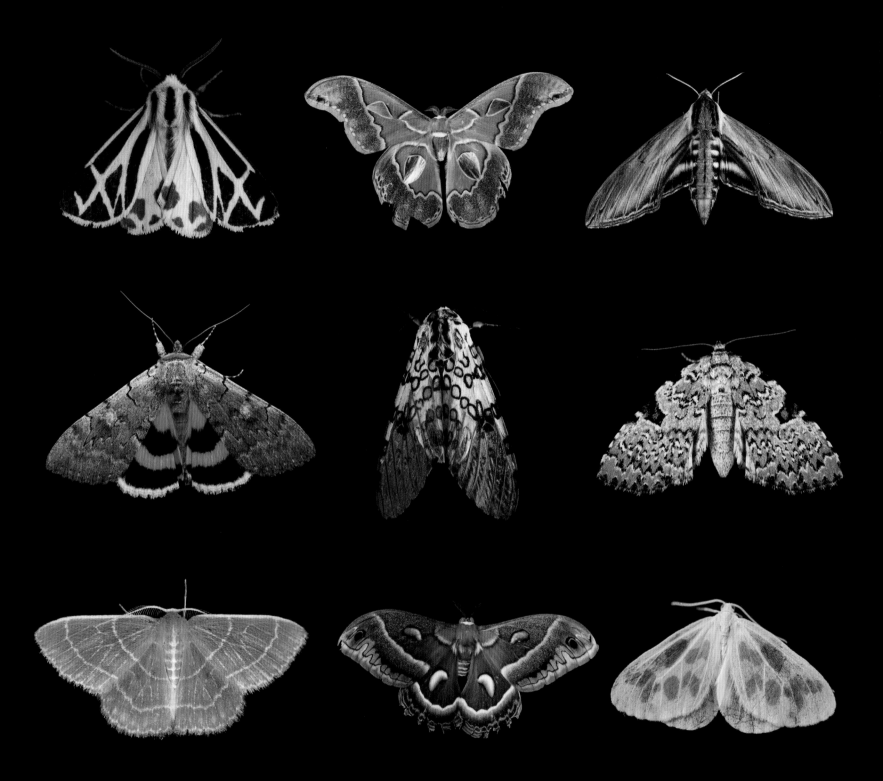

TOP ROW, L TO R: Nais tiger moth, *Apantesis nais* (NE); Window-winged saturnian, *Rothschildia aricia ariciopichinchensis* (NE); Laurel sphinx moth, *Sphinx kalmiae* (NE); **CENTER ROW, L TO R:** Pink underwing moth, *Catocala concumbens* (NE); Giant leopard moth, *Hypercompe scribonia* (NE); Green leuconycta moth, *Leuconycta diphteroides* (NE); **BOTTOM ROW, L TO R:** Wavy-lined emerald moth, *Synchlora aerata* (NE); Cecropia moth, *Hyalophora cecropia* (NE); Beggar moth, *Eubaphe mendica* (NE)

163

Southern three-banded armadillo,
Tolypeutes matacus (NT)

If threatened, this South American armadillo completely
closes its armor around its entire body, save for a small
space between two sections of its shell—which it snaps
shut on the paw (or finger) of the attacker.

Chambered nautilus, *Nautilus pompilius* (NE)

Behind those tiger stripes is a many-roomed home. As the nautilus grows, it creates more spiraling chambers—adults may have up to 30—and moves into the outermost one. Fossilized shells with a similar structure have been found that would have been 20 or 30 feet long if uncoiled.

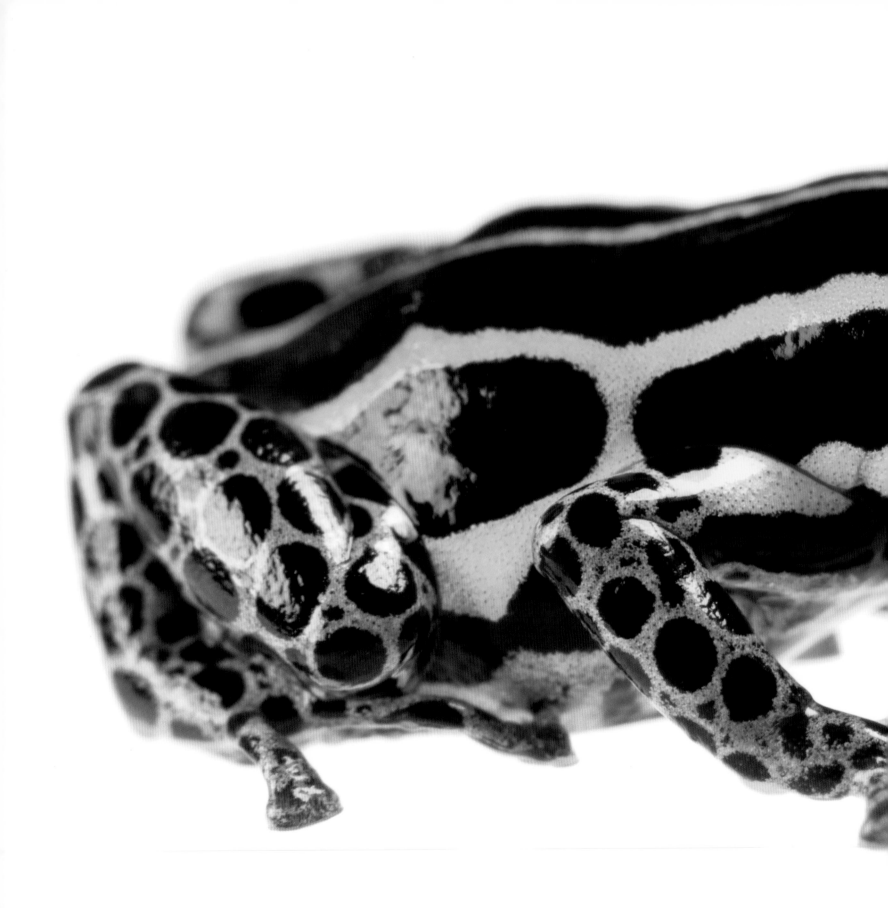

Across most of its range, this glossy and mildly toxic tree frog of the cloud forest sports bright yellow stripes—but in some regions the same species has stripes of red, blue, green, or orange.

THE BRIGHT COLORS OF MANY POISON DART FROGS ADVERTISE THEIR EXTREME TOXICITY TO ANY AND ALL POTENTIAL PREDATORS. THIS IS KNOWN AS APOSEMATIC COLORING, AND IT SIGNALS THAT

danger

IS AT HAND FOR ANY ANIMAL THAT MIGHT DARE TO EAT THEM.

167

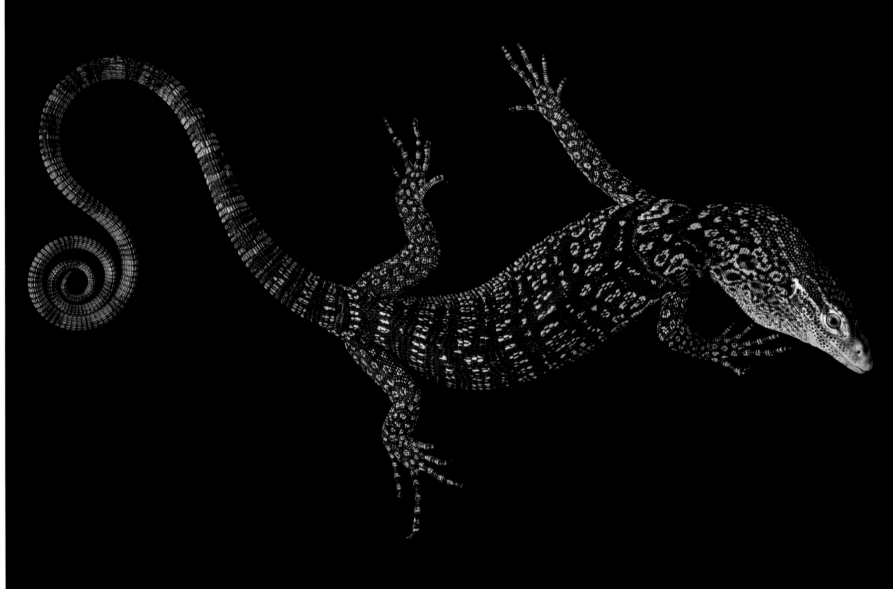

Blue speckled tree monitor, *Varanus macraei* (EN)

This spotted, banded lizard lives only in tropical rainforests on the
Indonesian island of Batanta. It uses its very long, grasping tail to
climb trees, hunting insects and smaller lizards. Its markings allow
it to hide on tree trunks to escape predators.

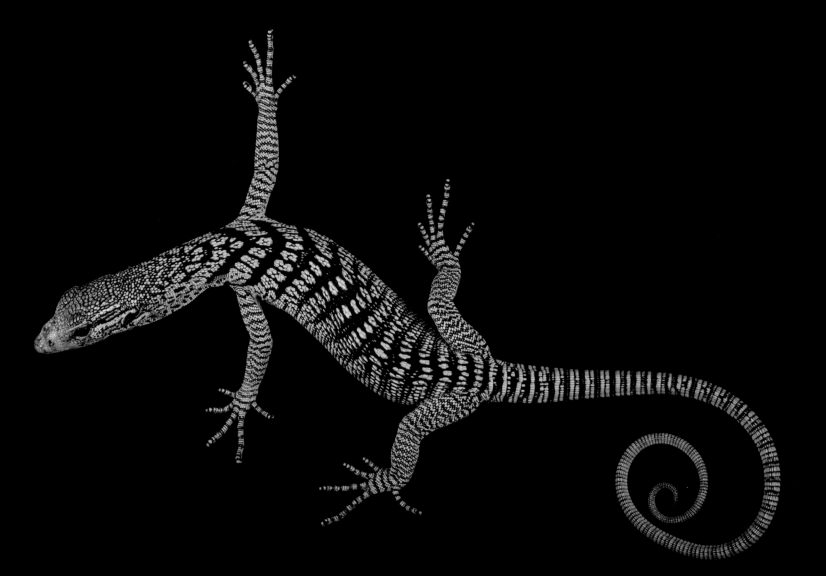

Yellow tree monitor, *Varanus reisingeri* (DD)

Stripes, spots, chevrons, and bands combine to give the scales
of this tree-climbing lizard an intricate design. Much is still
unknown about the behavior of the monitor, which is found
only within a small range in Indonesia.

Chapman's zebra, *Equus quagga chapmani* (NT)

A master artist couldn't improve upon these graceful bands of black and white. Each zebra has its own distinct pattern, and even the animal's short, bristly mane is striped. It lives in the grasslands of Botswana, South Africa, and Zimbabwe.

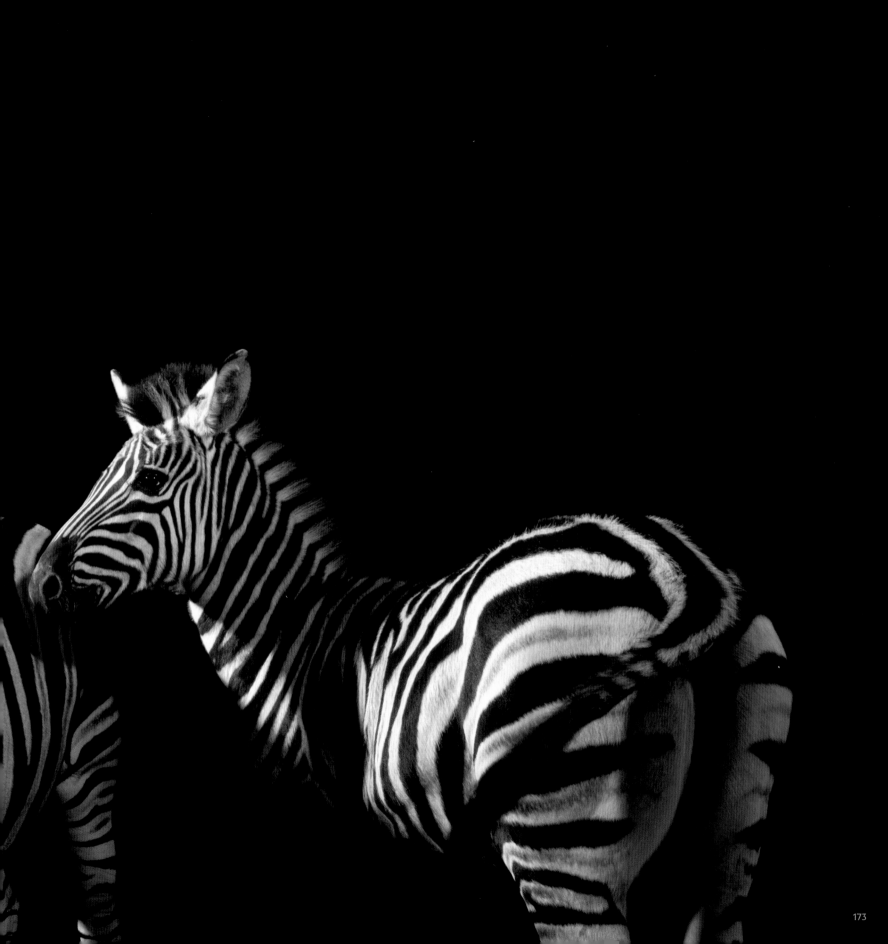

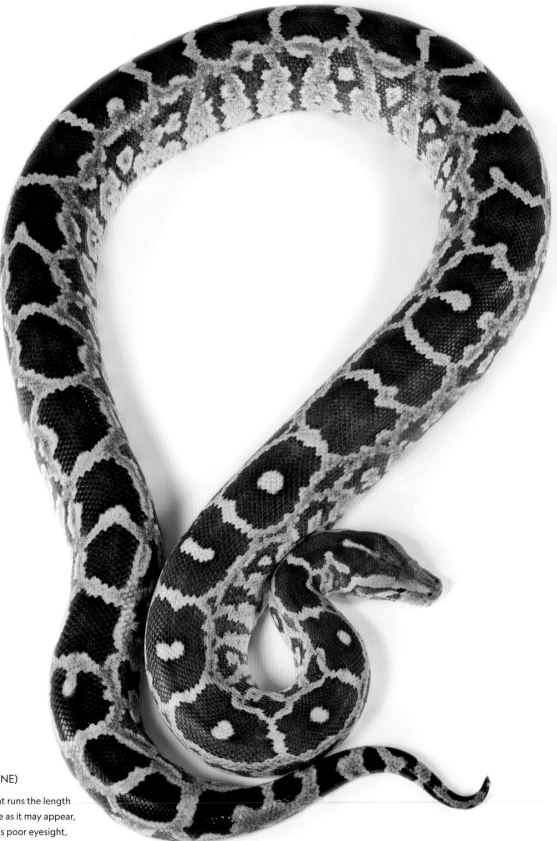

Indian rock python, *Python molurus* (NE)

Dark and light scales form a patchwork that runs the length
of this massive snake's body. As formidable as it may appear,
the python is timid, nonvenomous, and has poor eyesight,
mainly using heat-sensing pits on its head to detect prey.

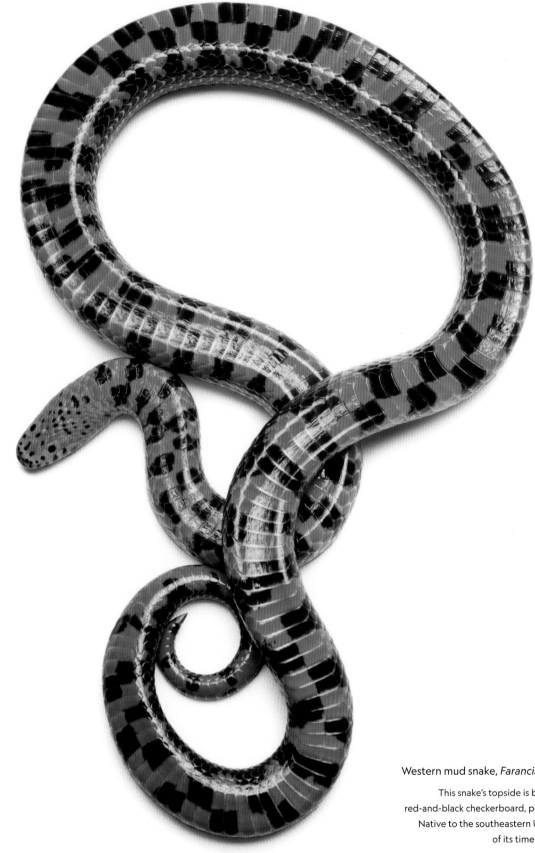

Western mud snake, *Farancia abacura reinwardtii* (LC)

This snake's topside is black, but its belly looks like a red-and-black checkerboard, polished to a high-gloss shine. Native to the southeastern United States, it spends most of its time buried in mud or near water.

Treasure Hunt

My family came along with me when I traveled to Plzeň Zoo in Czechia (Czech Republic) to shoot pictures of rare pheasants. We stayed in guest quarters in the pachyderm house. The giraffes watched us as we walked to the bathroom, mice rustled around outside, and the rhinoceros banged her horn against the bars all night long. It smelled like rhino, too. My wife and older son fled to a nearby resort. I took my daughter and younger son to the zoo cafeteria for dinner, but that was at 5:30 p.m. We were locked inside the zoo; I had no cash. And by dark they were hungry again. So I offered the best suggestion I could think of: I told them to use a stick to search for coins under the snow cone stands and vending machines, to buy a snack. Hours later they came back, filthy as chimney sweeps, horrified but also proud: They'd wandered the zoo and found just enough change to buy a can of Coke. ∎

Western tragopan, *Tragopan melanocephalus* (VU)

A speckled, crimson-throated bird of the Himalayan forests, this tragopan is one of the rarest pheasants in the world. In the northern Indian state of Himachal Pradesh, it is known locally as *jujurana*: king of birds.

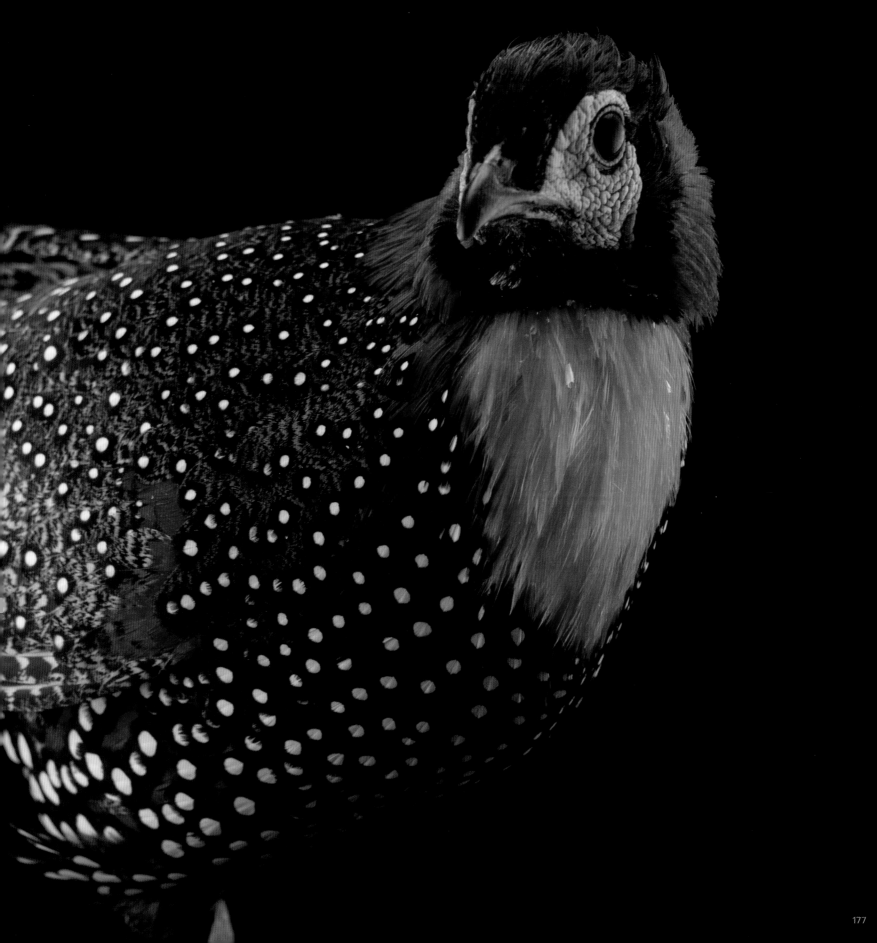

Queen angelfish, *Holacanthus ciliaris* (LC)

Sporting a crown of electric blue, this Technicolor fish swims regally through the sea whips and sea fans of coral reefs in the western Atlantic Ocean. Juveniles often hang around bigger fish, nibbling them clean of parasites and dead scales.

Conspicuous angelfish, *Chaetodontoplus conspicillatus* (LC)

A golden, glowing complexion accented with wire-rimmed
spectacles of inky violet gives this tropical fish a gussied-up look.
Found only in the western Pacific Ocean, the angelfish lives
in coral reefs as deep as 140 feet down.

Bird poop frog, *Theloderma asperum* (LC)

Tree bark, lichen, warts, or a dollop of poop? This frog's
likeness is all in the eye of the beholder. Found in tropical
and subtropical forests in Southeast Asia, the species
breeds in tree cavities filled with water.

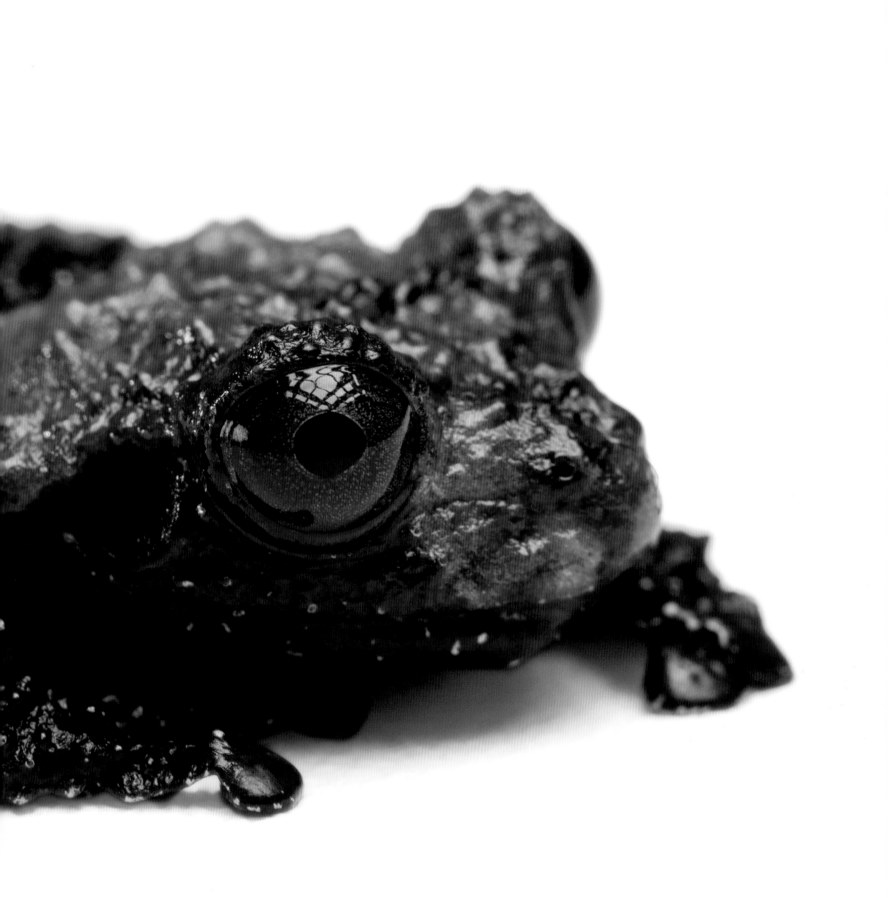

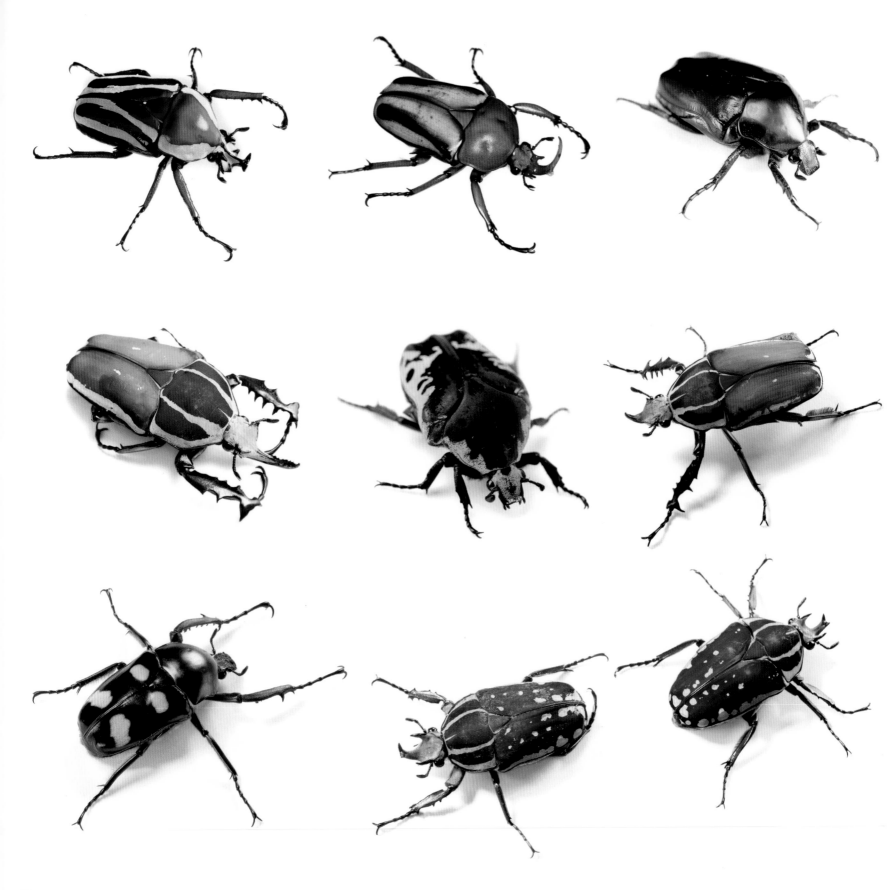

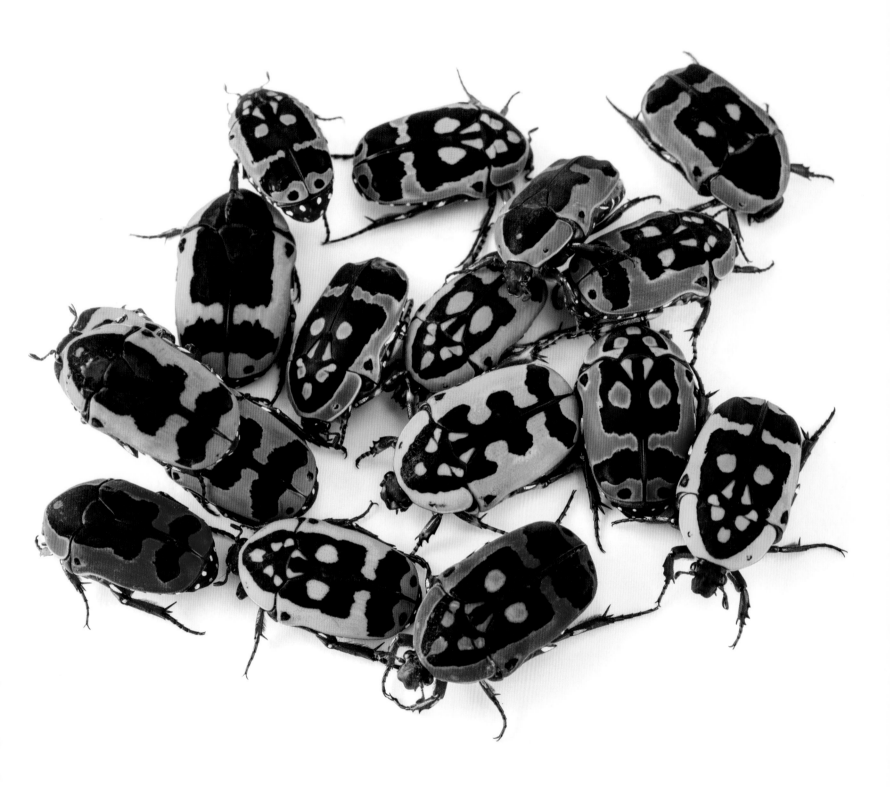

Flower beetles belong to the scarab beetle family. Frequent visitors to flowers, they feed on pollen, nectar, sap, and sometimes even fruit. **OPPOSITE PAGE, TOP ROW, L TO R:** Derby's flower beetle, *Dicronorhina derbyana* (NE); Flamboyant flower beetle, *Eudicella gralli* (NE); *Protaetia speciosa cyanochlora* (NE); **CENTER ROW, L TO R:** Giant flower beetle, *Mecynorhina torquata torquata* (NE); Harlequin flower beetle, *Gymnetis thula* (NE); Ugandan giant flower beetle, *Mecynorhina torquata ugandensis* (NE); **BOTTOM ROW, L TO R:** *Jumnos ruckeri* (NE); Polyphemus beetle, *Mecynorhina polyphemus confluens* (NE). **ABOVE:** *Pachnoda trimaculata* (NE)

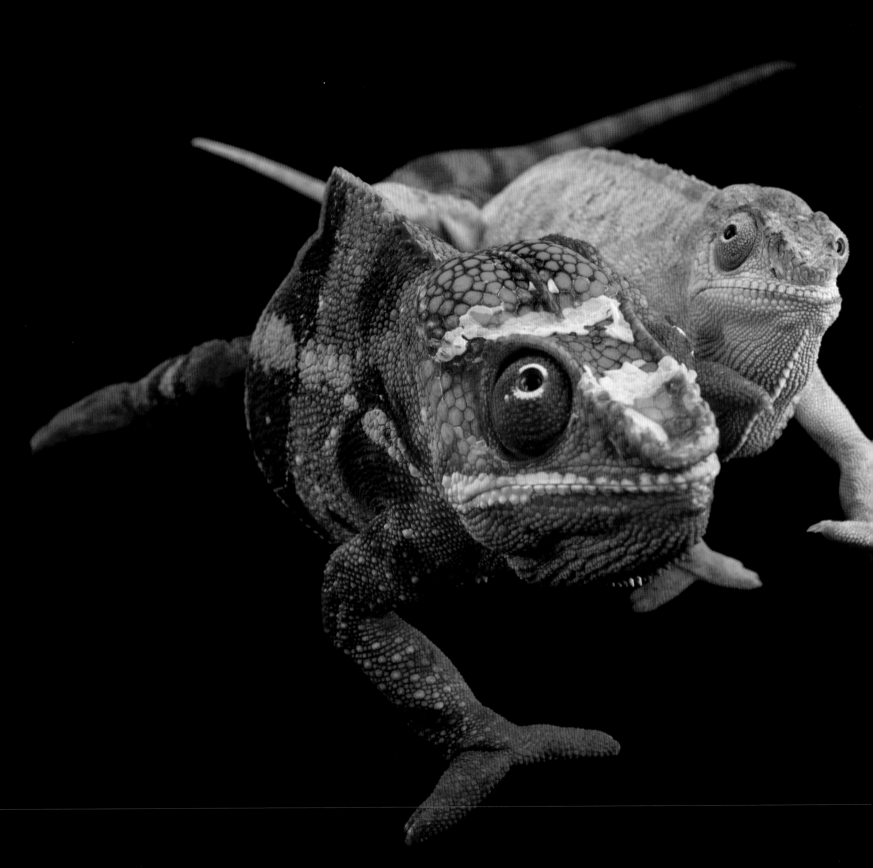

PANTHER CHAMELEONS CAN CHANGE THE COLOR OF THEIR SKIN, WHICH HAS LAYERS OF CELLS WITH IRIDESCENT NANOCRYSTALS THAT **reflect** CAN BE REARRANGED TO DIFFERENT WAVELENGTHS OF LIGHT. MALES MODIFY COLORS AND PATTERNS MOST DRAMATICALLY, HANDY FOR ATTRACTING A MATE OR CHASING AWAY A PROSPECTIVE MALE RIVAL.

Panther chameleon, *Furcifer pardalis* (LC)

Stripes, streaks, spots, and bands of green, crimson, turquoise, and white adorn this chameleon from Madagascar. Coloration varies by sex; females tend to be a tawny color with limited color changing ability, whereas males exhibit a dazzling array of jewel tones.

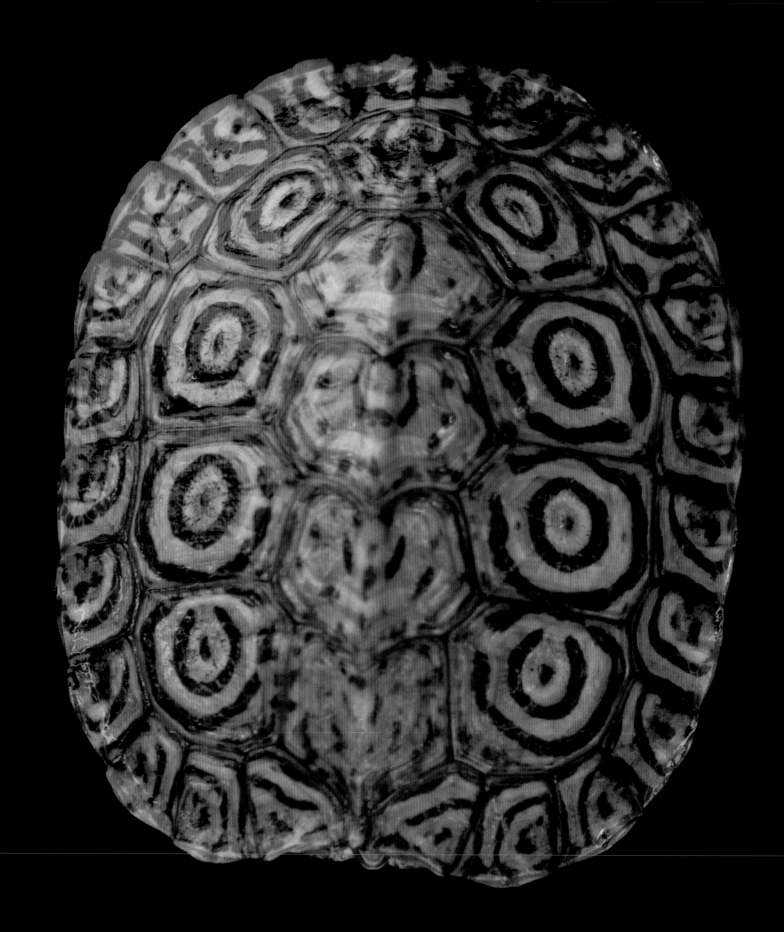

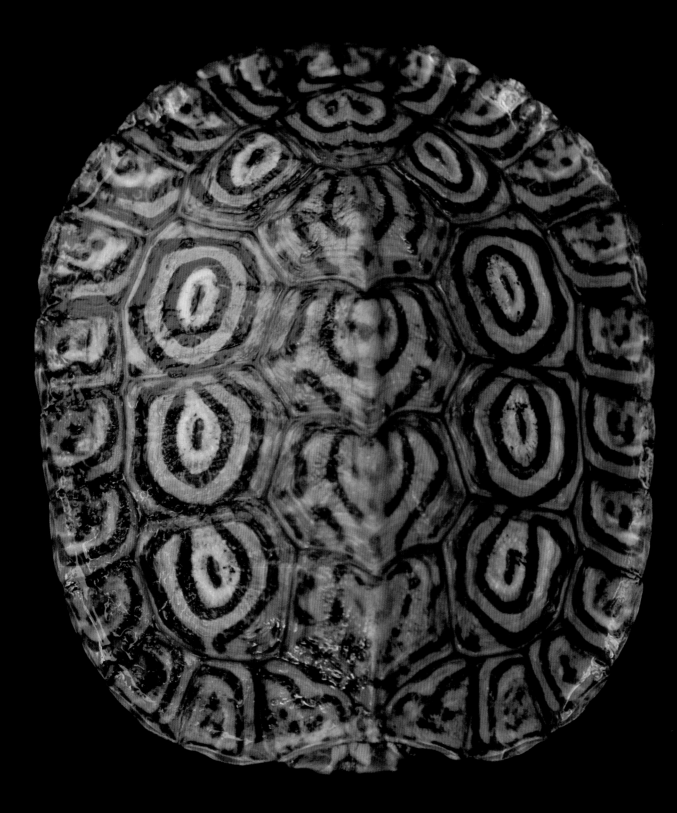

Painted wood turtle, *Rhinoclemmys pulcherrima manni* (NE)

In scrub and woodlands from Mexico to Costa Rica, this turtle
noses about, munching on flowers, fruit, insects, worms, and fish.
Its bold geometric patterns may help scare away predators
by mimicking those of venomous snakes.

Red-and-green macaw, *Ara chloropterus* (LC)

The brilliant plumage of macaws has long intrigued humans. Archaeologists have discovered that ancient Pueblo communities in the American Southwest kept imported macaws in captivity to harvest their feathers.

Last of Their Kind

Tiny freshwater fish like these butterfly splitfin at the Downtown Aquarium in Denver live on the edge. Many are extinct in the wild; their habitat has almost completely vanished. If it weren't for people who care for them out of a love for nature, these fish—including the La Palma pupfish, finescale splitfin, and golden skiffia—would be gone. They survive in captivity only because of dedicated caretakers at a handful of aquariums around the world. These are little bitty fish. They're not brightly colored; they're not showy. The photographic record of them is thin. They don't drive attendance or bring in money. Most people never even see them. Even in the aquariums where they are cared for, they're situated in little tanks behind the scenes. So when I go to an aquarium to photograph one of these fish, I often think about how my photo is going to be the only good picture anyone shoots of this animal. ■

Butterfly splitfin, *Ameca splendens* (CR)

A tiny freshwater fish with shimmering, iridescent scales, the critically endangered splitfin lives in shallow springs within a very small region of the Mexican state of Jalisco. It is no more than three or four inches long.

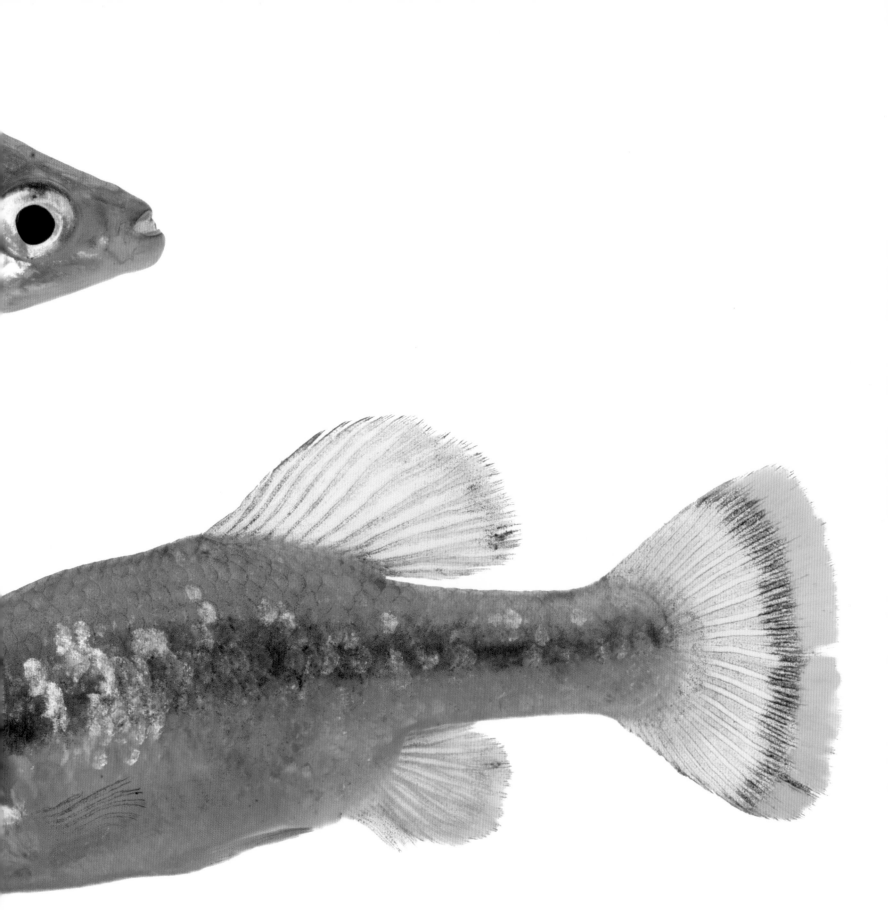

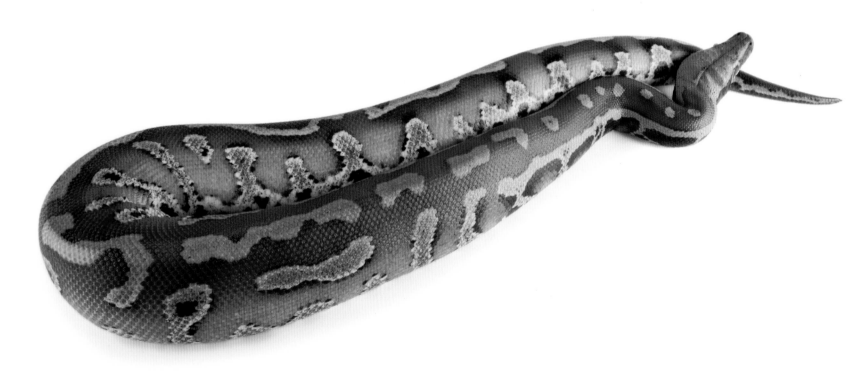

Brongersma's short-tailed python, *Python brongersmai* (LC)

This thick-bodied snake lives in tree plantations and other forested areas of South Thailand, Malaysia, and eastern Sumatra. Expert tree climbers, these snakes have scales on their bellies that allow them to grip tree bark.

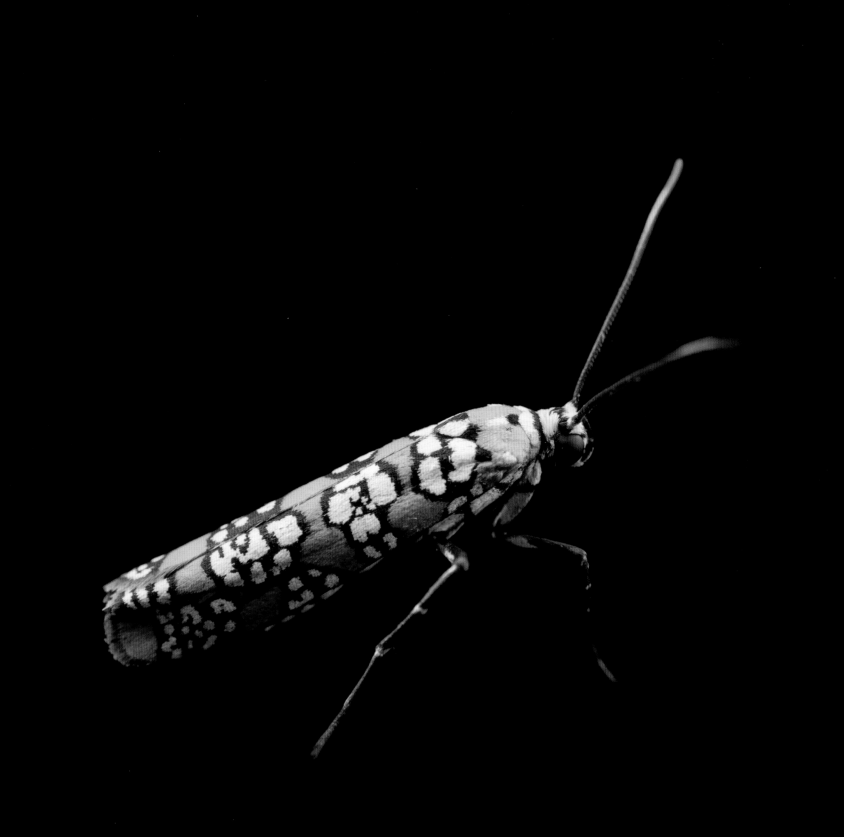

Ailanthus webworm moth, *Atteva aurea* (NE)

With its wings folded back over its body, this North American
moth is often mistaken for a beetle. Bands of yellow spots create
a bold pattern that may discourage potential predators.

EYESPOTS LIKE THOSE SEEN ON THE WINGS OF THIS YELLOW-EDGED

GIANT OWL BUTTERFLY APPEAR ON A VARIETY OF CREATURES.

THEY MAY SERVE AS A DETERRENT BECAUSE THEY

mimic

THE EYES OF OWLS AND OTHER FIERCE PREDATORS, FOOLING

HUNTERS INTO THINKING TWICE BEFORE APPROACHING THIS PREY.

Yellow-edged giant owl butterfly, *Caligo atreus* (NE)

The intricate underside of this large butterfly is so striated
with white, gold, brown, and black that it resembles a

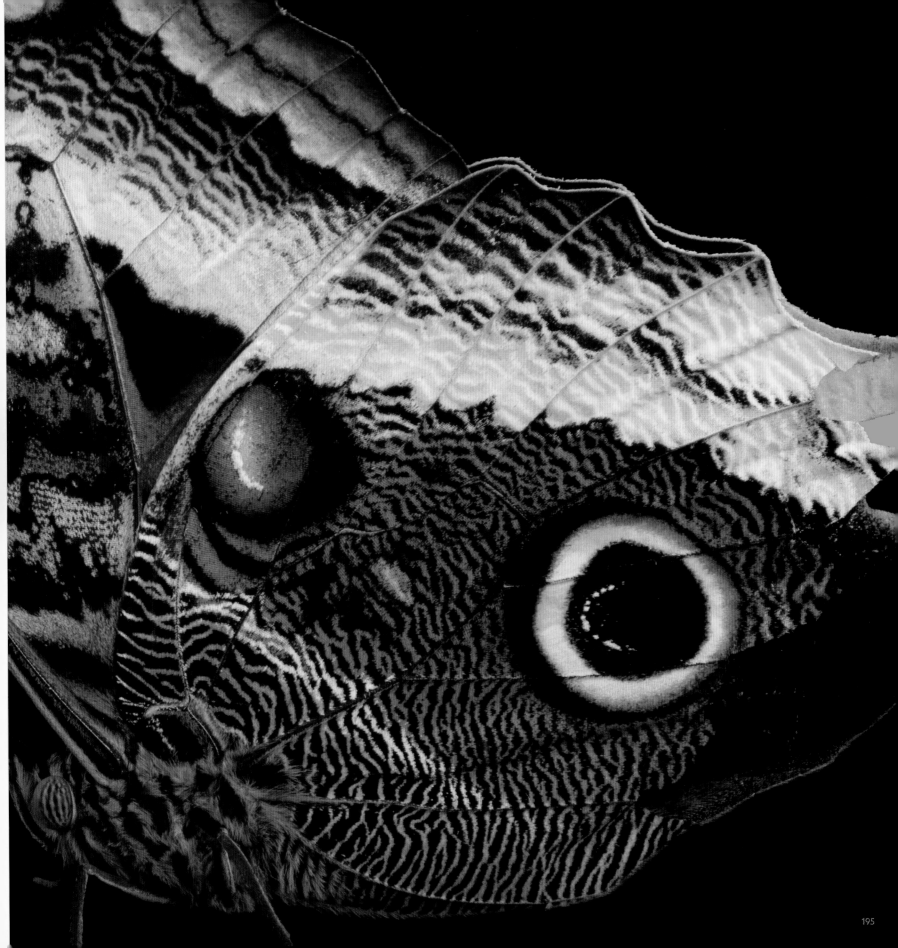

Spotted-tailed quoll, *Dasyurus maculatus* (NT)

This marsupial's spotted tail sets it apart from all other Australian mammals. A female gives birth after only three weeks' gestation; the tiny pups grow inside her pouch for 12 more weeks. Mothers call to their pups with distinct clucks.

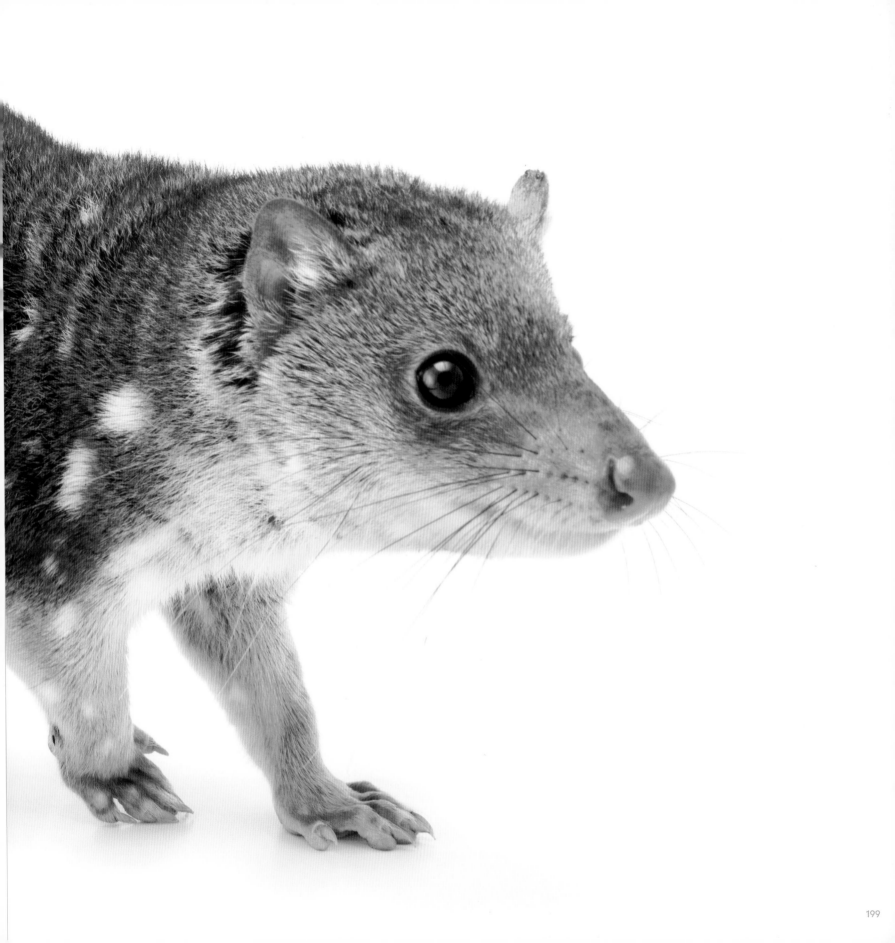

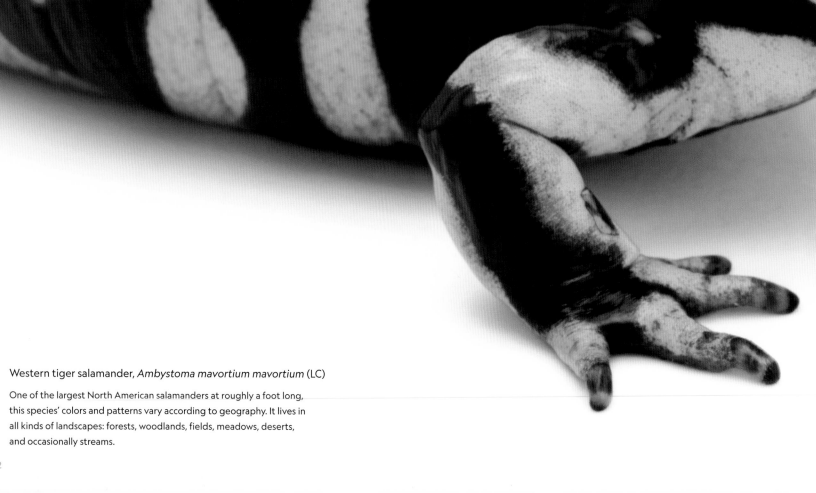

Western tiger salamander, *Ambystoma mavortium mavortium* (LC)

One of the largest North American salamanders at roughly a foot long,
this species' colors and patterns vary according to geography. It lives in
all kinds of landscapes: forests, woodlands, fields, meadows, deserts,
and occasionally streams.

Hello, Neighbor

Twenty-five years ago, we bought an abandoned little farm east of Lincoln. One day I was cleaning out the old storm cellar—cool, damp, and dark. I turned over a wash pan, expecting crickets and dust. Instead, I found a shiny tiger salamander. It looked like an alien: nearly a foot long, black with yellow stripes, high-gloss shine. Startled, I stumbled backward and ran outside. In the bright light of day I gathered my thoughts. I went back in to get one more good look, and then I put the wash pan back over it. Haven't seen it since. Years later I told our state herpetologist. He was amazed. Tiger salamanders haven't been seen in southeastern Nebraska for decades, he said. Mine may have been the last sighting. Hearing that, I was tempted to go back down into the cellar, but a woodchuck lives there now. He's the size of a bulldog, with big yellow teeth. I'm not going down there, not even to see an alien. ∎

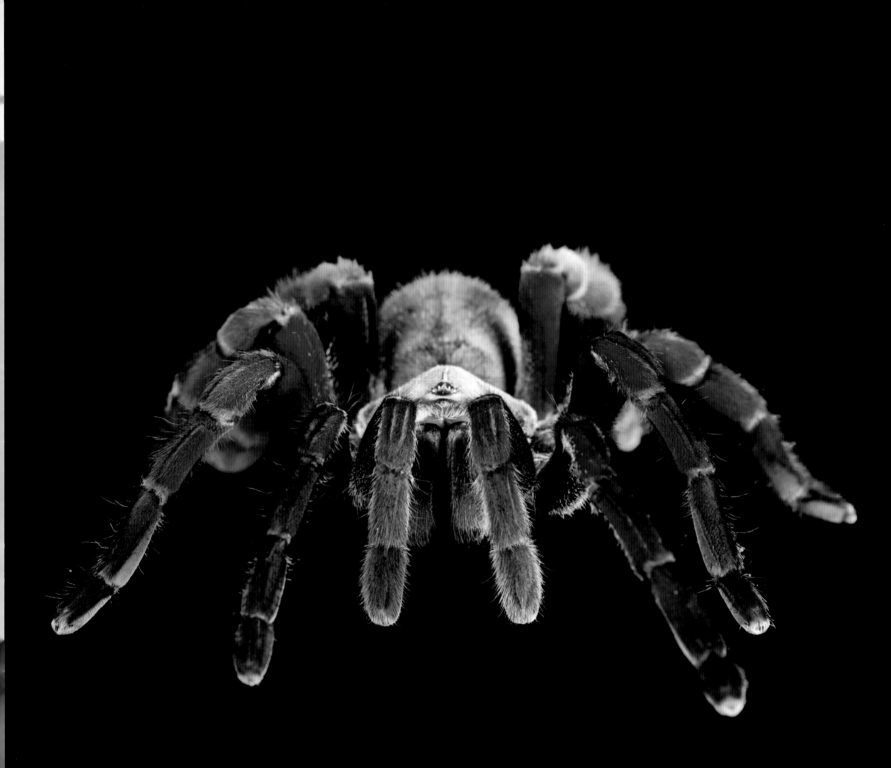

Cobalt blue tarantula, *Cyriopagopus lividus* (NE)

With a velvety gray abdomen and shocking blue legs,
this spider spends most of its time deep within a burrow in
the tropical rainforests of Southeast Asia. When it emerges,
its temperament can be feisty, its venomous bite fierce.

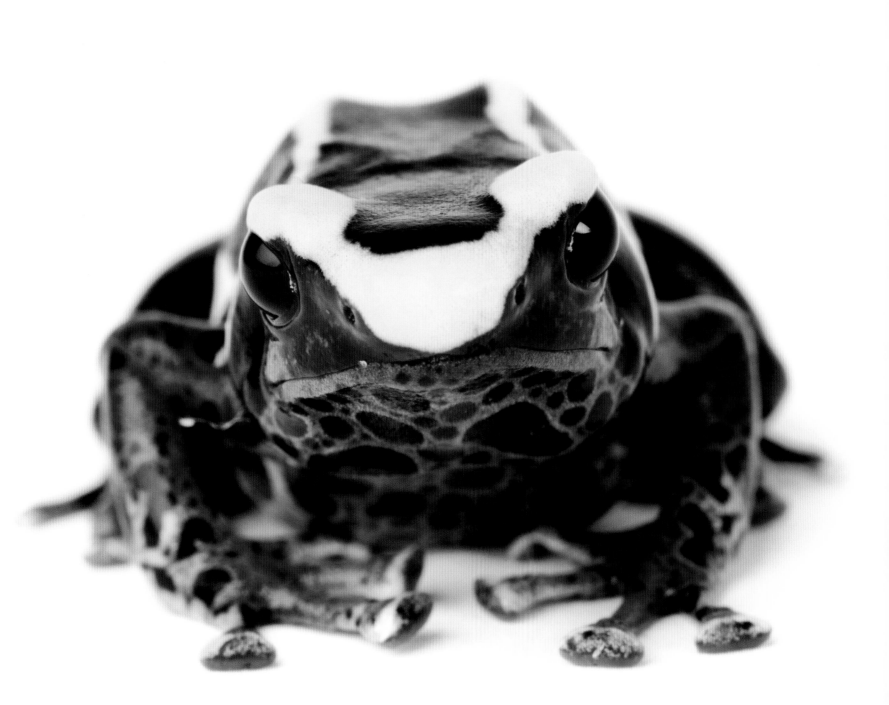

Dyeing poison frog, *Dendrobates tinctorius* (LC)

This poisonous frog of the humid South American rainforests
spends much of its time among leaf litter on the forest floor.
Its flashy colors and bold markings ward off any potential
predators who get close enough to spot it.

Oriental whip snake, *Ahaetulla prasina prasina* (LC)

Slender but reaching a length of about six feet, this Southeast
Asian snake nearly glows, covered in fluorescent green scales
with a bright yellow line that traces down its lower body.
Mildly venomous, it is not considered a danger to humans.

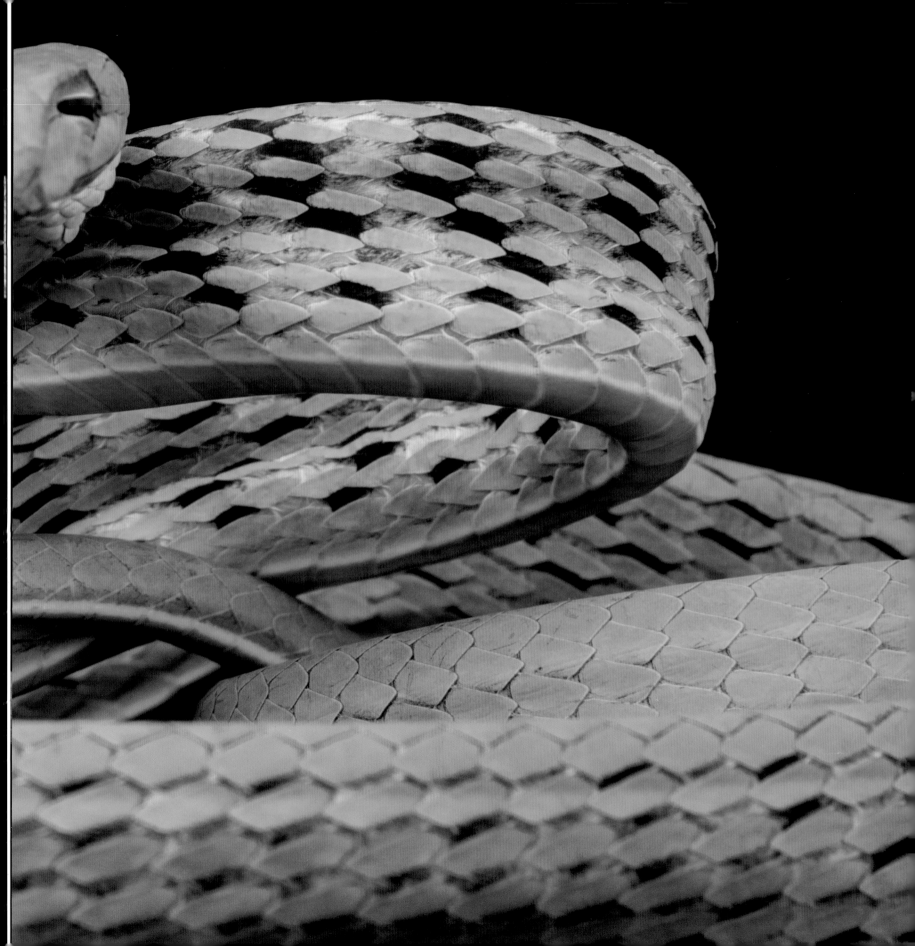

Gharial, *Gavialis gangeticus* (CR)

This critically endangered crocodile of India and Nepal
catches fish with its narrow snout, toothy like a serrated knife.
Males have a bulbous growth at the tip of the snout that
attracts females and produces bubbles during mating.

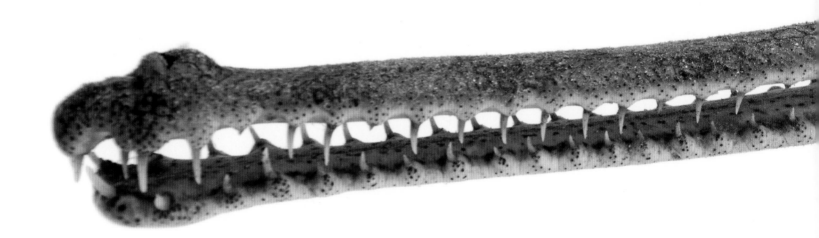

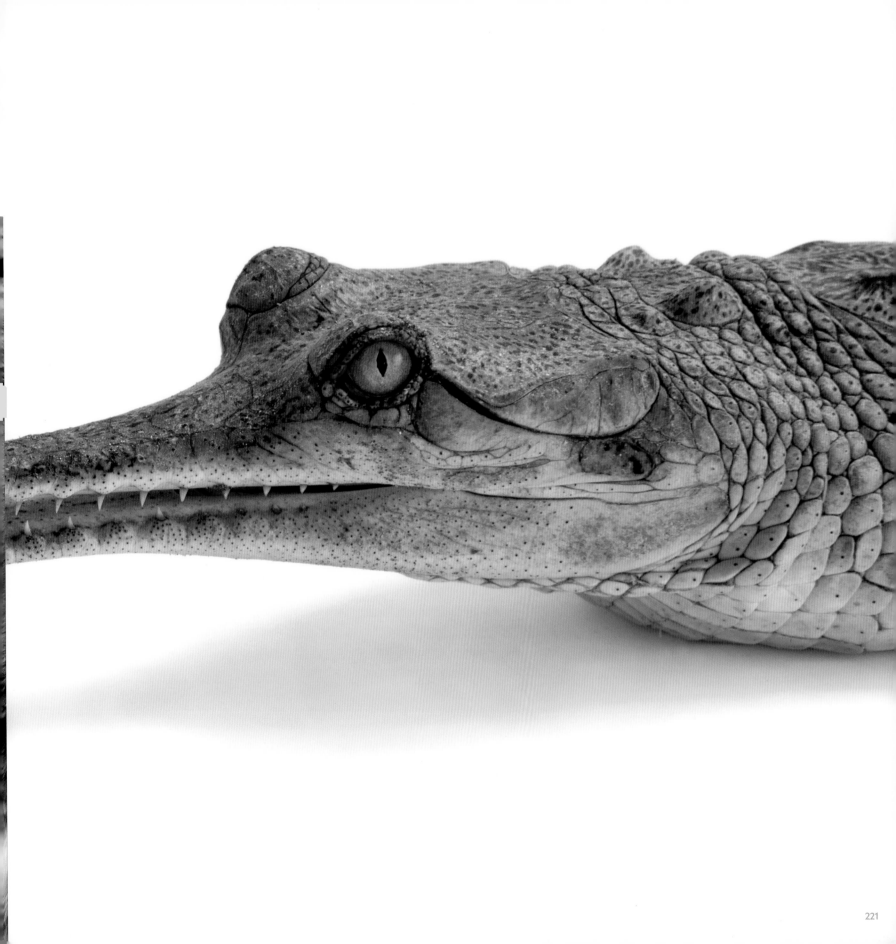

Spiny turtle, *Heosemys spinosa* (EN)

Making it look like a cross between a turtle and a crab,
spiky edges ring the shell of this endangered reptile native
to Southeast Asia's rainforests. Little is known of its habits,
but mating behavior appears to be linked to rainfall.

Spiny-backed orb weaver, *Gasteracantha clavigera* (NE)

These spiky little spiders perform a distinctive mating dance. When a male suitor approaches a female's elaborate web, he drums rhythmically. After mating, the female deposits an egg sac, which protects the spiderlings for several weeks after they hatch.

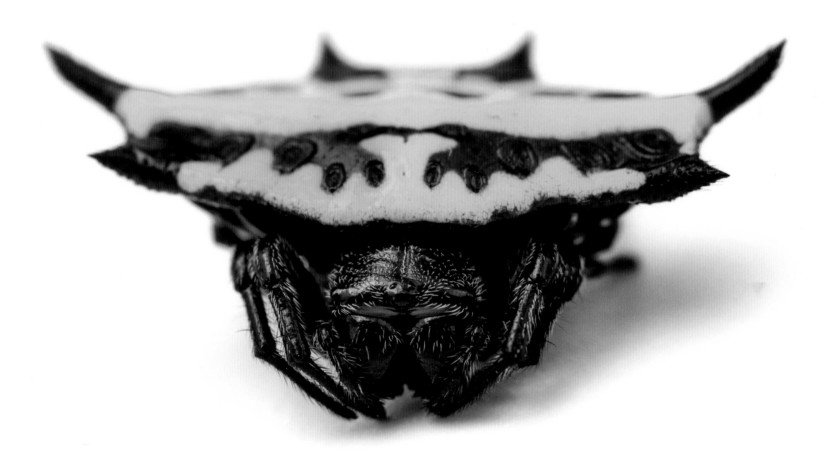

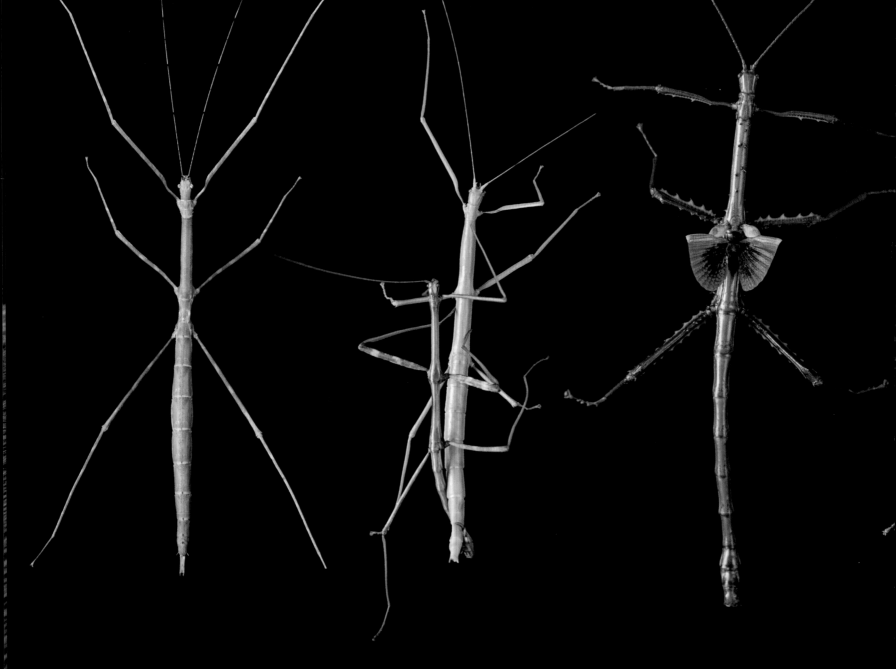

The world's 3,000 species of stick and leaf insects have some of the most effective forms of camouflage in nature, even sporting fake buds and leaf scars. **THIS PAGE, L TO R:** Walking stick, *Orxines xiphias* (NE); Arizona walking stick, *Diapheromera arizonensis* (NE); Malagasy blue stick insect, *Achrioptera fallax* (NE); **OPPOSITE PAGE, L TO R:** Stick insect, *Phasmatidae* sp. (NE); Jejunus stick insect, *Lonchodes jejunus* (NE); Thorny walking stick, *Trachyaretaon brueckneri* (NE)

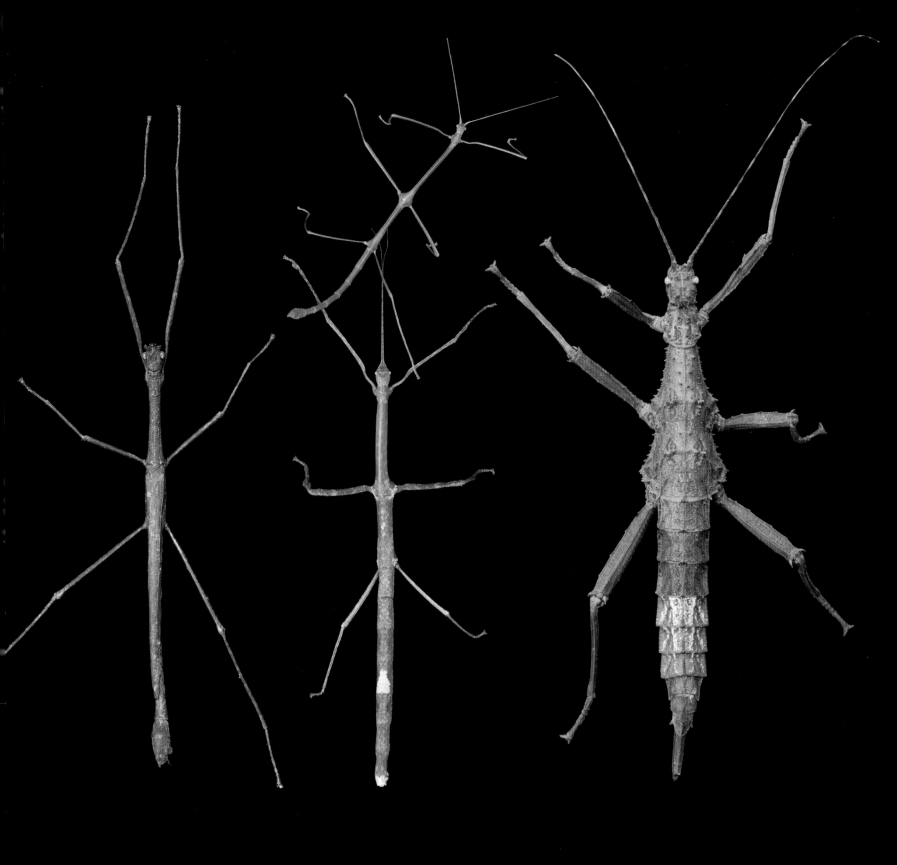

SURINAM HORNED FROGS HAVE MOUTHS THAT ARE WIDER THAN THEIR BODIES ARE LONG. THEY ARE VORACIOUS EATERS, THUS EARNING THE NICKNAME OF THE

pac-man

FROG. THEY ARE KNOWN TO DEVOUR WHATEVER FITS INTO THEIR MOUTHS—EVEN EATING ANIMALS NEARLY AS BIG AS THEY ARE.

Surinam horned frog, *Ceratophrys cornuta* (LC)

Buried in the mud with only its face exposed, this sneaky predator of South American rainforests waits for unsuspecting passersby— mice, fish, even tadpoles of its own species—and then strikes. The sharp protrusions on its head may deter predators.

Pale giant squirrel, *Ratufa affinis hypoleucos* (NT)

One of the largest squirrels in the world lives in rainforests of Southeast Asia. It has an unusually long tail, which hangs down and acts as a counterweight when the squirrel is perched on a branch to nibble at bark, leaves, seeds, or fruit.

Hawaiian monk seal, *Neomonachus schauinslandi* (EN)

Mother monk seals—named for their solitary lifestyle, and for folds of skin that resemble a monk's cowl—remain with their pups constantly for the first few weeks of their lives. They don't eat during this time and may lose hundreds of pounds.

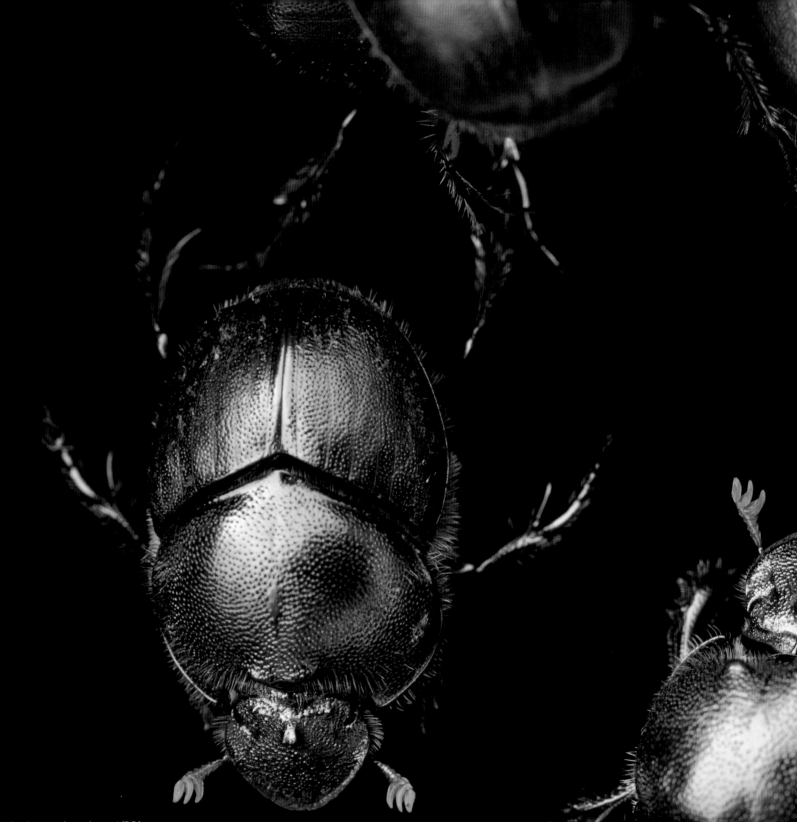

Dung beetle, *Proagoderus brucei* (DD)

Dung beetles, or tumblebugs, live on every continent but Antarctica. These iridescent insects rely on feces as a place to lay eggs, and also as a food source: Most feast on a stinky liquid found in the grassy excrement of cows, elephants, and other herbivores.

Rainbow Surprise

Huffing and puffing my way up a grassy slope in Cameroon, I dropped to my knees and yelled, "Dung beetles!" I'd come to this mountainous area to search for the elusive Cross River gorilla. Hours on foot had yielded nothing. I wasn't surprised; these gorillas are rare and wary, and if they smell or hear people, they're gone. But as I made my way up the hill, I kicked over a cow pie, and there they were, wiggling in the excrement: a pile of beetles, every color of the rainbow, and metallic, as though lit from inside. Gorillas they weren't, but it's all a matter of perspective. If you look at them up close, beetles are every bit as interesting. So I dumped out my water bottle and flicked in a couple of each species of beetle so I could take them back to camp and photograph them. The expedition was saved. I'm still amazed that something so beautiful lives in poop. ■

Michie's tufted deer, *Elaphodus cephalophus michianus* (NT)

Named for the thatch of fur on its forehead, this deer of Myanmar and China also has conspicuous canines that stick out like tusks. When bucks spar over territory or potential mates, these sharp teeth can become dangerous weapons.

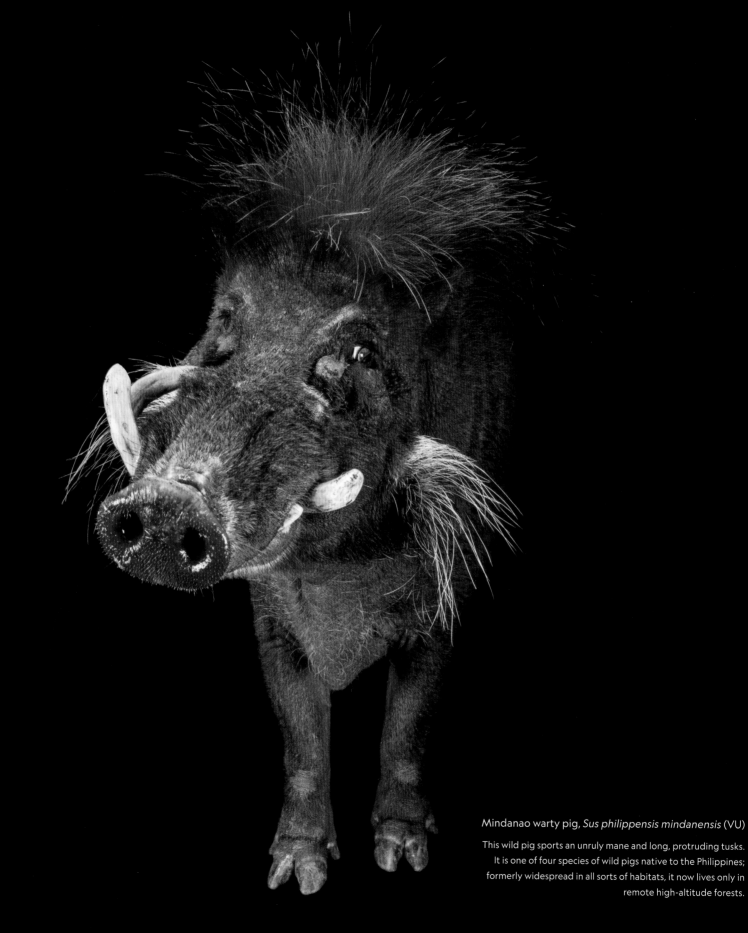

Mindanao warty pig, *Sus philippensis mindanensis* (VU)

This wild pig sports an unruly mane and long, protruding tusks. It is one of four species of wild pigs native to the Philippines; formerly widespread in all sorts of habitats, it now lives only in remote high-altitude forests.

Sumatran orangutan, *Pongo abelii* (CR)

The largest tree-dwelling primate in the world has long, red hair that receives much grooming. Males' prominent cheek pads accentuate dark, knowing eyes; flexible lips allow orangutans to make a wide range of facial expressions.

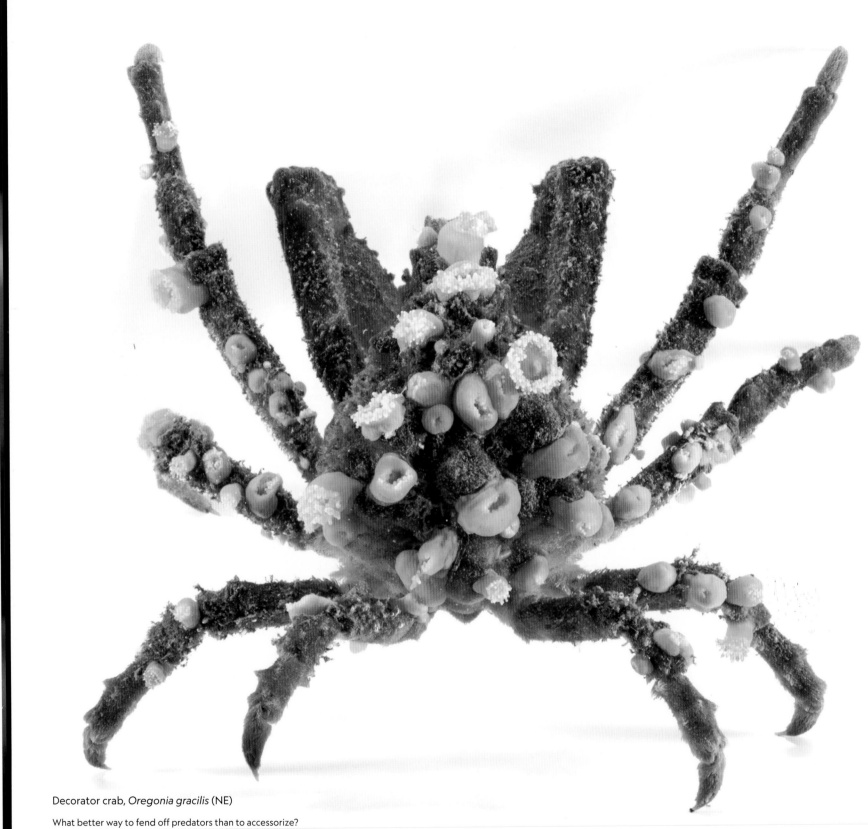

Decorator crab, *Oregonia gracilis* (NE)

What better way to fend off predators than to accessorize?
This crab of the western Atlantic Ocean gathers algae and
invertebrates from its surroundings and fastens them to its
carapace with hooklike bristles.

Brazilian jewel tarantula, *Typhochlaena seladonia* (NE)

By ripping off pieces of bark or lichen from a tree, this intricate spider of Brazil's Atlantic Forest builds a secret trapdoor. The spider waits for unsuspecting prey to pass by, ambushes them, and then retreats back inside the hideaway.

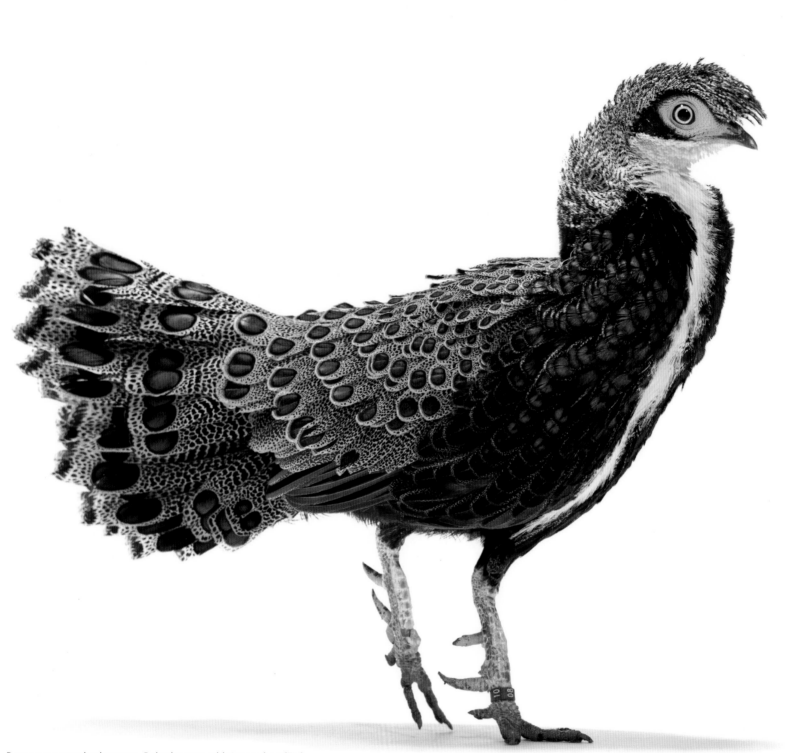

Bornean peacock-pheasant, *Polyplectron schleiermacheri* (EN)

With its shaggy crest, sharp spurs, luminous vest, and elegant tail,
this endangered peacock-pheasant struts through forests of Borneo
with style. Fewer than 2,500 individual birds are thought to remain.

Eastern aardwolf, *Proteles cristata septentrionalis* (LC)

Looking like a Davy Crockett cap come to life, a single aardwolf can eat more than a hundred million termites a year. This makes them partners in pest control, preventing crop damage for African farmers and limiting termite damage in the grasslands where livestock graze.

Electric eel, *Electrophorus electricus* (LC)

This giant knifefish of murky South American rivers has three organs that emit electric charges of varying intensity. A weak charge helps the eel navigate its dim surroundings, find prey, and choose a mate; a more powerful charge can stun prey.

The Body Electric

Moving an electric eel requires shoulder-high thick rubber gloves and a lot of nerve. At most aquariums, nobody wants to touch these creatures: They use powerful shocks to stun or kill prey, fend off predators, and communicate with one another. As I was taking pictures of one at the Oklahoma Aquarium, a keeper told me how the eel had once zapped Kenny Alexopoulos, the aquarium's chief operating officer. He had been on a ladder trying to fish out a zip tie floating near the surface of the eel's tank. "As soon as my hand grabbed that zip tie, he let me have it," Alexopoulos told me later. The shock nearly knocked him off the ladder; he hooted and hollered as the electricity surged through his body. Best of all, he said, electrodes in the eel's tank picked up the sound of the charge and broadcast it to the public. "That speaker sounded like a chain saw going off," he said. "When I went back out front, all the kids wanted to know what it felt like." ▪

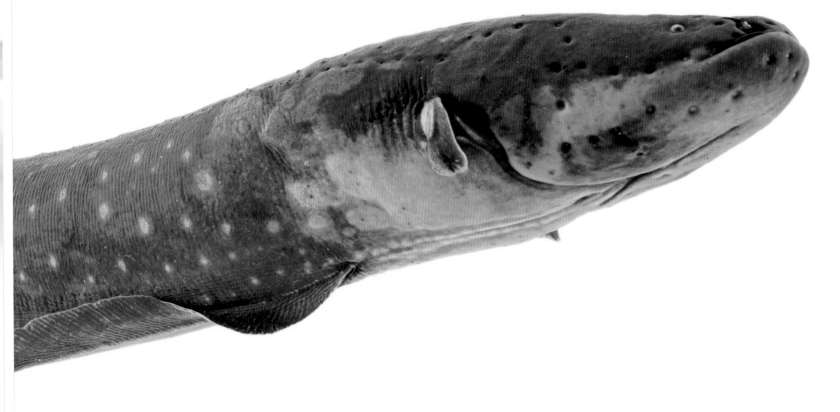

White-belted ruffed lemur, *Varecia variegata subcincta* (CR)

These lemur moms are exceptional planners. Before giving birth, a female ruffed lemur builds as many as 15 nests in different trees. When her young are a couple of weeks old, Mom begins moving about to forage and transports the babies many times a day among the various nests.

Himalayan tahr, *Hemitragus jemlahicus* (NT)

This shaggy resident of the southern Himalaya migrates vertically each day. Tahrs spend their days at higher altitudes, their nights on the lower slopes. Introduced populations exist in New Zealand, the United States, Canada, and South Africa.

Spiny tailed fairy shrimp, *Streptocephalus sealii* (NE)

Hardy and endlessly innovative, the world's 300-plus species of
fairy shrimp can withstand extreme conditions: Eggs of one species
were sent up in a space shuttle, exposed to the vacuum of space for
a week (no air, heat, or water), and still survived.

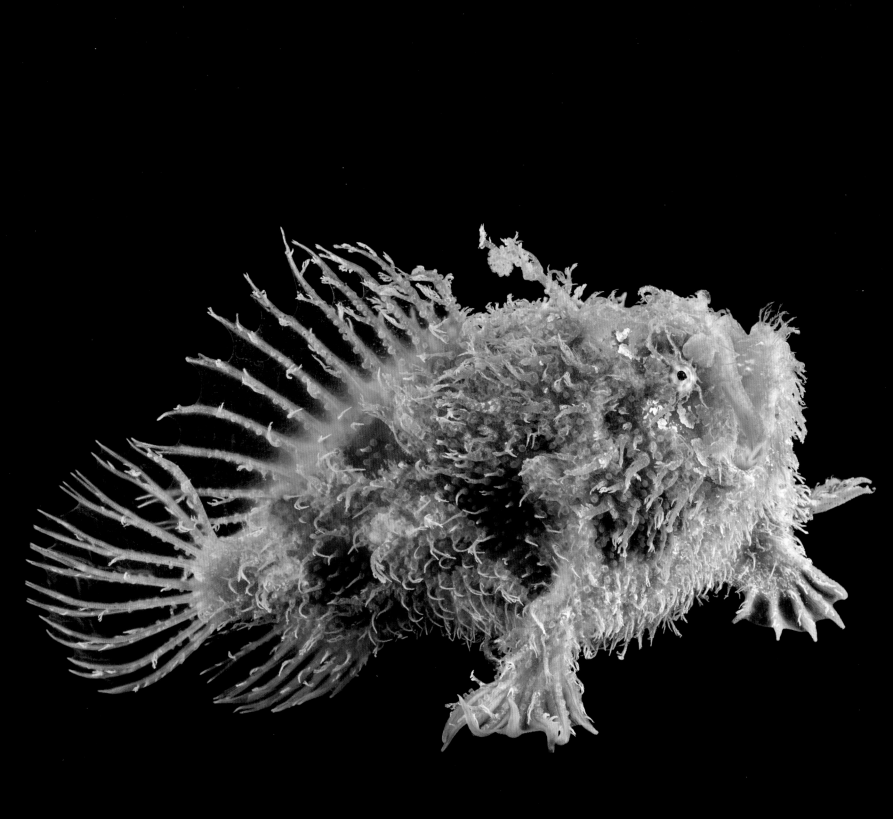

Tasselled anglerfish, *Rhycherus filamentosus* (NE)

Algae or fish? Covered in hairlike skin extensions, this superbly
camouflaged bottom dweller gets its name for a habit of
baiting prey with its very own fishing lure. It lives in reefs off
the coast of southern Australia.

Leafy seadragon, *Phycodurus eques* (LC)

This seadragon's botanically inclined disguise helps it evade predators;
so do several sharp spines on the sides of its body. Females develop
eggs, but males incubate them: For up to eight weeks, a male will carry
as many as 250 eggs in special cups on its tail.

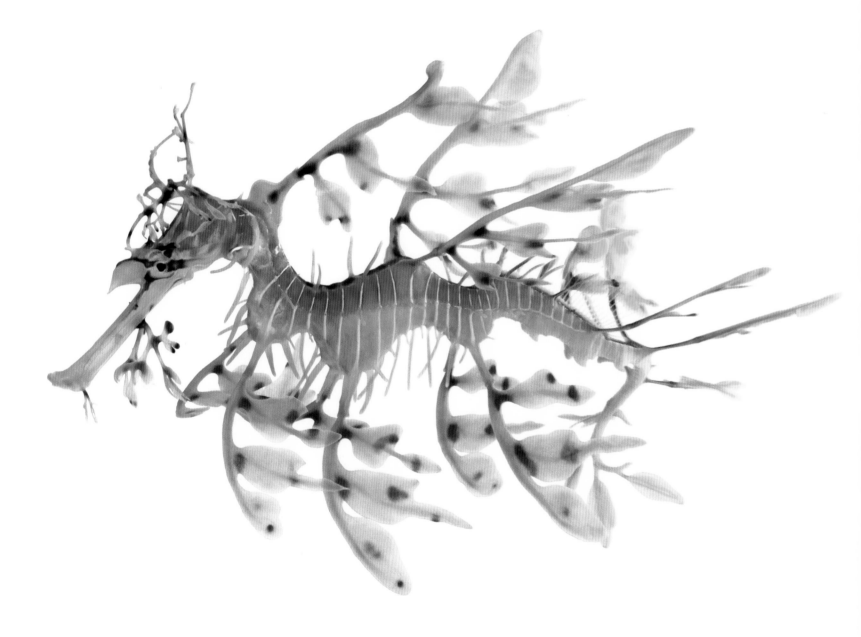

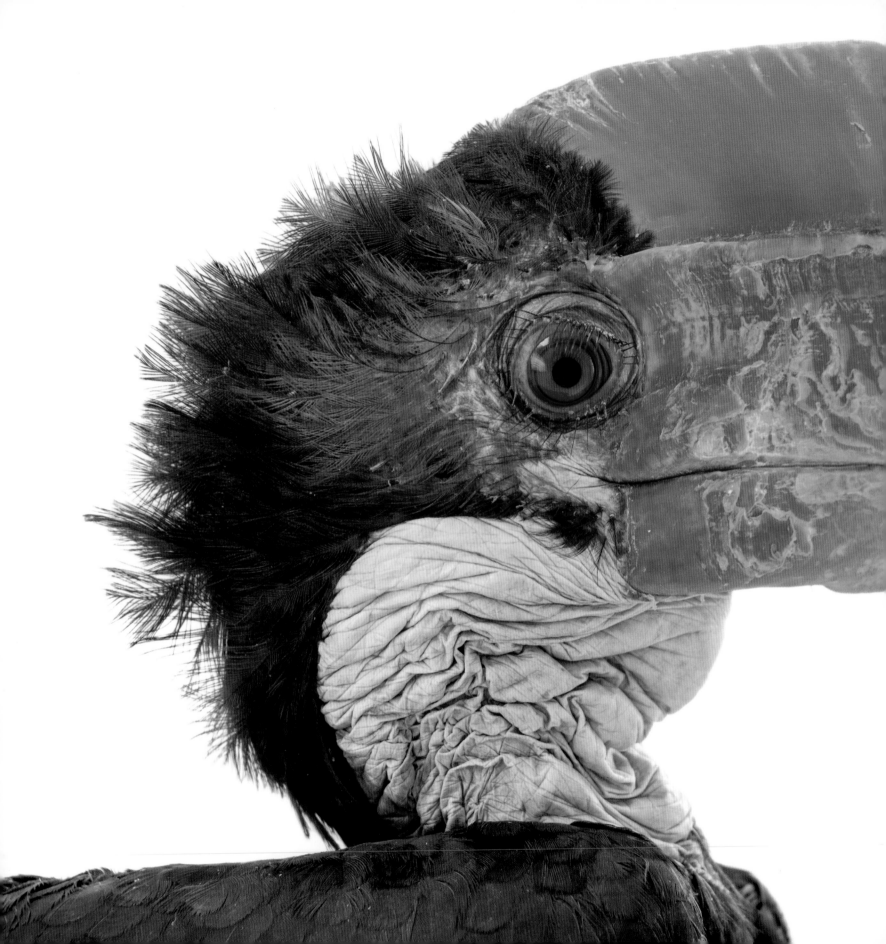

Free at Last

Helmeted hornbills are glorious birds but coveted in the illegal wildlife trade for their solid casques, or helmets. Softer than ivory, they can be carved into beads and statuary. As if sensing the threat, these birds fiercely protect their young: The male helps seal the female inside the cavity of a tree for months, bringing food to her and the chick through a tiny slit. When it's time for the young to fledge, the hornbills chisel away the seal. The hornbills at Malaysia's Penang Bird Park had been brought there by a logger who heard the birds squawking inside the trunk after their tree was cut down. These hornbills were lucky. Deforestation is a major threat to this species' survival, and in most cases, birds still inside a tree would die. This man knew how rare they were and brought them to the bird park. But it's not easy to keep these birds alive when their habitat has disappeared. ■

Helmeted hornbill, *Rhinoplax vigil* (CR)

A rare and unmistakable bird of Southeast Asia, the hornbill has a casque whose front is solid keratin—the same material as a rhinoceros's horn. Hornbills regurgitate and defecate so many seeds that they are known as "farmers of the forest."

Caracal, *Caracal caracal* (LC)

Erect ears with tufts of black fur distinguish this cat of Asia and Africa. Caracals can conquer prey several times their mass, often with an acrobatic leap. They are equally agile when evading predators, and can scare off much larger aggressors.

Brown long-eared bat, *Plecotus auritus* (LC)

This Eurasian bat with oversize ears—nearly as long as its body—hunts moths and other insects. When resting, it curls up in hollow trees or along the beams of barns and old buildings and bends its ears sideways like horns.

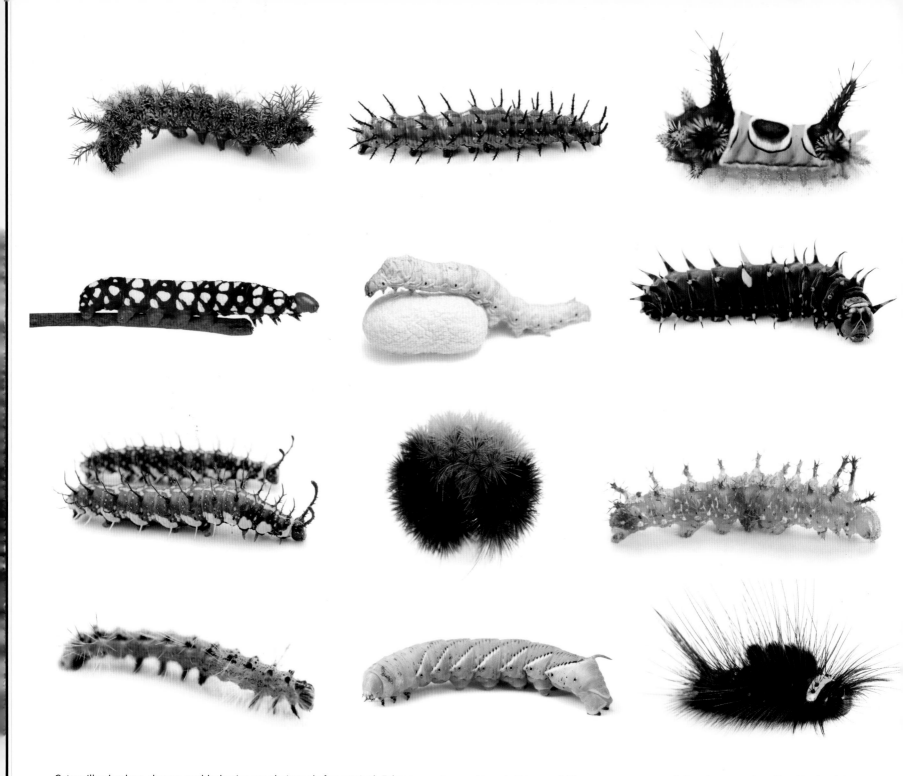

Caterpillars' colors, shapes, and behavior are their tools for survival. False eyespots, bark- or leaflike camouflage, and venomous spines or barbs deter predators or help the larvae blend in with their surroundings. **TOP ROW, L TO R:** Buck moth caterpillar, *Hemileuca maia* (NE); Gulf fritillary caterpillar, *Agraulis vanillae* (LC); Saddleback moth caterpillar, *Acharia stimulea* (NE); **SECOND ROW, L TO R:** African giant skipper, *Pyrrhochalcia iphis* (NE); Silkworm, *Bombyx mori* (NE); Cairns birdwing caterpillar, *Ornithoptera euphorion* (LC); **THIRD ROW, L TO R:** Cruiser caterpillar, *Vindula arsinoe* (NE): Isabella tiger moth caterpillar, *Pyrrharctia isabella* (NE); Nymphalid butterfly caterpillar, *Nymphalidae* sp. (NE); **BOTTOM ROW, L TO R:** Fall webworm caterpillar, *Hyphantria cunea* (NE); Tobacco hornworm, *Manduca sexta* (NE); Tussock moth caterpillar, subfamily Lymantriina (NE); **OPPOSITE, TOP ROW, L TO R:** *Noctuidae* sp. (NE); Yellow tussock moth caterpillar, *Calliteara horsfieldii* (NE); Schaus' swallowtail butterfly caterpillar, *Papilio aristodemus ponceanus* (LC); **CENTER ROW:** Orange lacewing caterpillars, *Cethosia penthesilea* (NE); **BOTTOM ROW, L TO R:** Unidentified species; Milkweed tussock moth caterpillar, *Euchaetes egle* (NE); Tussock moth caterpillar, *Orgyia* sp. (NE)

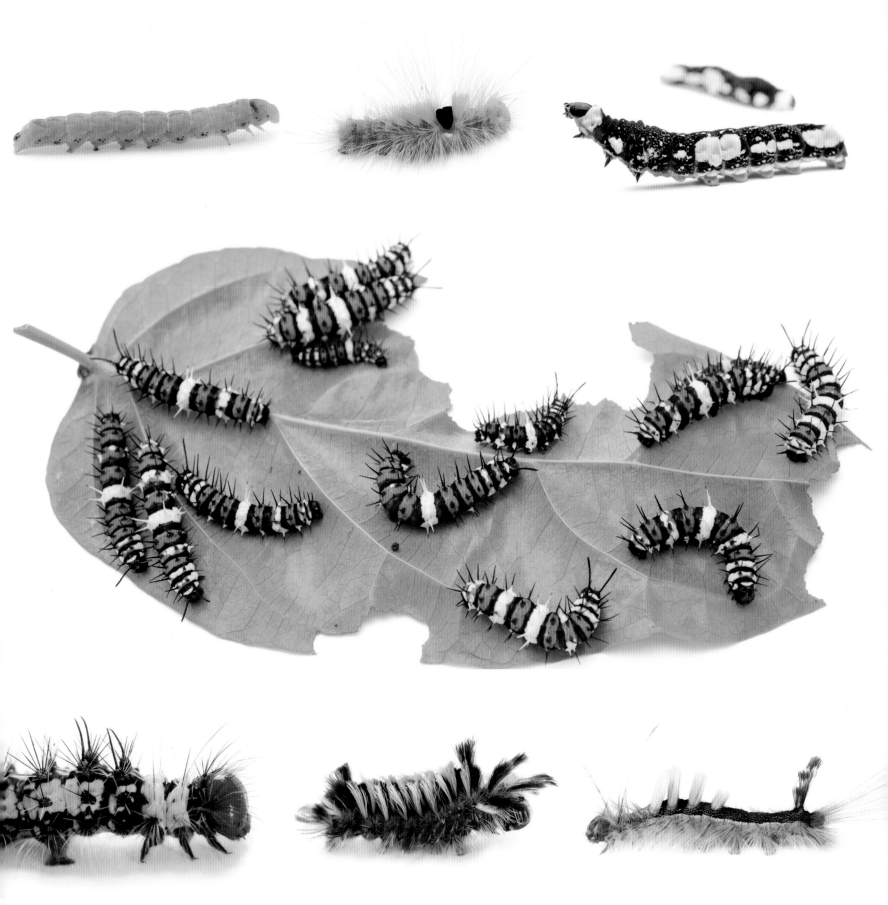

Pacific walrus, *Odobenus rosmarus divergens* (DD)

Enormous tusks are key for life on the Arctic ice. Framed by
whiskers that help in navigating the ocean floor, walruses'
canines can break through nearly eight inches of ice.
They also help the massive animals haul themselves
up onto the ice.

Banded tree snail, *Orthalicus floridensis* (NE)

Only a handful of snails spend most or all of their lives in trees. Florida's banded tree snail is one: Moving slowly about, it feeds on lichen, algae, and fungi growing on leaves and bark, and only visits the ground to deposit eggs.

The Big Sleep

Arctic ground squirrels are world-champion hibernators. They sleep eight months out of the year—more than any other mammal. The first time I photographed one was at the University of Alaska at Fairbanks. A researcher took a couple of snoozing squirrels and put them out on a snowbank. It was near Valentine's Day, so we arranged them into a heart shape. The next time I photographed this species, the squirrels were alert, and I had to work fast. These furry guys are quick. They have to be: It seems every predator in the Arctic likes to feast on them. Scientists are studying what happens to the squirrels during their prolonged sleep. Their brains actually lose synapses while they hibernate, but the brain cells reconnect when the squirrels warm up. Scientists are studying this process, along with some other neurological quirks of these creatures, because they could hold clues for treating Alzheimer's disease and traumatic brain injuries. ▪

Arctic ground squirrel, *Urocitellus parryii* (LC)

These resourceful natives of the frozen north build three kinds of burrows to stay warm, safe, and cozy: one plugged with lichens and dirt for hibernating; a getaway tunnel to escape predators; and a multiroomed dwelling for raising young.

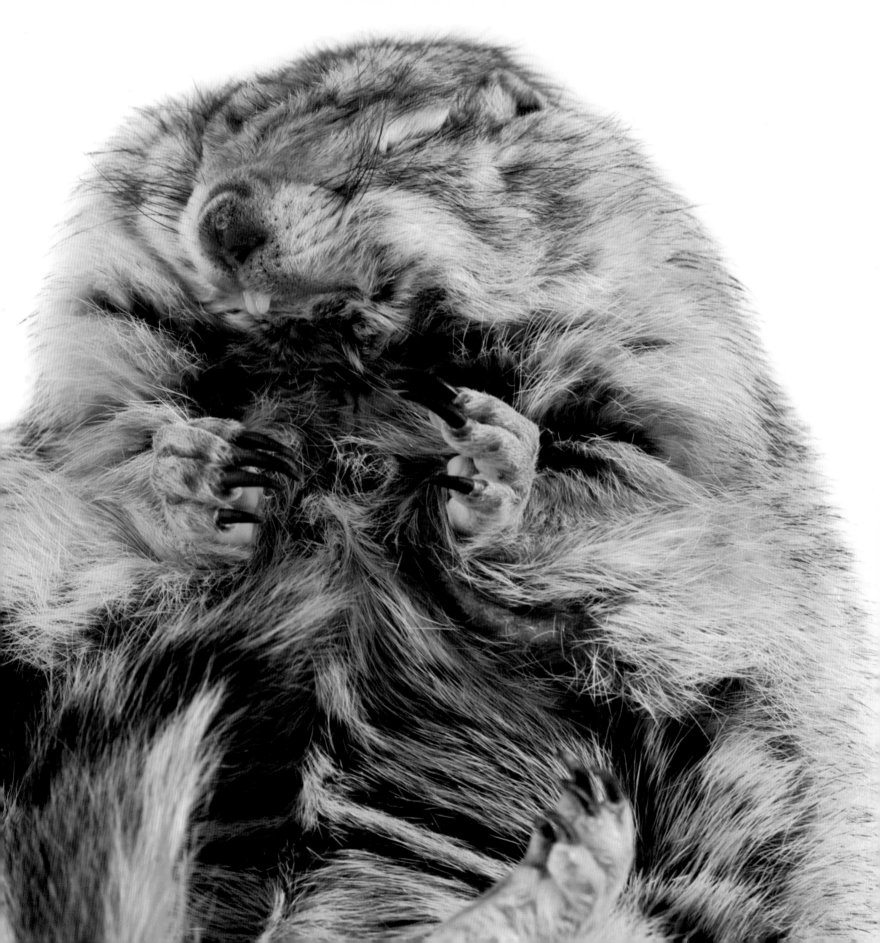

Thorny devil, *Moloch horridus* (LC)

The thorny devil's spiny, armored exterior isn't just for self-defense. It also helps this resident of Australia's hot, dry interior capture moisture from condensation on its body. Over the course of a day, its scales can change color from brown or olive to light yellow.

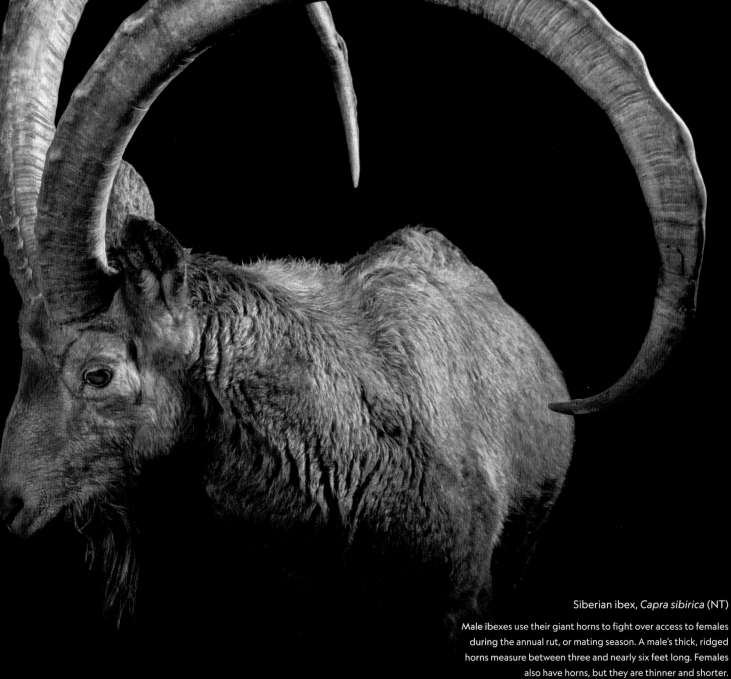

Siberian ibex, *Capra sibirica* (NT)

Male ibexes use their giant horns to fight over access to females
during the annual rut, or mating season. A male's thick, ridged
horns measure between three and nearly six feet long. Females
also have horns, but they are thinner and shorter.

SIZE MATTERS—NOSE SIZE AT LEAST—TO PROBOSCIS

MONKEYS. THE LARGER THE NOSE, THE LOUDER THE

honk,

AND A HEALTHY HONK CAN HELP SCARE OFF RIVAL

MALES COMPETING FOR THE FEW AVAILABLE MATES.

Proboscis monkey, *Nasalis larvatus* (EN)

Although trees are their preferred home, these monkeys of
Borneo never stray far from rivers and are excellent swimmers.
They can also cross narrow waterways by jumping from a tree
on one bank to a tree on the opposite bank.

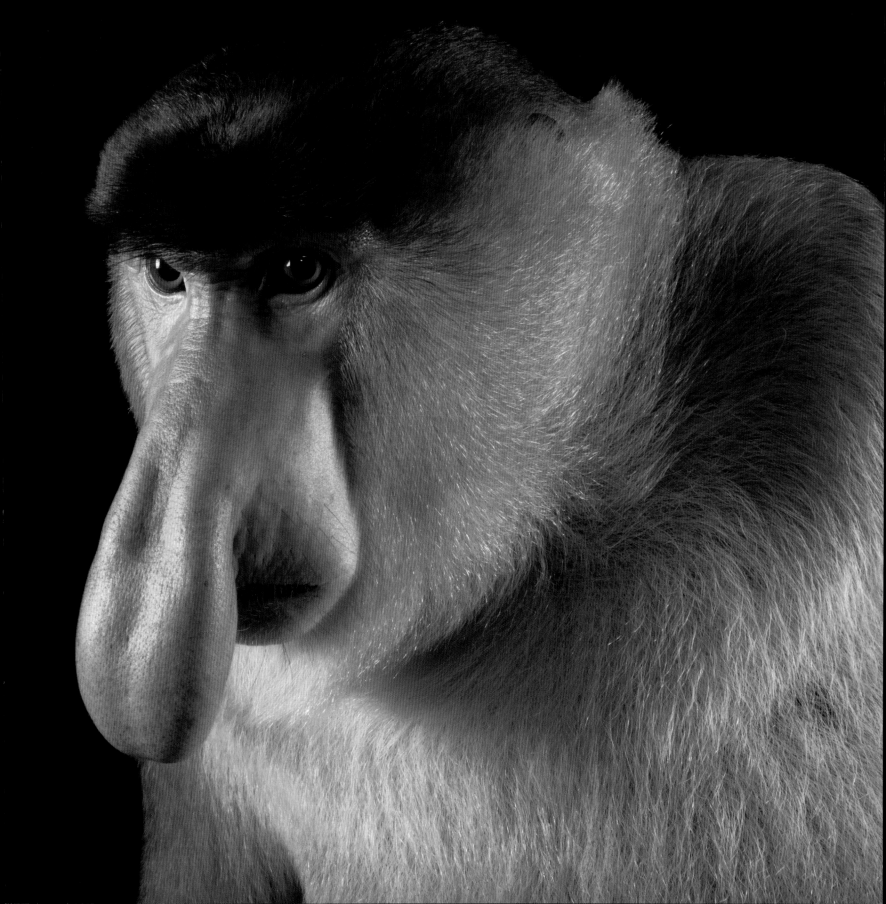

Rhinoceros snake, *Gonyosoma boulengeri* (LC)

Scientists don't know why this nonvenomous snake of northern
Vietnam and southern China has a scaly horn on its snout.
The snake lives in trees and is active at night. Gray-brown for
the first two years of life, it turns bluish green as it matures.

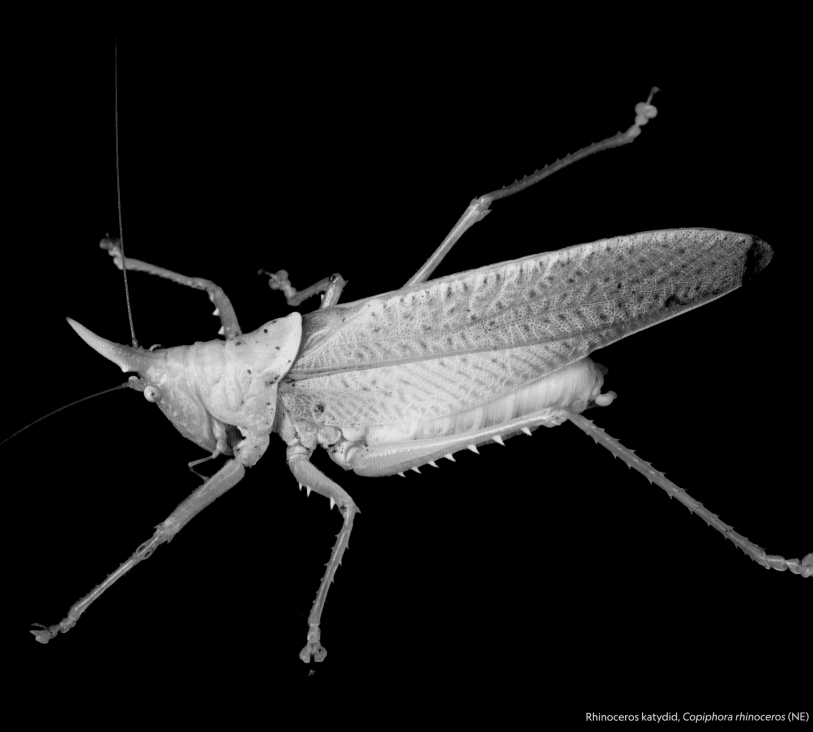

Rhinoceros katydid, *Copiphora rhinoceros* (NE)

Although most katydids are strict vegetarians, munching only
on plants, this Central American katydid uses its strong jaw to
eat animals such as tiny lizards, as well as fruits and seeds. Its
horn serves to ward off bats.

American comb duck, *Sarkidiornis sylvicola* (LC)

Only male comb ducks have the distinctive knob over their bills. The knobs grow smaller outside of the breeding season, and males also lose the golden wash over their heads.

Honeypot ant, *Myrmecocystus mexicanus* (NE)

These busy ants have developed a unique way to survive
boom-and-bust desert life: In flush times, forager ants gather
food and regurgitate it to a class of worker ants known as
repletes, which expand their abdomens to act as storage bins.

Long-spine porcupinefish, *Diodon holocanthus* (LC)

When a predator attacks, this fish gulps water or air and inflates into a perfect sphere, like a spiky balloon; even its vertebrae bend. The spines covering the fish's body are actually scales that typically lie flat.

Bristlenose plecostomus, *Ancistrus dolichopterus* (LC)

With fleshy tentacles, a suckermouth, and dermal teeth,
this small freshwater fish of Central and South America is
well suited for a life of harvesting algae, tiny animals,
and detritus from aquatic surfaces.

Attitude

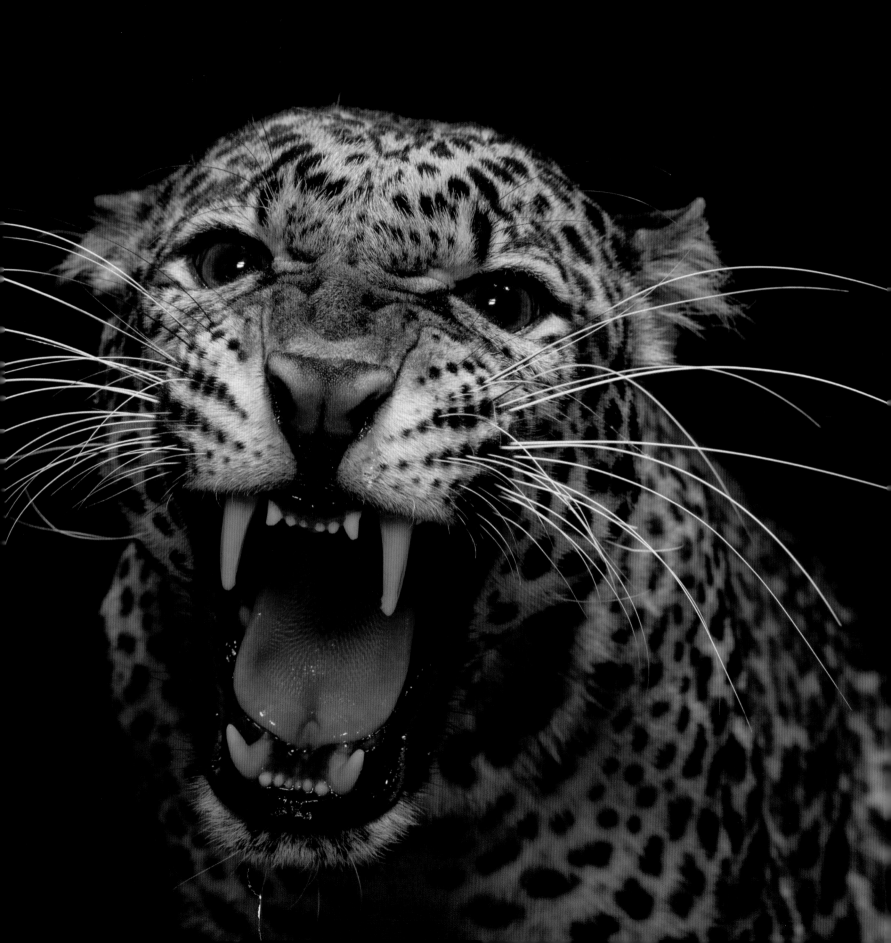

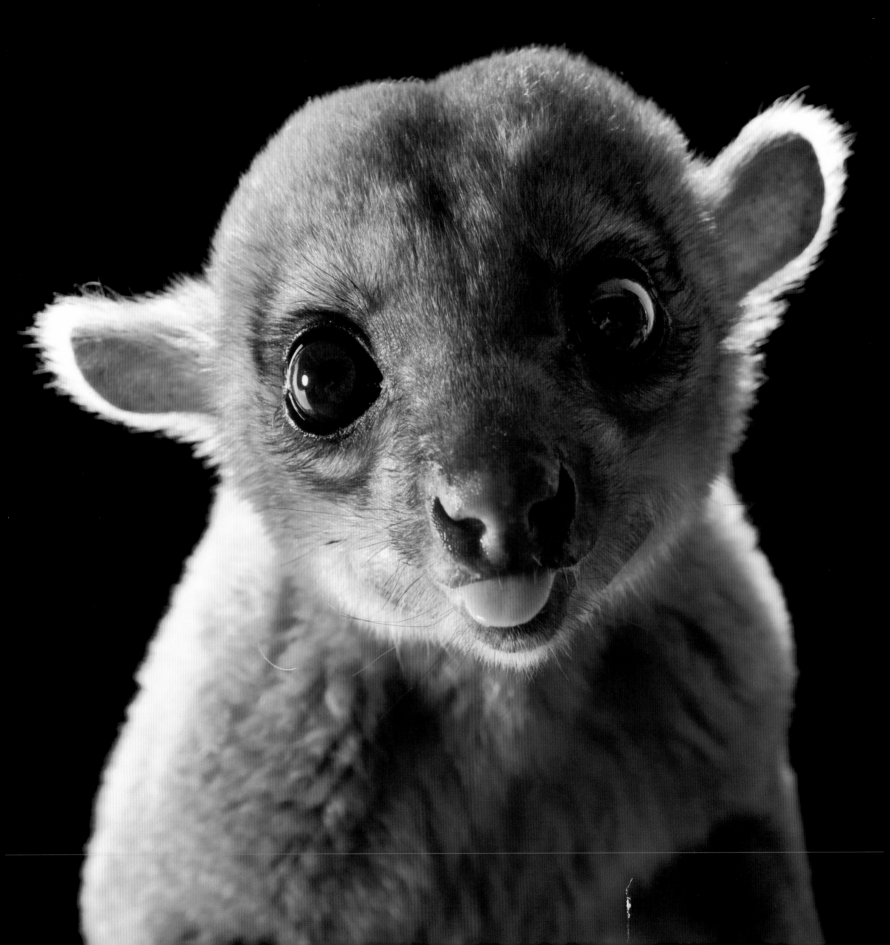

Say What?

In the halls of academia, anthropomorphizing—assigning human characteristics to other animal species—is frowned upon. For most of us, though, it's irresistible. We see ourselves in their faces, their gestures, their postures. It's part of why we love to visit zoos and wildlife centers—and a big piece of the fascination of the Photo Ark.

That short-finned pilot whale certainly seems to be smiling, broad thin lips turned up at either end. The Mohol bush baby looks shocked, eyes bugging out and tail curling round to protect it from whatever it sees coming. The barn owl's a traffic cop, the patas monkey's a heartbroken lover, the Texas alligator lizard's a party guy, the prairie dog's a nervous Nellie.

Scientists frown on these human-centered interpretations because they cloud understanding of the animals' own inclinations. To us, the macaque pulls its lips back into a toothy, smile-for-the-camera grin—but to its kind, that look might signal antagonism. The dance of a honeybee may seem a mindless zigzag—but researchers have learned over many decades of study that maps and directionals are coded in those tiny movements.

But perhaps our inclination to see ourselves in every one of the world's creatures is a way for us to recognize our connections to them all. That, after all, is the mission of the Photo Ark: to invite us to look closely at the tens of thousands of kinds of animals with whom we share the planet—and, for a moment, to become them, and to care. ▪

OPPOSITE: Kinkajou, *Potos flavus* (LC)
PREVIOUS PAGES: Javan leopard, *Panthera pardus melas* (CR)

Southern cassowary, *Casuarius casuarius* (LC)

Although cassowaries are shy fruit-eaters, they have moments of relative ferocity: Charging through the rainforest on strong legs and clawed feet, or emitting a guttural roar, the cassowary can look and sound like a modern dinosaur.

SOMETIMES CALLED THE MOST DANGEROUS BIRD IN THE WORLD, THE FLIGHTLESS SOUTHERN CASSOWARY IS FAMOUSLY

ornery

AND IS ONE OF THE FEW AVIAN SPECIES KNOWN TO HAVE KILLED FULLY GROWN MEN, ALBEIT RARELY.

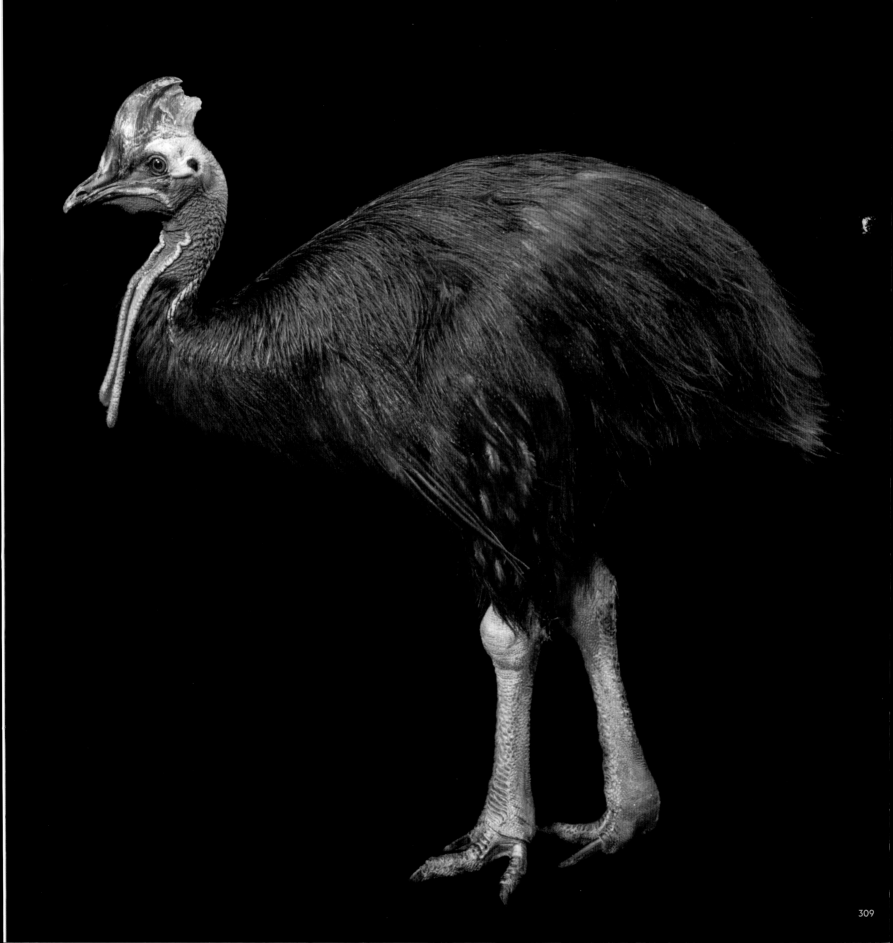

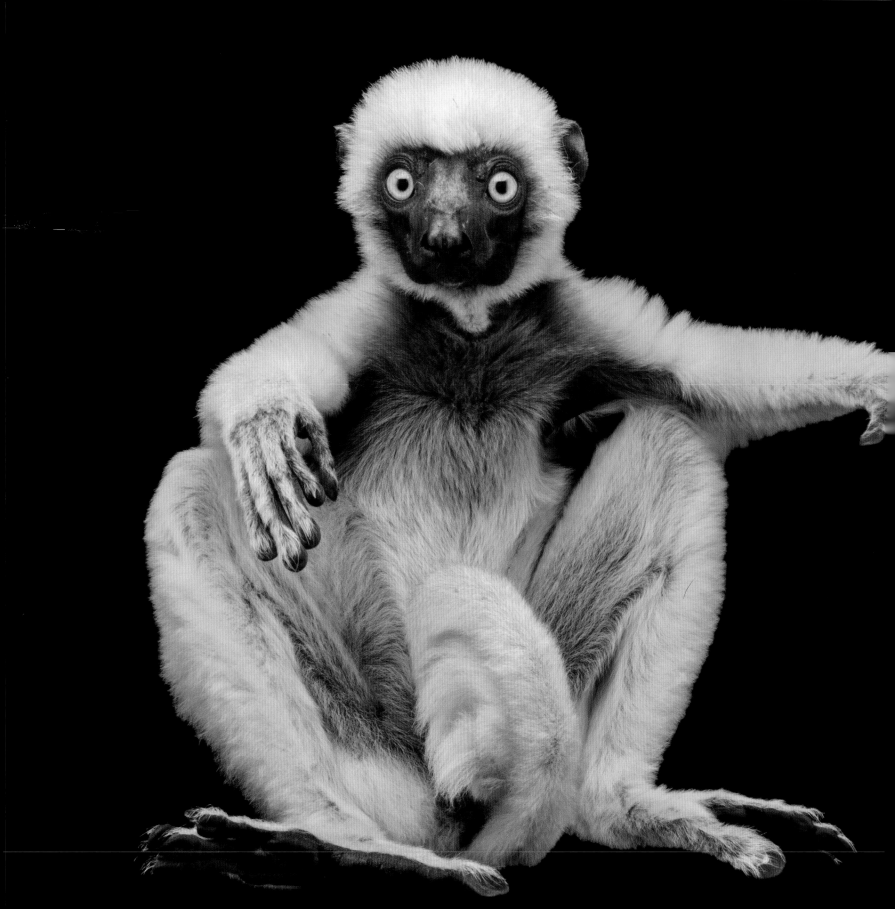

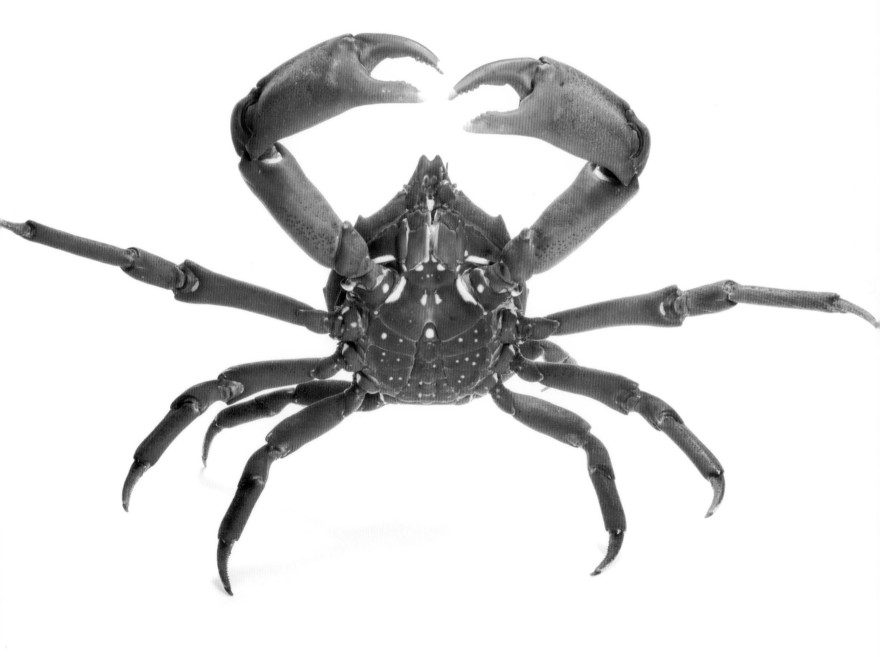

Southern kelp crab, *Taliepus nuttallii* (NE)

This crab, found in kelp forests off the coast of Southern California and the Baja California peninsula, has an olive green shell when a juvenile, which serves as an effective camouflage. Fully mature crabs are more ostentatious, ranging from deep red to almost purple in color.

Black-tailed jackrabbit, *Lepus californicus* (LC)

Flush this jackrabbit from the scrub of the southwestern United States, and it may cover 20 feet in a single leap—then take off at speeds up to 35 miles an hour. Young jackrabbits nurse for only a few weeks and are independent after a month.

Eurasian lynx, *Lynx lynx* (LC)

From western Europe to the Tibetan Plateau, this large cat is one
of the top predators in Eurasia. The sharp-sighted lynx is
believed to take its name from the mythical Lynceus of Greece,
whose eyesight was so keen he could see through the earth.

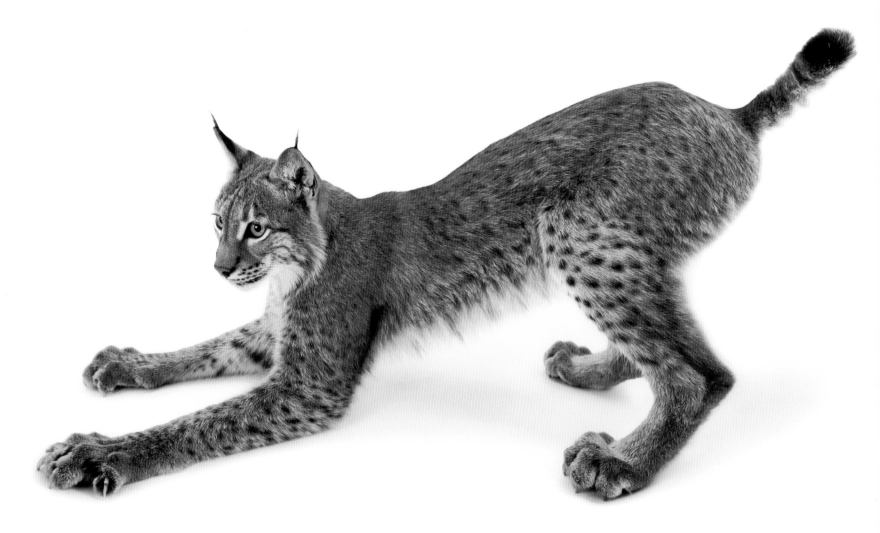

Northern pintail, *Anas acuta* (LC)

On their breeding grounds across the northern latitudes, male pintails carry out elaborate courtship rituals to attract mates. They whistle, swim with head down and tail up, preen, and pursue females in acrobatic flights.

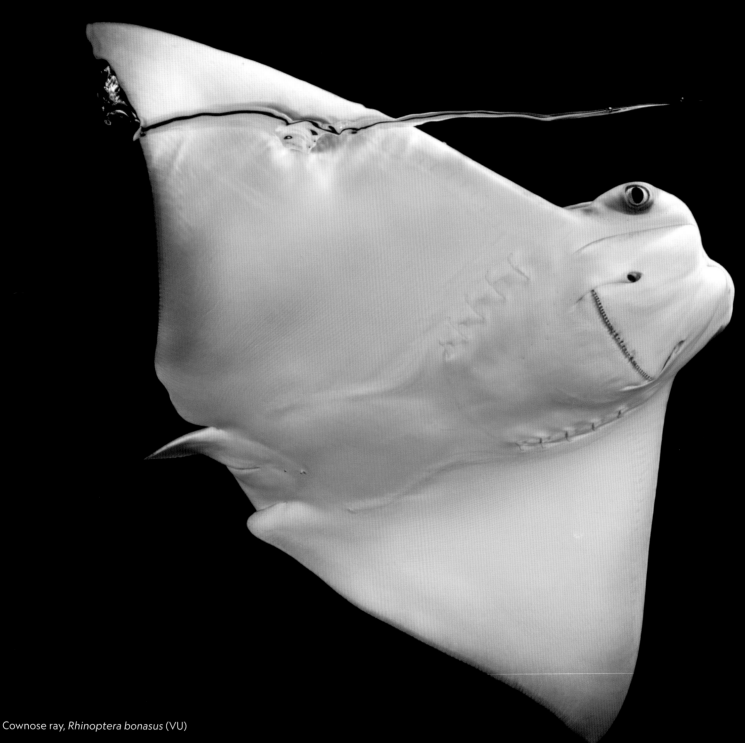

Cownose ray, *Rhinoptera bonasus* (VU)

In a dramatic territorial display, cownose rays will occasionally
jump out of the water, landing with a loud smack. They migrate
in great numbers: Every autumn, schools with thousands of rays
leave the west Atlantic, bound for Mexico's Yucatán.

Australian owlet-nightjar, *Aegotheles cristatus* (LC)

Found in open woodlands and shrublands across Australia, this nocturnal bird catches insects on the wing or sallies from its perch to snatch prey midflight. Adult birds encourage their young to fledge with a high-pitched *yuk*.

Short-finned pilot whale, *Globicephala macrorhynchus* (LC)

Female pilot whales can live more than 60 years and spend decades
birthing and rearing calves, typically only four to five in a lifetime.
They give birth every few years between the ages of nine and 40,
and then they help care for other calves in their pod.

Cooper Creek turtle, *Emydura macquarii emmotti* (NE)

This turtle lives in rivers, backwaters, and oxbows of eastern Australia. Shunning shallow water, it instead makes its home in waterways at least six feet deep. The turtle nests on land; its eggs typically hatch within two or three months.

Eastern barn owl, *Tyto alba javanica* (LC)

Barn owls' skill at finding prey by sound alone is reportedly the most accurate of any animal. They are such efficient hunters—sometimes needing only 10 or 15 minutes to catch a mouse—that they can even cache extra food.

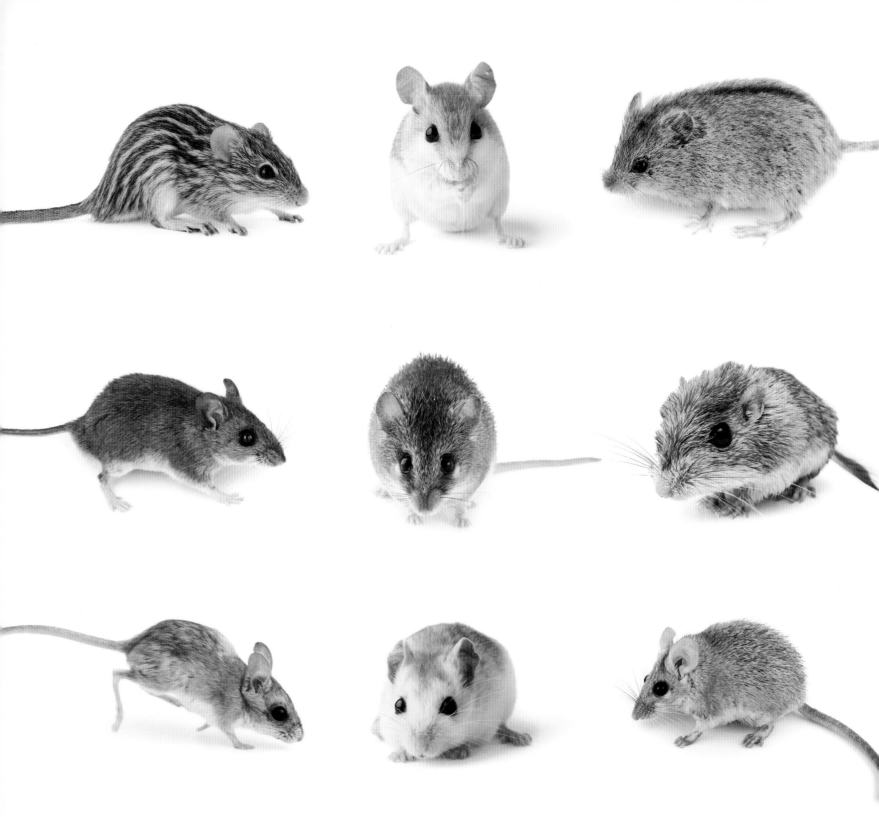

The house mouse (*Mus musculus*) is one of dozens of mouse species that scurry about forests, fields, hillsides, deserts, and houses. **TOP ROW, L TO R:** Barbary striped grass mouse, *Lemniscomys barbarus* (LC); Choctawhatchee beach mouse, *Peromyscus polionotus allophrys* (EN); Northern birch mouse, *Sicista betulina* (LC); **CENTER ROW, L TO R:** Florida cotton mouse, *Peromyscus gossypinus palmarius* (LC); South African spiny mouse, *Acomys spinosissimus* (LC); Desert pocket mouse, *Chaetodipus penicillatus* (LC); **BOTTOM ROW, L TO R:** Spinifex hopping mouse, *Notomys alexis* (LC); St. Andrew beach mouse, *Peromyscus polionotus peninsularis* (EN); Seurat's spiny mouse, *Acomys seurati* (LC)

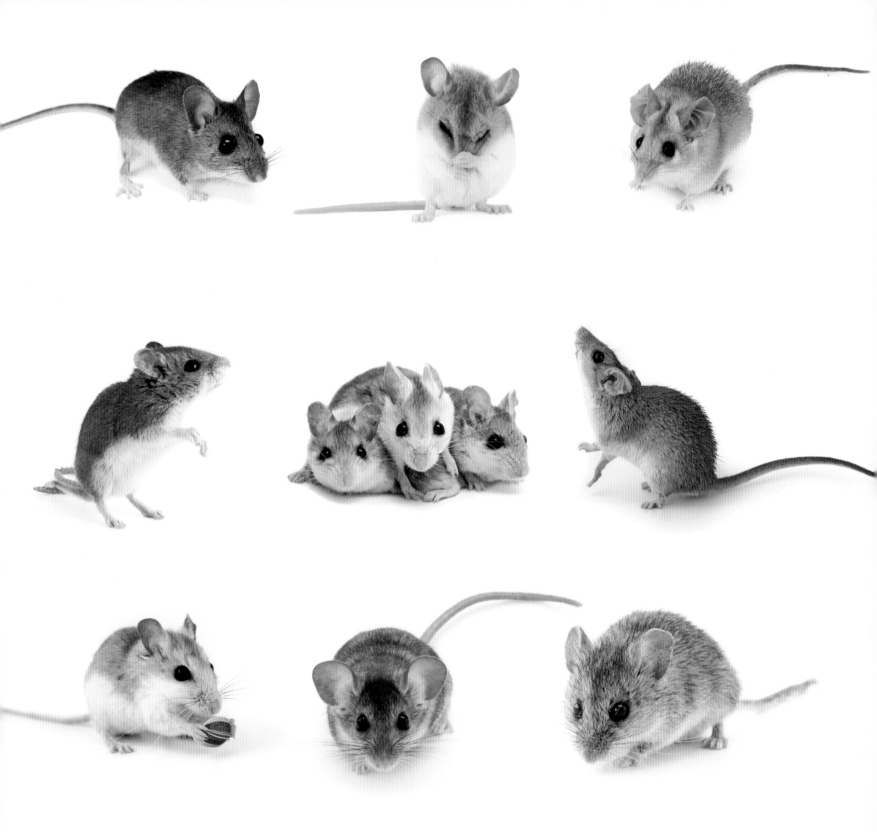

TOP ROW, L TO R: North American deer mouse, *Peromyscus maniculatus gracilis* (LC); Southeastern beach mouse, *Peromyscus polionotus niveiventris* (NT); Egyptian spiny mouse, *Acomys dimidiatus dimidiatus* (LC); **CENTER ROW, L TO R:** Northern grasshopper mouse, *Onychomys leucogaster articeps* (LC); Perdido Key beach mouse, *Peromyscus polionotus trissyllepsis* (CR); Crete spiny mouse, *Acomys minous* (DD); **BOTTOM ROW, L TO R:** Anastasia Island beach mouse, *Peromyscus polionotus phasma* (EN); Cactus mouse, *Peromyscus eremicus* (LC); Western harvest mouse, *Reithrodontomys megalotis* (LC)

Red bald-headed uakari, *Cacajao calvus rubicundus* (DD)

This monkey's fierce face belies a social nature. Uakaris are quiet, intelligent, playful primates of the upper Amazon region that live in groups numbering as many as a hundred. They feast on fruits, leaves, and insects of the tropical rainforest.

Patas monkey, *Erythrocebus patas* (NT)

Moving about in groups of up to 40 individuals—and typically just one adult male—female patas monkeys are fiery defenders of their territory and its resources. Females typically spend their lives in the same group as their mothers.

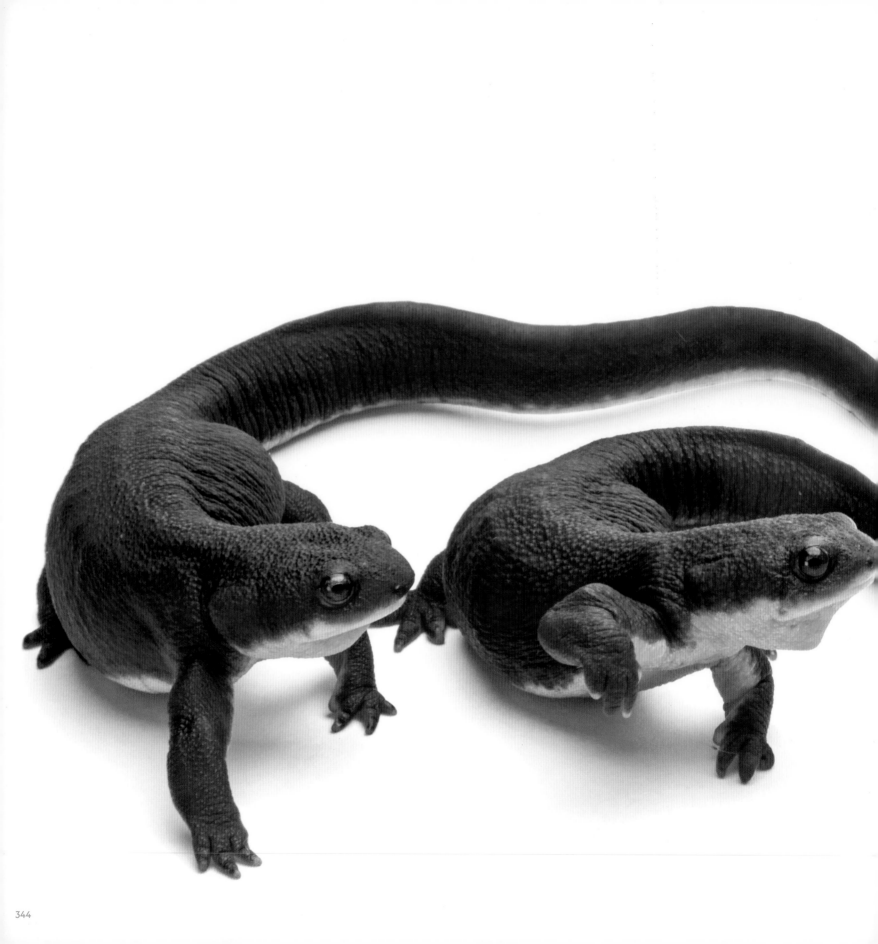

ONE OF THE WORLD'S MOST TOXIC ANIMALS, THE ROUGH-SKIN NEWT IS ALSO A

survivor.

THESE CREATURES HAVE BEEN OBSERVED CRAWLING OUT OF THE MOUTHS OF

DECEASED FROGS THAT HAD SWALLOWED THEM WHOLE MINUTES EARLIER.

Rough-skin newt, *Taricha granulosa* (LC)

Glands in this newt's skin produce a lethal toxin known as tetrodo-toxin—the same poison found in certain puffer fish, the blue-ringed octopus, and a few other animals. Only one known predator is resistant to the newt's noxious skin: the common garter snake.

Mohol bushbaby, *Galago moholi* (LC)

This tiny, nocturnal primate of southern Africa lives in small groups in wooded areas; it eats insects and the gum of acacia trees. Bushbabies communicate with loud sounds: An alarm call can result in several ganging up on a potential predator.

Flat-headed cat,
Prionailurus planiceps (EN)

This rare cat of Malaysia and Indonesia
is made for life near the water. It can
submerge its head several inches
underwater to catch fish and frogs;
close-set eyes and a strong jaw and
teeth help the cat find and grab its
slippery prey.

Pearse's mudskipper, *Periophthalmus novemradiatus* (DD)

This fish of coastal India shuttles back and forth between water
and land, often using its tail as a springboard and its pectoral fins
as feet. When the fish leaves water, it closes its gill flaps and relies
primarily on a chamber filled with air and water to breathe.

Hippopotamus, *Hippopotamus amphibius* (VU)

Hippos rest in pools by day, often submerged so only their nostrils show; they graze at night. When sparring with rivals or protecting females, males spray dung and urine, yawn, roar, and open their jaws wide to reveal sharp tusks and teeth.

Northern Luzon cloud rat, *Phloeomys pallidus* (LC)

Scientists don't know much about this elusive rodent of the Philippine island of Luzon. It dwells mainly in the upper branches of trees in lowland tropical rainforests and montane rainforests, from sea level up to the high mountains.

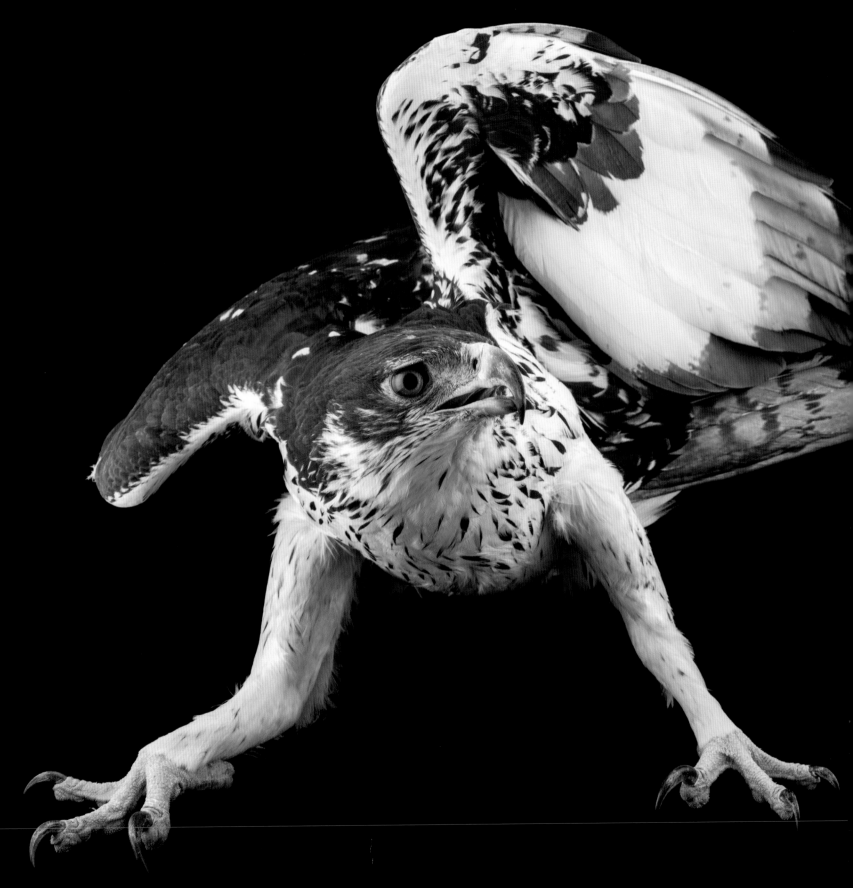

Early Warnings

I went to Zoopark Zájezd, a small zoo in Czechia (Czech Republic), to photograph an African hawk-eagle with razor-sharp curved talons. I was adjusting the cloth tent with my left hand. The bird saw my shadow, pounced, and punctured my hand through the cloth. Right away I started to bleed heavily. I washed my hand, wrapped it in paper towels, and kept going with the shoot. Later that same month, a cormorant at a wildlife rehab center in Scotland drove its beak hard into the same hand. After those back-to-back injuries, my lymph nodes swelled up. Six months later, a scan revealed one lymph node was still swollen. It turned out to be stage 1 Hodgkin's lymphoma. I'm well now, glad to say, and grateful to those birds, because they enabled us to catch the disease very early—so early that my doctors say it's unlikely to return. The Photo Ark saved my life. ∎

African hawk-eagle, *Aquila spilogaster* (LC)

This formidable sub-Saharan bird of prey is a vigorous hunter. From a high perch or a flight far above land, it will swoop down at great speed to attack large birds or mammals with razorlike talons. Pairs often hunt cooperatively.

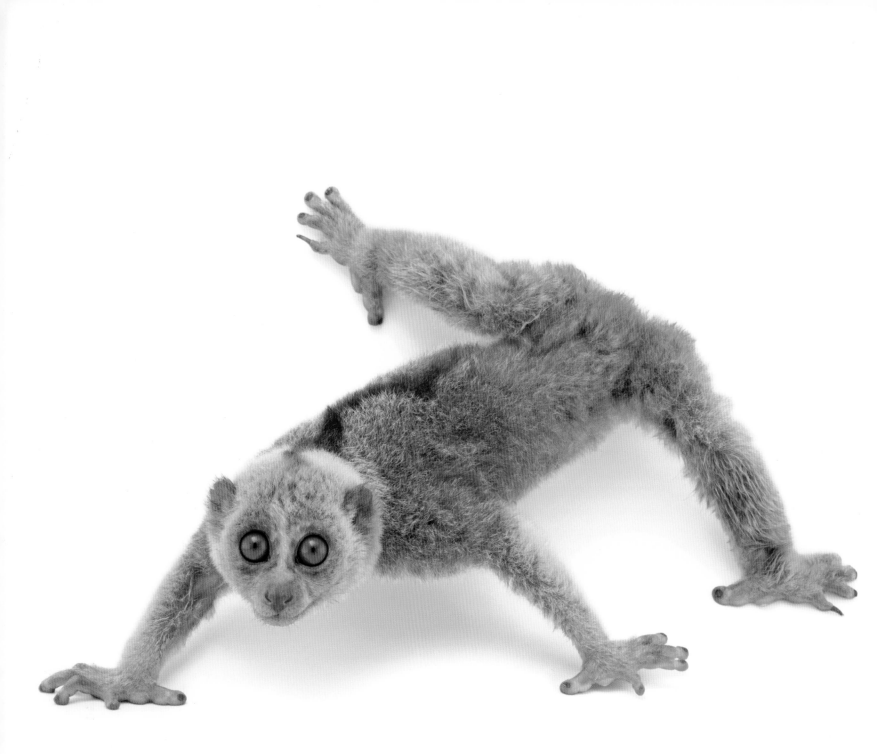

Bengal slow loris, *Nycticebus bengalensis* (EN)

Glands on the inside of a slow loris's elbows secrete venom that can cause anaphylactic shock in predators (and humans). Mothers use their tongues to coat infants in a protective layer of this venom before leaving their babies alone while they forage nearby.

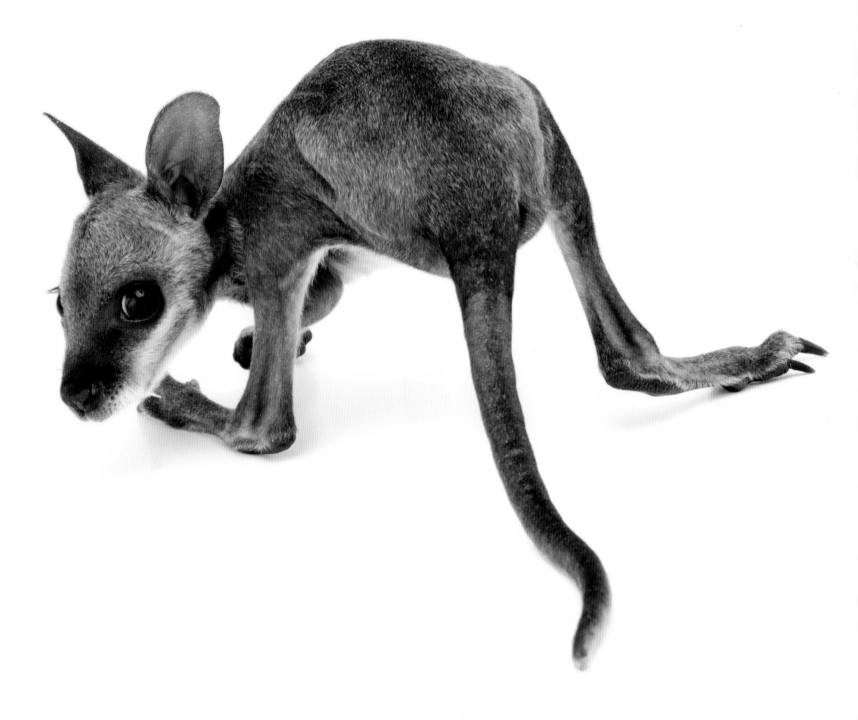

Tammar wallaby, *Notamacropus eugenii* (LC)

Wallabies live in hierarchical mobs ruled by the biggest and strongest individuals. Males vie for dominance by standing upright, flexing the muscles of their forearms, expanding their chests, and grabbing and kicking their opponents.

Cook Strait giant wetas, *Deinacrida rugosa* (LC)

The Latin name of the species, one of New Zealand's largest and rarest insects, means "wrinkled terrible grasshopper." Wetas wander the forest floor at night, munching on plants. Conservationists have worked for decades to bolster their numbers, threatened as they are by non-native mammals such as stoats and possums.

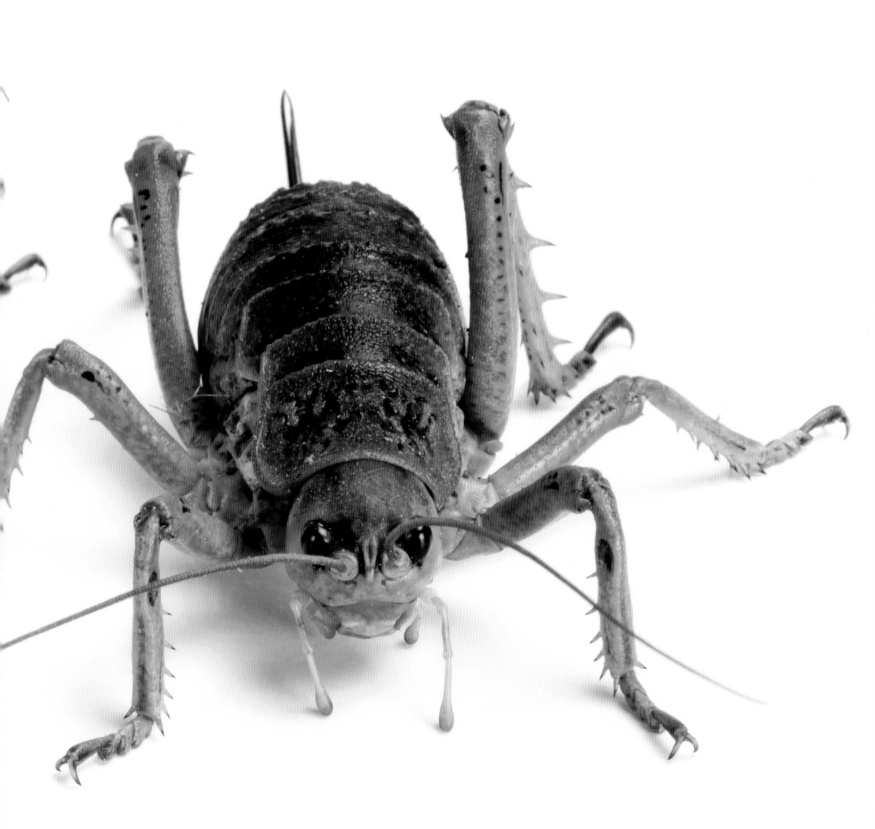

Red giant flying squirrel, *Petaurista petaurista petaurista* (LC)

Membranes like those found in bats and flying frogs extend from this Asian squirrel's wrists to its hind legs. It leaps off the highest branches of a tree and can glide nearly 500 feet, relaxing and tensing the membrane muscles to steer.

Addax, *Addax nasomaculatus* (CR)

Of all antelopes, the critically endangered addax is best adapted for desert life. Isolated herds roam the sand and stones of Niger and Chad, searching for vegetation. Addaxes rarely drink water; the plants they eat provide enough moisture.

Timber wolf, *Canis lupus* (LC)

Canis lupus was once the world's most widely distributed mammal;
gray wolves hunted in packs across much of the northern latitudes.
Today, the species' range is far more restricted, but several subspecies,
including the timber wolf, remain.

Australian sea lion, *Neophoca cinerea* (EN)

Unlike others of their kind, these sea lions are nimble on land—scientists have found them many miles inland and nearly 100 feet up a cliff. Females foster pups that are not their own, or care for a fellow female's pup while its mother forages for food.

Nashville crayfish, *Faxonius shoupi* (EN)

Making its home beneath slabs of limestone, this large crayfish lives only in the waters and tributaries of a 30-mile-long creek that runs through Nashville, Tennessee. The state is home to 90 species of crayfish.

Little Terminators

I remember once as a kid tagging along with a friend to the marsh. "We're going to catch crawdads," he said. His dad used them as bait. My friend tied a piece of meat to a string and threw it into the water. A couple minutes later, he pulled up three or four of these little gray lobsters. I'd heard about "mudbugs" from my grandmother, but these were the first I'd seen. I picked one up. I was the size of a skyscraper to this animal, and it pinched me, hard. No matter how much I flailed and waved my arms, that crayfish hung on. Later I caught some crayfish to keep in an aquarium down in the basement (where I also had a box turtle, a garter snake, and a kiddie pool with bullhead catfish). In a matter of days, only one crayfish was left. Turns out they eat one another. They're the toughest little animal I know. ■

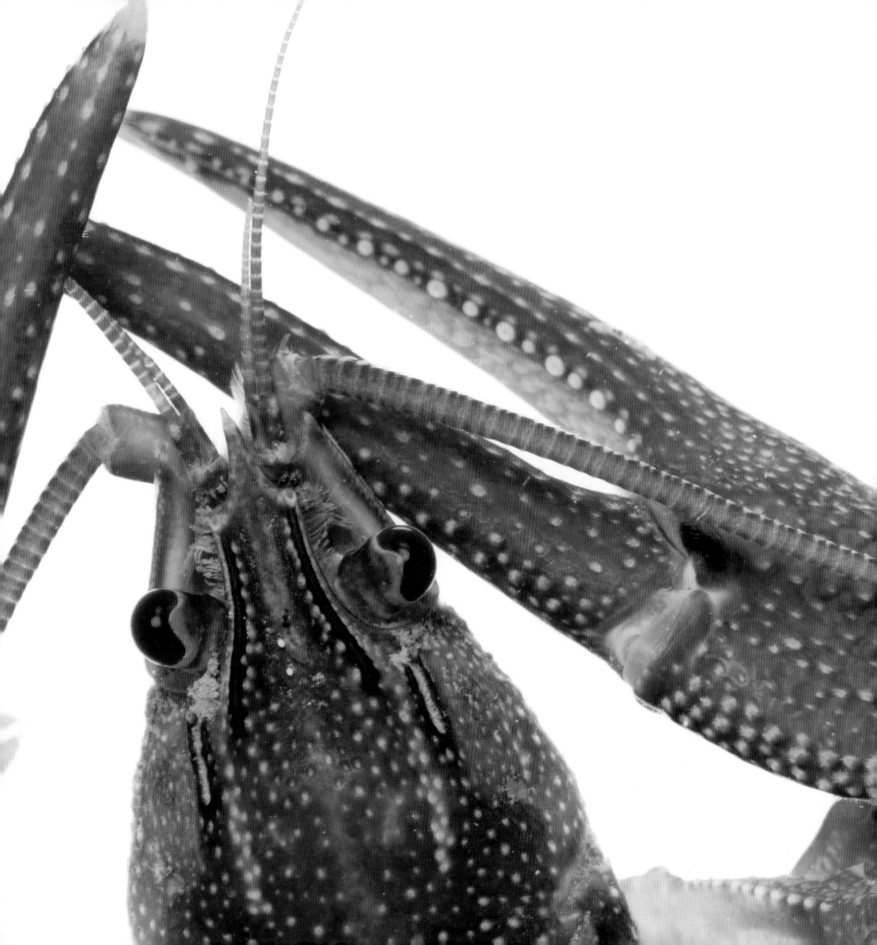

Brownbelly leaf frog, *Phyllomedusa tarsius* (LC)

This common nocturnal tree frog of the Amazon hangs out on branches above temporary ponds. Females lay a mass of hundreds of eggs on a leaf nest; tadpoles hatch and then fall directly from the nest into the water below.

Blue spiny lizard, *Sceloporus cyanogenys* (LC)

Rocky hills and scrubland of Texas and Mexico are home to this large lizard. Males have vivid blue throats and rapidly bob their heads in confrontations. Females give birth to live young; little lizards are born between February and June.

Goeldi's marmoset, *Callimico goeldii* (VU)

Leaping and climbing silently through forests of the northern Amazon in search of fungi and fruit, this small, agile monkey can turn mid-leap before grabbing onto its desired landing spot. Scientists have documented horizontal leaps of 13 feet.

Musk ox, *Ovibos moschatus moschatus* (LC)

In the bitter cold landscape of the Arctic, food can be hard to come by. Musk oxen roam the tundra in search of roots, mosses, and lichens, often using their powerful hooves to dig out a meal of frozen flora.

Texas alligator lizard, *Gerrhonotus infernalis* (LC)

The habits and behavior of this secretive reptile are still a bit of a mystery. But scientists know it lives in many habitats, including semidesert, pine forests, wooded canyons, and rocky slopes, and likely lays eggs underground.

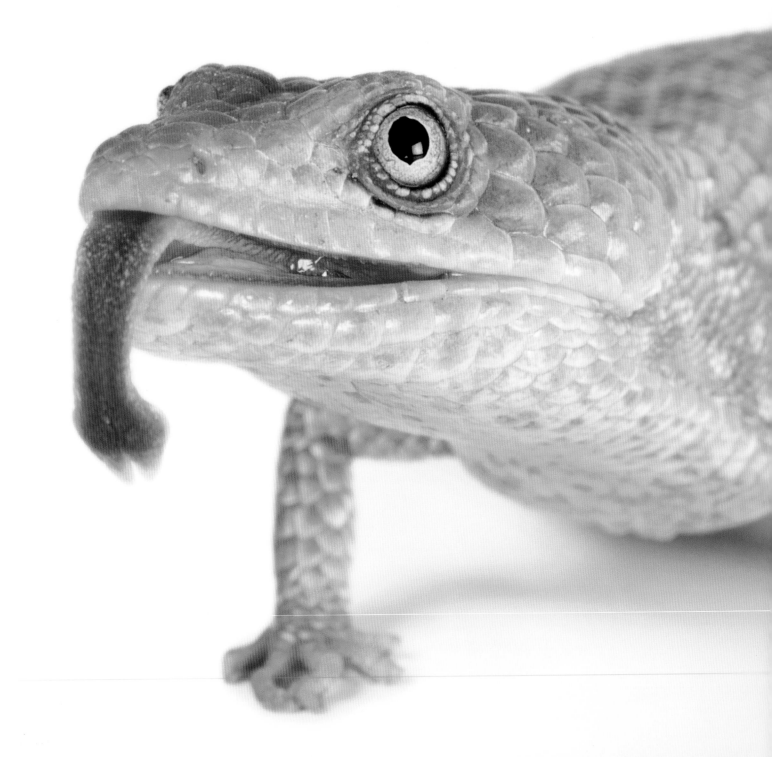

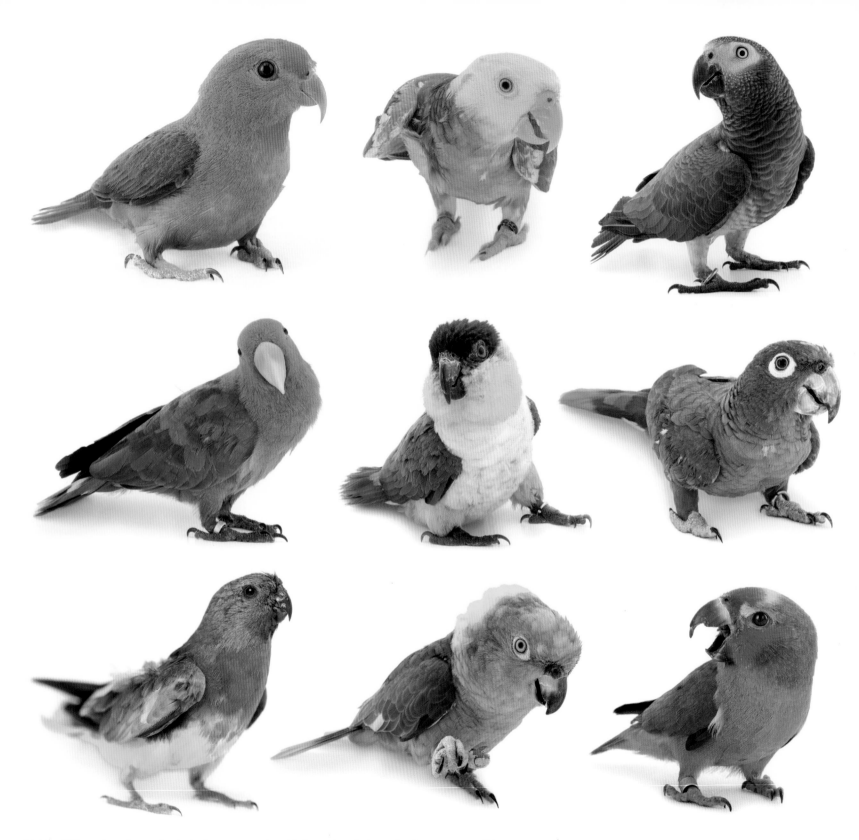

Nearly 400 species of parrots—including macaws, lovebirds, and cockatoos—live in forested habitats across the globe. Some reach 50 years old in the wild. **TOP ROW, L TO R:** Philippine hanging-parrot, *Loriculus philippensis* (LC); Yellow-headed parrot, *Amazona oratrix* (EN); Grey parrot, *Psittacus erithacus* (EN); **CENTER ROW, L TO R:** Tanimbar eclectus parrot, *Eclectus roratus riedeli* (VU); Black-headed parrot, *Pionites melanocephalus* (LC); Southern mealy amazon parrot, *Amazona farinosa* (NT); **BOTTOM ROW, L TO R:** Scarlet-chested parrot, *Neophema splendida* (LC); Yellow-naped amazon parrot, *Amazona auropalliata parvipes* (EN); Double-eyed fig parrot, *Cyclopsitta diophthalma* (LC)

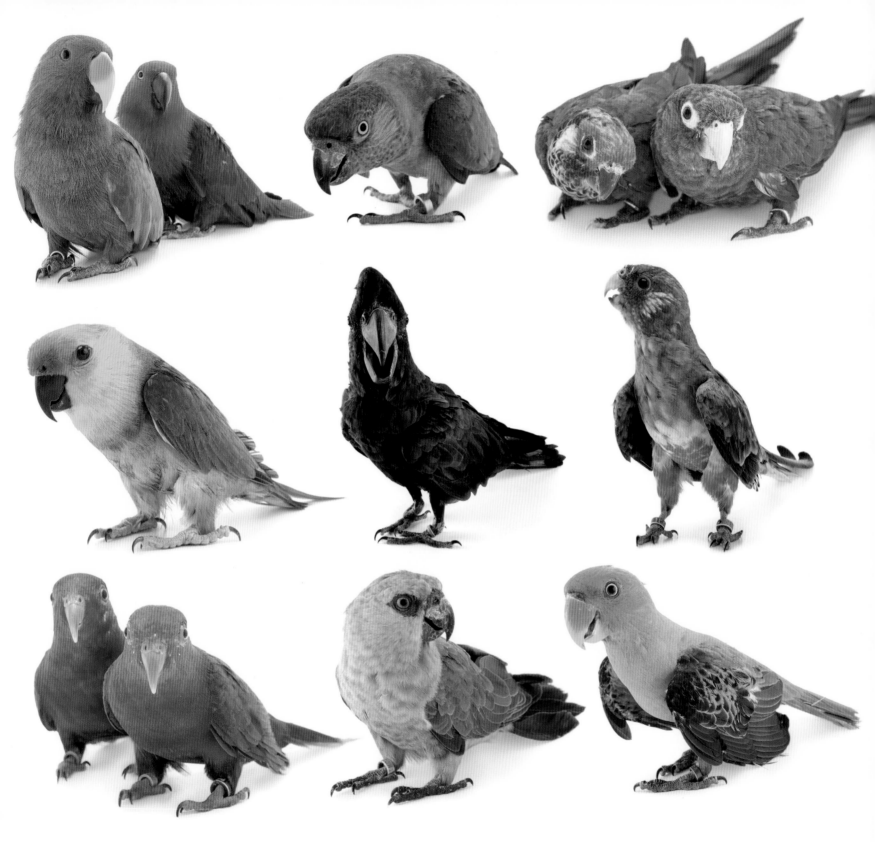

TOP ROW, L TO R: Aru Island eclectus parrot, *Eclectus roratus aruensis* (LC); Eastern Senegal parrot, *Poicephalus senegalus mesotypus* (LC); Red-crowned parakeet, *Pyrrhura roseifrons roseifrons* (LC); Hoffmann's parakeet, *Pyrrhura hoffmanni* (LC); **CENTER ROW, L TO R:** Large fig parrot, *Psittaculirostris desmarestii occidentalis* (LC);

Red-tailed black-cockatoo, *Calyptorhynchus banksii* (LC); Red-vented greater bluebonnet, *Northiella haematogaster haematorrhoa* (LC); **BOTTOM ROW, L TO R:** Josephine's lorikeets, *Charmosyna josefinae* (LC); Red-bellied parrot, *Poicephalus rufiventris* (LC); Blue-naped parrot, *Tanygnathus lucionensis salvadorii* (NT)

Spanish pond turtle, *Mauremys leprosa* (NL)

This turtle of Spain, Portugal, and northern Africa lives in fresh
and brackish rivers, swamps, and ponds. Like others of its genus,
it loves to bask in the sun. Its numbers are dwindling as pollution
and development taint its habitat.

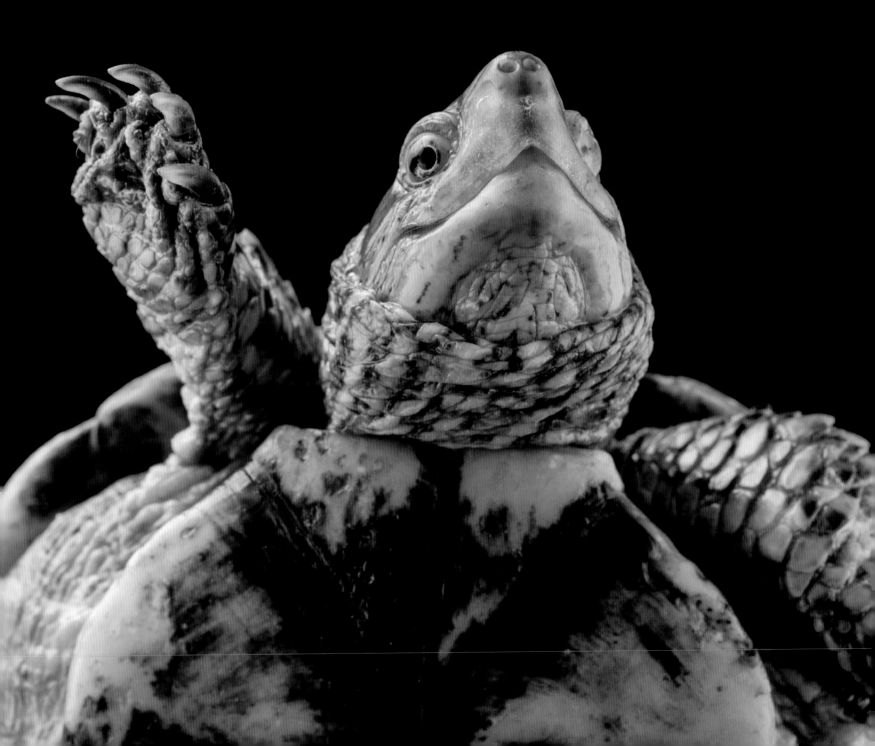

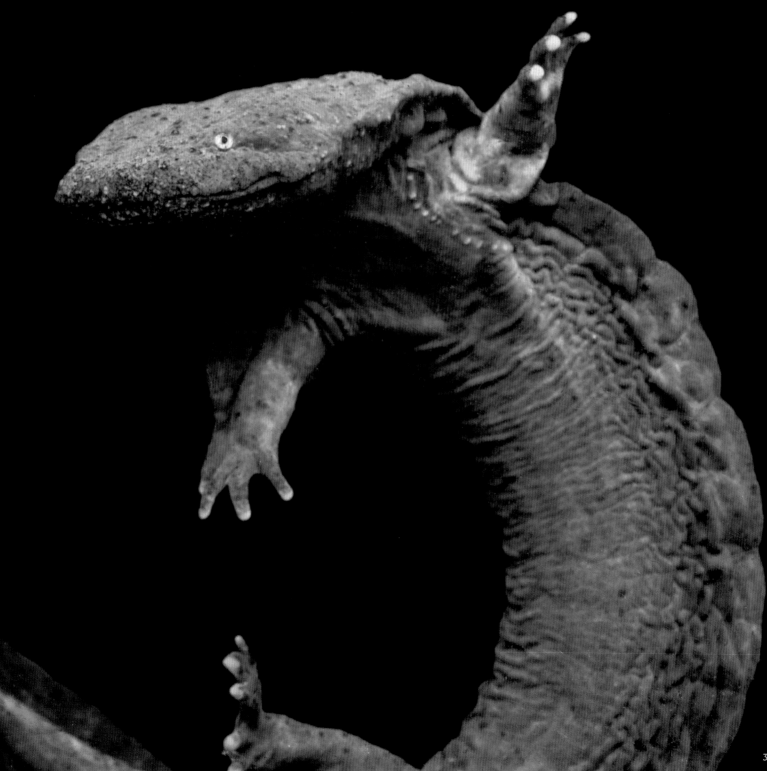

Eastern hellbender, *Cryptobranchus alleganiensis alleganiensis* (NT)

Mud cat, devil dog, lasagna lizard—North America's largest salamander is a two-foot-long amphibian of many names. Excessively slimy and nocturnal, this sub-species inhabits freshwater streams from New York to Georgia and Missouri.

PRAIRIE DOGS HAVE ONE OF THE MOST COMPLEX LANGUAGES IN THE ANIMAL KINGDOM, WITH EXPRESSIONS TO COMMUNICATE VARIOUS DANGERS TO OTHER MEMBERS OF THEIR **colony** INCLUDING DIFFERENT SOUNDS FOR HAWK, COYOTE, AND EVEN THE CONCEPT OF A TALL HUMAN IN A YELLOW SHIRT.

Black-tailed prairie dog, *Cynomys ludovicianus* (LC)

Prairie dogs are incredibly social, and their so-called towns can have hundreds of residents and many different neighborhoods. In 1902, the largest town ever documented stretched across 25,000 square miles in Texas and was home to an estimated 400 million prairie dogs.

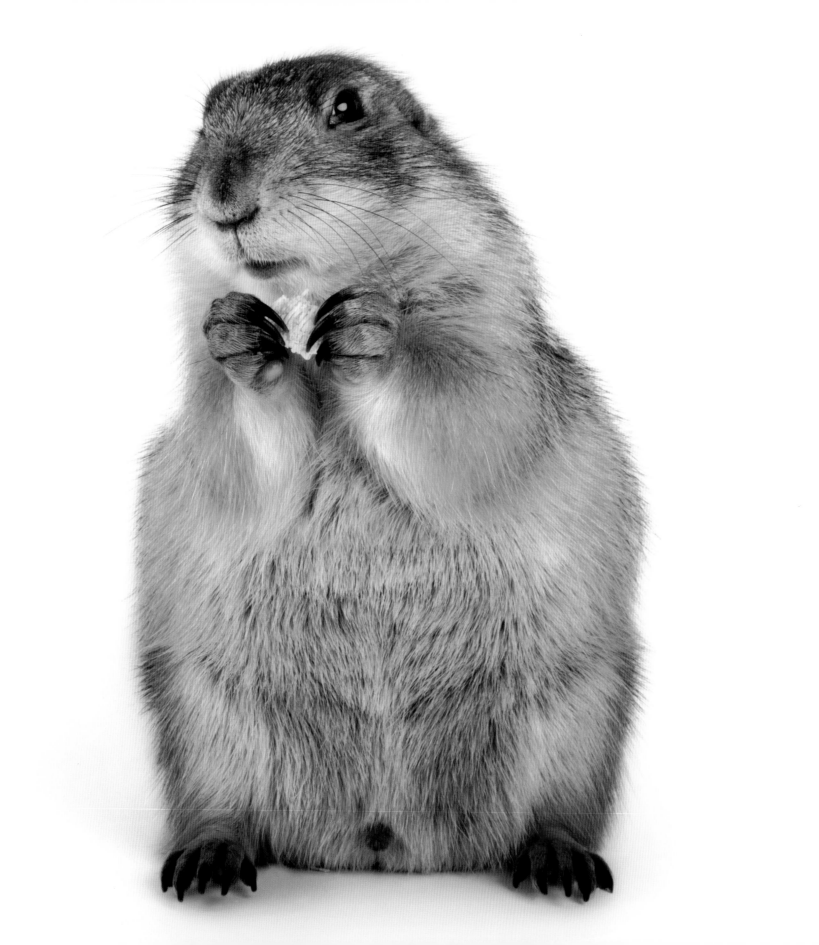

Philippine long-tailed macaque, *Macaca fascicularis philippensis* (NT)

In the mangroves and forests of the Philippines, this subspecies with a black crest and a very long tail moves about in groups, seeking fruit. More broadly, the species occurs across much of Asia, but its numbers are declining because of hunting.

Florida black bear, *Ursus americanus floridanus* (LC)

Intelligent and curious, this subspecies of the American black bear roams Florida's forests. At certain times of year, adult males travel long distances—more than a hundred miles—to search for food or mates; females devote considerable time to raising young.

Royal antelope, *Neotragus pygmaeus* (LC)

The world's smallest antelope—about the size of a hare—is native to West Africa's lowland forests. Timid, secretive, nocturnal, and seldom seen, it lives a solitary life munching on plants; much of its ecology is still unknown.

Western smooth knob-tailed gecko, *Nephrurus levis pilbarensis* (LC)

This big-eyed, thick-tailed reptile of Australia's sand plains, grasslands, and shrublands shelters in burrows by day and emerges at night to hunt insects. It belongs to a family of geckos known to make a rasping bark.

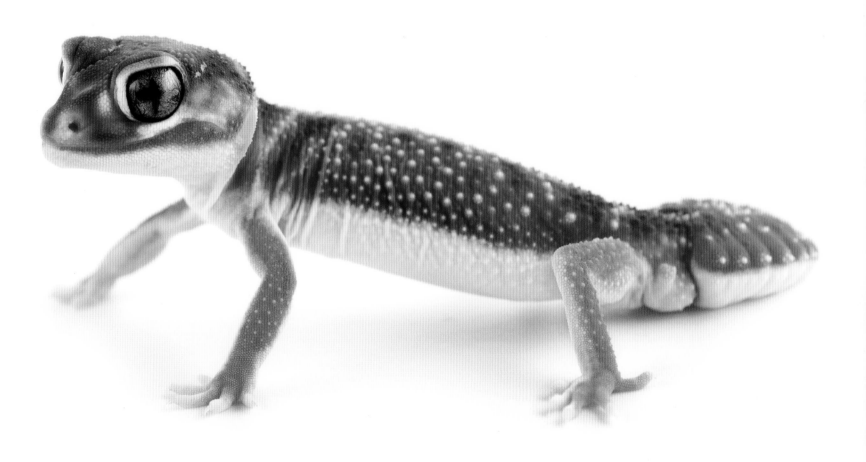

Smart & Sneaky

Early on in the Photo Ark, my son Cole and I set up for a shoot with chimpanzees by lining an enclosure with heavy paper and duct tape. When we finished, I said, "How long will this last? Sixty seconds?" Not even. The staff opened the door and a chimp stuck his arm in and ripped the setup apart in one swoop. A person could have pulled and pulled and not been able to tear this thing out, but it seems chimps have the strength of 10 men. They don't behave like any other animal. They're fast, aggressive, smart, strong, and sneaky. For me to take their picture, I have to place my camera lens through an opening in the enclosure. I can just imagine a chimp rushing at the lens, popping it, and breaking my nose. So I've given up. I've photographed tigers and wolverines, but never did get a photo I liked of an adult chimp. That's my white whale. ■

ee, *Pan troglodytes* (EN)

es have complex social lives. Strong, lifelong bonds exist
others and their young, and also among siblings. Adult
females mate more often than is necessary, suggesting
encounters strengthen their ties to one another.

| ABOUT THE PHOTO ARK |

The intersection of plants, animals, and their environment is the engine that keeps the planet healthy for all of us. But for many species, time is running out. When you remove one, it affects us all. The National Geographic Photo Ark is using the power of photography to inspire people to help save species at risk before it's too late. Photo Ark founder Joel Sartore has photographed more than 11,000 species around the world as part of a multiyear effort to document every species living in zoos and wildlife sanctuaries, to inspire action through education, and to help save wildlife by supporting on-the-ground conservation efforts.

Sartore has visited more than 40 countries in his quest to create a photo archive of global biodiversity, which will feature portraits of an estimated 20,000 species of birds, fish, mammals, reptiles, amphibians, and invertebrates. Once completed, the Photo Ark will serve as an important record of each animal's existence and a powerful testament to the importance of saving them.

Photo Ark fans are invited to learn about thousands of species and explore the Photo Ark at *natgeophotoark.org*. ■

Painted tree frog, *Boana picturata* (LC)

HOW THE PHOTOS ARE MADE

S o just how do we make these photos? We start with the animal in front of a black or white background, and in nice light. Smaller animals are usually quite easy; they're moved into a space that has black or white on the walls and underfoot. Most often, this means they go into our soft cloth shooting tents. Once inside, they see only the front of my lens. For larger, more skittish animals like zebras, rhinos, and even elephants, we install a background and may use only natural light. We seldom put anything under their feet that could scare them or cause them to slip. In those cases, we either don't photograph the animal's feet, or we later use Photoshop to darken the floor to black.

The majority of Photo Ark participants have been around people all their lives and are calm when we work with them. Still, we want the photo shoots to go as quickly as possible, so we don't stop to clean up dirt or debris they may deposit on the backgrounds. For that, we later use Photoshop and touch up the final frames. The goal is to end up with a clear, focused portrait of the animal with nothing but pure black or white around them. To eliminate all distractions. To get viewers to care. ■

Pale fox, *Vulpes pallida* (LC)

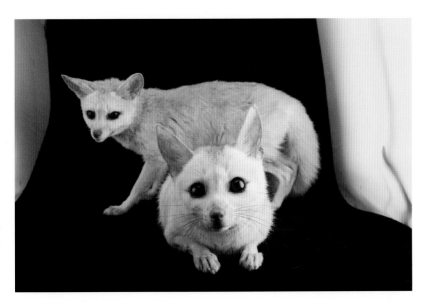

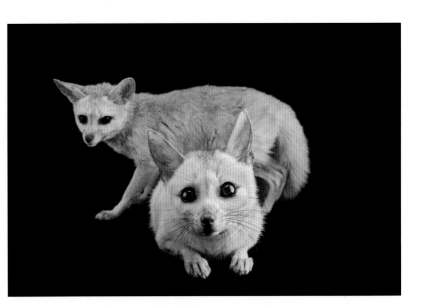

BEFORE: Our number one goal is to make photographs quickly to reduce stress on the animals. This means cleaning up the backgrounds digitally after the shoot.

AFTER: The finished product, after dirt and fur have been removed electronically

389

ABOUT THE AUTHOR

Known for his sense of humor and midwestern work ethic, Joel Sartore is a photographer, author, teacher, conservationist, National Geographic Fellow, and regular contributor to *National Geographic* magazine. He specializes in documenting endangered species and landscapes around the world. He is the founder of the Photo Ark, a 25-year documentary project to save species and habitat. In addition to the work he has done for National Geographic, Joel has contributed to *Audubon* magazine, *Sports Illustrated,* the *New York Times, Smithsonian* magazine, and numerous book projects, including three other Photo Ark books. Joel and his wife, Kathy, and their three children, Cole, Ellen, and Spencer, live in Lincoln, Nebraska.

CONTRIBUTORS

PIERRE DE CHABANNES (science consultant)

Based in France, Pierre de Chabannes is a conservation, zoology, and taxonomy adviser for the National Geographic Photo Ark, as well as other animal conservation organizations. A lecturer, author, and avid wildlife photographer, de Chabannes is also founder of an animal conservation education project called Pierre Wildlife.

LIBBY SANDER (writer)

Libby Sander is a Washington, D.C.–based journalist and a writer for National Geographic Books, where her recent projects include *Photo Ark Vanishing* and Brian Skerry's *Secrets of the Whales*. Her writing has appeared in the *New York Times,* the *Washington Post, Hakai* magazine, and other publications.

MICHELLE CASSIDY (editor)

Michelle Cassidy is a writer and editor who has worked with National Geographic, Atlas Obscura, Quartz, and more. She is based in Brooklyn, New York.

ACKNOWLEDGMENTS

From the very start, our North Star has been simple enough: Document biodiversity, engage the public, and inspire the action needed to save the planet.

Looking back across 16 years and 11,000 species, it's obvious that a legion of supporters helped every step of the way. This includes all the zoos, aquariums, wildlife rehabbers, private breeders, donors, and volunteers. There are too many to name, but they know who they are.

Then there's the team at National Geographic who continue to build the Ark right alongside me: Lindsay Anderson, Colby Bishop, Pierre de Chabannes, Melissa Farris, Susan Tyler Hitchcock, Kathryn Keane, Gary Knell, Kathy Moran, Maura Mulvihill, Jill Tiefenthaler, Mike Ulica, and Nayer Youakim, to name just a few.

And finally, there's the engine behind it all, the staff at Joel Sartore Photography, led by Rebecca Wright: Dakota Altman, Sarah Booth, Alex Crisp, Daisha Marquardt, Emilia Roberts, Keri Smith, Krista Smith, and Bryn Wells.

Together, we're doing all we can to save species and their habitats.

Now, how about you?

INDEX OF ANIMALS

Here we list, in the order they appear in the book, the common name of each species, the place where the photograph was taken and, when possible, the website of that location.

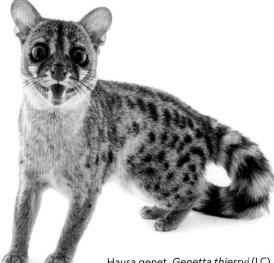

Hausa genet, *Genetta thierryi* (LC)

60–61: North Island brown kiwi, Kiwi Birdlife Park, Queenstown, New Zealand | www.kiwibird.co.nz

62: Ground beetle larva, University of Nebraska–Lincoln, Lincoln, Nebraska | www.unl.edu

63: Eastern blue-tongued skink, Lincoln Children's Zoo, Lincoln, Nebraska | www.lincolnzoo.org

64–5: Bluespotted fantail ray, Lisbon Oceanarium, Lisbon, Portugal | www.oceanario.pt

66: Luna moth, Lincoln Children's Zoo, Lincoln, Nebraska | www.lincolnzoo.org

67: Transcaspian urial, Tierpark Berlin, Berlin, Germany | www.tierpark-berlin.de

68: Mediterranean snakelocks sea anemone, Lisbon Oceanarium, Lisbon, Portugal | www.oceanario.pt

69: Golden Polish chicken, Soukup Acreage, Davey, Nebraska

70–71: Bornean rhinoceros, Kelian Sumatran Rhino Sanctuary, Borneo, Indonesia | www.savesumatranrhinos.org

72: Lelwel hartebeest, San Antonio Zoo, San Antonio, Texas | www.sazoo.org

73: Peruvian green-and-gold millipede, Miller Park Zoo, Bloomington, Indiana | www.bloomingtonparks.org/facilities/miller-park-zoo

74–5: Coconut crab, Private collection

76: Razor-backed musk turtle, Tennessee Aquarium, Chattanooga, Tennessee | www.tnaqua.org

77: Mountain tapir, Los Angeles Zoo, Los Angeles, California | www.lazoo.org

78–9: Rajah Brooke's birdwing, Malacca Butterfly and Reptile Sanctuary, Ayer Keroh, Malaysia | www.malacca.ws/attractions/butterfly-reptile.htm

80: Hasselquist's fan-footed gecko, Scaly Dave's Herp Shack, Manhattan, Kansas

81: Greater bulldog bat, Omaha's Henry Doorly Zoo and Aquarium, Omaha, Nebraska | www.omahazoo.com

82–3: Giant ibis, Angkor Centre for Conservation of Biodiversity, Kbal Spean, Cambodia | www.accb-cambodia.org

84: Wunderpus, Monterey Bay Aquarium, Monterey, California | www.montereybayaquarium.org

85: Tropical huntsman spider, Moscow Zoo, Moscow, Russia | www.moscowzoo.su

86–7: White-bellied tree pangolin, Pangolin Conservation, St. Augustine, Florida | pangolinconservation.org

88: Greater Egyptian jerboa, Plzeň Zoo, Plzeň, Czechia | www.zooplzen.cz

89: Black-sided meadow katydid, Wild caught, Denton, Nebraska

90–91: Siebenrock's snake-necked turtle, Tennessee Aquarium, Chattanooga, Tennessee | www.tnaqua.org

92: Miller's saki, Cafam Zoo,

White-collared kingfisher, *Todiramphus chloris humii* (LC)

Tolima, Colombia | www.cafam.com.co

93: Ringed seal, Alaska SeaLife Center, Seward, Alaska | www.alaskasealife.org

94: Brown sea urchin, Littoral Station of Aguda, Praia da Aguda, Portugal

94: Double-spined urchin, Semirara Marine Hatchery Laboratory, Philippines

94: Cake urchin, Aquarium Berlin, Berlin, Germany | www.aquarium-berlin.de

94: Short-spined sea urchin, Melbourne Zoo, Parkville, Australia | www.zoo.org.au

94: Slate pencil urchin, Oklahoma City Zoo, Oklahoma City, Oklahoma | www.okczoo.org

94: Variegated sea urchin, Gulf Specimen Marine Laboratories, Panacea, Florida | www.gulfspecimen.org

94: Slate pencil urchin, Aquarium of the Pacific, Long Beach, California | www.aquariumofpacific.org

94: Black sea urchin, Aquarium Berlin, Berlin, Germany | www.aquarium-berlin.de

94: Atlantic purple sea urchin, Gulf Specimen Marine Laboratories, Panacea, Florida | www.gulfspecimen.org

95: Flower urchin, Semirara Marine Hatchery Laboratory, Philippines

96–7: Indian elephant, Singapore Zoo, Singapore | www.wrs.com.sg/en/singapore-zoo

98: Giant red hermit crab, Gulf Specimen Marine Laboratories, Panacea, Florida | www.gulfspecimen.org

99: Lesser Malayan chevrotain, Singapore Zoo, Singapore | www.wrs.com.sg/en/singapore-zoo

100–101: Egyptian fruit bat, Omaha's Henry Doorly Zoo and Aquarium, Omaha, Nebraska | www.omahazoo.com

102: Tanzanian whip scorpion, Butterfly Pavilion, Westminster, Colorado | www.butterflies.org

103: Smooth sun star, Maine State Aquarium, West Boothbay Harbor, Maine | www.maine.gov/dmr/education/aquarium

104–105: Whooper swan, Sylvan Heights Bird Park, Scotland Neck, North Carolina | www.shwpark.com

106: Bolivian squirrel monkey, Rio de Janeiro Zoological Garden, Rio de Janeiro, Brazil | www.bioparquedorio.com.br

107: Golden-striped salamander, Natural History and Science Museum of the University of Porto, Porto, Portugal | www.up.pt

108–109: Violin mantis, Omaha's Henry Doorly Zoo and Aquarium, Omaha, Nebraska | www.omahazoo.com

110: Aardvark, Omaha's Henry Doorly Zoo and Aquarium, Omaha, Nebraska | www.omahazoo.com

111: Fennec fox, Denver Zoo, Denver, Colorado | www.denverzoo.org

112–13: Chestnut-eared araçari, National Aviary of Colombia, Barú, Colombia | www.aviarionacional.co

PATTERN

114–15: Vulturine guineafowl, Omaha's Henry Doorly Zoo and Aquarium, Omaha, Nebraska | www.omahazoo.com

116: West Australian seahorse, Aquarium Berlin, Berlin, Germany | www.aquarium-berlin.de

118: Sonoran desert millipede, Fort Worth Zoo, Fort Worth, Texas | www.fortworthzoo.org

119: Veiled chameleon, Private collection

120–21: Honeycomb moray, Gulf Specimen Marine Laboratories, Panacea, Florida | www.gulfspecimen.org

122: Common murre egg, University of Nebraska State Museum, Lincoln, Nebraska | www.museum.unl.edu

123: Striped hyena, Assam State Zoo and Botanical Garden, Ambikagirinagar, India | www.assamstatezoo.in

124–5: Sumatran tiger, Miller Park Zoo, Bloomington, Indiana | www.bloomingtonparks.org/facilities/miller-park-zoo

126: Western spotted skunk, Hogle Zoo, Salt Lake City, Utah | www.hoglezoo.org

126: Question mark cockroach, Budapest Zoo and Botanical Garden, Budapest, Hungary | www.zoobudapest.com

126: Carnaby's black cockatoo, Jurong Bird Park, Singapore | www.wrs.com.sg/en/jurong-bird-park.html

126: Clown knifefish, Porte Dorée Tropical Aquarium, Paris, France | www.palais-portedoree.fr/en/tropical-aquarium

126: Malayan tree nymph, Malacca Butterfly and Reptile Sanctuary, Ayer Keroh, Malaysia | www.malacca.ws/attractions/butterfly-reptile.htm

126: Frosted flatwoods salamander, Atlanta Botanical Garden, Atlanta, Georgia | www.atlantabg.org

126: Snow leopard, Miller Park Zoo, Bloomington, Illinois | millerparkzoo.org

126: Snowy owl, Raptor Conservation Alliance, Elmwood, Nebraska

126: Eastern Florida terrapin, Brevard Zoo, Melbourne, Florida | www.brevardzoo.org

127: Black-necked swan, Omaha's Henry Doorly Zoo and Aquarium, Omaha, Nebraska | www.omahazoo.com

127: Black phantom tetra, River Safari, Singapore | www.wrs.com.sg/en/river-safari

127: Black-and-white ruffed lemur, Lincoln Children's Zoo, Lincoln, Nebraska | www.lincolnzoo.org

127: Malayan krait, Sedgwick County Zoo, Wichita, Kansas | www.scz.org

127: Horntail, Wild caught, Deerwood, Minnesota

127: Black ocellaris clownfish, Omaha's Henry Doorly Zoo and Aquarium, Omaha, Nebraska | www.omahazoo.com

127: Xingu River ray, Dallas World Aquarium, Dallas, Texas | www.dwazoo.com

127: Spotted nutcracker, Plzeň Zoo, Plzeň, Czechia | www.zooplzen.cz

127: Rusty-spotted genet, Miller Park Zoo, Bloomington, Indiana | www.bloomingtonparks.org/facilities/miller-park-zoo

128–9: Paradise tanager, Zoo Berlin, Berlin, Germany | www.zoo-berlin.de

130: Gran Canaria skink, Plzeň Zoo, Plzeň, Czechia | www.zooplzen.cz

131: Blue discus, Dallas World Aquarium, Dallas,

Texas I www.dwazoo.com

132-3: Chain catshark, Omaha's Henry Doorly Zoo and Aquarium, Omaha, Nebraska I www.omahazoo.com

134: Chital, Kamla Nehru Zoological Garden, Kankaria, India I www.ahmedabadzoo.in

135: Marbled lungfish, Moscow Zoo, Moscow, Russia I www.moscowzoo.su

136-7: Dog-day cicada, Wild caught, Bioko Island, Equatorial Guinea

138: Striped Raphael catfish, Auburn University Fish Biodiversity Lab, Auburn, Alabama I www.auburn.edu

139: Typical striped grass mouse, Plzeň Zoo, Plzeň, Czechia I www.zooplzen.cz

140-41: Banded Gila monster, Woodland Park Zoo, Seattle, Washington I www.zoo.org

142: Green tree python, Riverside Discovery Center, Scottsbluff, Nebraska I www.riversidediscoverycenter.org

143: Red-eyed tree frog, Sunset Zoo, Manhattan, Kansas I www.sunsetzoo.com

144-5: Red-crested turaco, Tracy Aviary, Salt Lake City, Utah I www.tracyaviary.org

146-7: Fried egg jellyfish, Loro Parque Foundation, Tenerife, Spain I www.loroparque-fundacion.org

148: Steller's eider, Alaska SeaLife Center, Seward, Alaska I www.alaskasealife.org

149: Okapi, White Oak Conservation Center, Yulee, Florida I www.whiteoakwildlife.org

150-51: Candy-striped leafhopper, Wild caught, Walton, Nebraska

152-3: Daum's reef lobster, Pure Aquariums, Lincoln, Nebraska

154: Amazon leaffish, Porte Dorée Tropical Aquarium, Paris, France I www.palais-portedoree.fr/en/tropical-aquarium

155: Leaf katydid, Las Gralarias Reserve, Mindo, Ecuador I www.reservalasgralarias.com

156-7: Banded linsang, Taman Safari Indonesia, Bogor, Indonesia I www.tamansafari.com

158: Meso-American slider, Chapultepec Zoo, Mexico City, Mexico

159: Lady Amherst's pheasant, Gladys Porter Zoo, Brownsville, Texas I www.gpz.org

160-61: Libyan striped weasel, Plzeň Zoo, Plzeň, Czechia I www.zooplzen.cz

162: Grapevine looper, Wild caught, Lincoln, Nebraska

162: False crocus geometer moth, Wild caught, Valparaiso, Nebraska

162: Whitney's underwing moth, Wild caught, Deerwood, Minnesota

162: Yellow slant-line, Wild caught, Deerwood, Minnesota

162: Virginia creeper sphinx, Wild caught, Deerwood, Minnesota

162: Horned spanworm moth, Wild caught, Deerwood, Minnesota

162: Ultronia underwing, Wild caught, Lincoln, Nebraska

162: LeConte's haploa moth, Wild caught, Deerwood, Minnesota

162: Orange-barred carpet moth, Wild caught, Deerwood, Minnesota

163: Nais tiger moth, Wild caught, Lakeside, Nebraska

163: Window-winged saturnian moth, Wild caught, Mindo, Ecuador

163: Laurel sphinx moth, Wild caught, Deerwood, Minnesota

163: Pink underwing moth, Wild caught, Deerwood, Minnesota

163: Giant leopard moth, Wild caught, Deerwood, Minnesota

163: Green leuconycta moth, Wild caught, Deerwood, Minnesota

163: Wavy-lined emerald moth, Wild caught, Deerwood, Minnesota

163: Cecropia moth, Wild caught, Lincoln. Nebraska

163: Beggar moth, Wild caught, Deerwood, Minnesota

164: Southern three-banded armadillo, Lincoln Children's Zoo, Lincoln, Nebraska I www.lincolnzoo.org

165: Chambered nautilus, Monterey Bay Aquarium, Monterey, California I www.montereybayaquarium.org

166-7: Sira poison frog, Private collection

168: Clown triggerfish, Pure Aquariums, Lincoln, Nebraska

169: Green-backed twinspot, Zoo Berlin, Berlin, Germany I www.zoo-berlin.de

170: Blue speckled tree monitor, Gladys Porter Zoo, Brownsville, Texas I www.gpz.org

171: Yellow tree monitor, Fort Worth Zoo, Fort Worth, Texas I www.fortworthzoo.org

172-3: Chapman's zebra, Wrocław Zoo, Wrocław, Poland I www.zoo.wroclaw.pl

174: Indian rock python, Cleveland Metroparks Zoo, Cleveland, Ohio I www.clevelandmetroparks.com/zoo

175: Western mud snake, Oklahoma City Zoo, Oklahoma City, Oklahoma I www.okczoo.org

176-7: Western tragopan, Himalayan Nature Park, Kufri, India

178: Queen angelfish, Pure Aquariums, Lincoln, Nebraska

179: Conspicuous angelfish, Dallas World Aquarium, Dallas, Texas I www.dwazoo.com

180-81: Bird poop frog, Saint Louis Zoo, St. Louis, Missouri I www.stlzoo.org

182: Derby's flower beetle, Saint Louis Zoo, St. Louis, Missouri I www.stlzoo.org

182: Flamboyant flower beetle, Saint Louis Zoo, St. Louis, Missouri I www.stlzoo.org

182: *Protaetia speciosa cyanochlora,* Aquarium Berlin, Berlin, Germany I www.aquarium-berlin.de

182: Giant flower beetle, Houston Zoo, Houston, Texas I www.houstonzoo.org

182: Harlequin flower beetle, Houston Zoo, Houston, Texas I www.houstonzoo.org

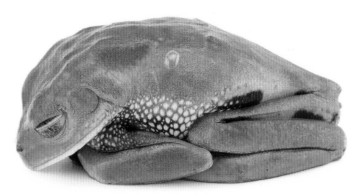

Ecuadorian monkey frog, *Callimedusa ecuatoriana* (VU)

182: Ugandan giant flower beetle, Budapest Zoo and Botanical Garden, Budapest, Hungary I www.zoobudapest.com

182: *Jumnos ruckeri,* Budapest Zoo and Botanical Garden, Budapest, Hungary I www.zoobudapest.com

182: Polyphemus beetle, Budapest Zoo and Botanical Garden, Budapest, Hungary I www.zoobudapest.com

183: *Pachnoda trimaculata,* Moscow Zoo, Moscow, Russia I www.moscowzoo.su

184-5: Panther chameleon, Dallas World Aquarium, Dallas, Texas I www.dwazoo.com

186-7: Painted wood turtle, Tennessee Aquarium, Chattanooga, Tennessee I www.tnaqua.org

188-9: Red-and-green macaw, World Bird Sanctuary, Valley Park, Missouri I www.worldbirdsanctuary.org

190-91: Butterfly splitfin, Downtown Aquarium, Denver, Colorado I www.aquariumrestaurants.com/downtown aquariumdenver

192: Brongersma's short-tailed python, Omaha's Henry Doorly Zoo and Aquarium, Omaha, Nebraska I www.omahazoo.com

193: Ailanthus webworm moth, Wild caught, Lincoln, Nebraska

194-5: Yellow-edged giant owl butterfly, Omaha's Henry Doorly Zoo and Aquarium, Omaha, Nebraska I www.omahazoo.com

196: Striped burrfish, Virginia Aquarium, Virginia Beach, Virginia I www.virginiaaquarium.com

197: Common sand star, Aquarium Berlin, Berlin, Germany I www.aquarium-berlin.de

198-9: Spotted-tailed quoll, Moonlit Sanctuary Wildlife Park, Pearcedale, Australia I www.moonlitsanctuary.com.au

200: Gelada, Parco Natura Viva, Bussolengo, Italy I www.parconaturaviva.it

201: Negros bleeding-heart, Talarak Foundation, Negros Island, Philippines I www.talarak.org

202-203: Western tiger salamander, Oklahoma City Zoo, Oklahoma City, Oklahoma I www.okczoo.org

204: Fire bug, Quinta dos Malvedos Vineyard, Castedo, Portugal I www.grahams-port.com

205: Ornate titi, Piscilago Zoo, Piscilago, Colombia

206: Cobalt blue tarantula, Butterfly Pavilion, Westminster, Colorado I www.butterflies.org

207: Dyeing poison frog, Rolling Hills Zoo, Salina, Kansas I www.rollinghillszoo.org

208-209: Oriental whip snake, Singapore Zoo, Singapore I www.wrs.com.sg/en/singapore-zoo

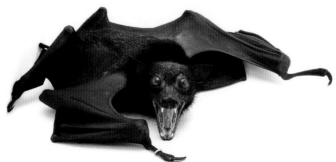

Giant Malay fruit bat, *Pteropus vampyrus lanensis* (NT)

EXTRA

210–11: Bearded emperor tamarin, Plzeň Zoo, Plzeň, Czechia | www.zooplzen.cz

212: Australian sea apple, Dallas World Aquarium, Dallas, Texas | www.dwazoo.com

214: Palm cockatoo, Bali Bird Park, Bali, Indonesia | www.balibirdpark.com

215: Woodland caribou, Zoo New York, Watertown, New York | www.zoonewyork.org

216–17: Giant day gecko, Private collection

218: Western long-beaked echidna, Batu Secret Zoo, Batu, Indonesia | www.jtp.id/batusecretzoo

219: Acorn weevil, Wild caught, Waubonsie State Park, Iowa

220–21: Gharial, Kukrail Gharial and Turtle Rehabilitation Centre, Lucknow, India

222–3: Great horned owl, Raptor Conservation Alliance, Lincoln, Nebraska

224: Spiny turtle, Zoo Atlanta, Atlanta, Georgia | www.zooatlanta.org

225: Spiny-backed orb weaver, University of the Philippines, Philippines | www.up.edu.ph

226: Blue eared-pheasant, Tierpark Berlin, Berlin, Germany | www.tierpark-berlin.de

227: Texas blind salamander, Detroit Zoo, Royal Oak, Michigan | www.detroitzoo.org

228: Walking stick, Plzeň Zoo, Plzeň, Czechia | www.zooplzen.cz

228: Arizona walking stick, Phoenix Zoo, Phoenix, Arizona | www.phoenixzoo.org

228: Malagasy blue stick insect, ABQ BioPark Zoo, Albuquerque, New Mexico | www.cabq.gov/arts culture/biopark/zoo

229: Stick insect, University of the Philippines, Philippines | www.up.edu.ph

229: Jejunus stick insect, Moscow Zoo, Moscow, Russia | www.moscowzoo.su

229: Thorny walking stick, Exmoor Zoo, Barnstaple, United Kingdom | www.exmoorzoo.co.uk

230: Guereza, Lisbon Zoo, Lisbon, Portugal | www.zoo.pt

231: Barbary sheep, Dallas Zoo, Dallas, Texas | www.dallaszoo.com

232–3: Surinam horned frog, Riverbanks Zoo and Garden, Columbia, South Carolina | www.riverbanks.org

234: Tiger clearwing butterfly chrysalis, Audubon Nature Institute, New Orleans, Louisiana | www.audubonnatureinstitute.org

235: Western diamondback rattlesnake, Reptile Gardens, Rapid City, South Dakota | www.reptilegardens.com

236: Pale giant squirrel, Private collection

237: Hawaiian monk seal, Minnesota Zoo, Apple Valley, Minnesota | www.mnzoo.org

238–9: Dung beetle, Wild caught, Cameroon

240: Michie's tufted deer, Tierpark Berlin, Berlin, Germany | www.tierpark-berlin.de

241: Mindanao warty pig, Davao Crocodile Park, Davao City, Philippines | www.crocodilepark.ph

242–3: Sumatran orangutan, Rolling Hills Zoo, Salina, Kansas | www.rollinghillszoo.org

244: Yellow catfish, Zoo Negara, Ulu Klang, Malaysia | www.zoonegaramalaysia.my

244: Three-stripe corydoras, Pure Aquariums, Lincoln, Nebraska

244: Snowball pleco, Manaus Zoo, Manaus, Brazil

244: Clown squeaker, Moscow Zoo, Moscow, Russia | www.moscowzoo.su

244: Silver catfish, Porte Dorée Tropical Aquarium, Paris, France | www.palais-portedoree.fr/en/tropical-aquarium

244: Günther's catfish, Zoo Negara, Ulu Klang, Malaysia | www.zoonegaramalaysia.my

244: Black catfish, Templestowe College, Templestowe, Australia | www.tc.vic.edu.au

244: Giant pangasius, Tennessee Aquarium, Chattanooga, Tennessee | www.tnaqua.org

244: Leopard frog pleco, Private collection

245: Black bullhead, Gavins Point National Fish Hatchery and Aquarium, Yankton, South Dakota | www.fws.gov/mountain-prairie/fisheries/gavinsPoint.php

245: Blue salmon catfish, Templestowe College, Templestowe, Australia | www.tc.vic.edu.au

245: Spoon-head catfish, Dallas World Aquarium, Dallas, Texas | www.dwazoo.com

245: Yaqui catfish, Arizona-Sonora Desert Museum, Tucson, Arizona | www.desertmuseum.org

245: Striped Raphael catfish, Jurong Bird Park, Singapore | www.wrs.com.sg/en/jurong-bird-park.html

245: Sterba's corydoras, Private collection

245: Brown bullhead, Buttonwood Park Zoo, New Bedford, Massachusetts | www.bpzoo.org

246: Whiskered auklet, Cincinnati Zoo, Cincinnati, Ohio | www.cincinnatizoo.org

247: Eastern whip-poor-will, Iowa Bird Rehabilitation, Des Moines, Iowa | www.iowabirdrehab.org

248–9: Brazilian porcupine, Saint Louis Zoo, St. Louis, Missouri | www.stlzoo.org

250: Largescale four-eyed fish, Oklahoma City Zoo, Oklahoma City, Oklahoma | www.okczoo.org

251: Belitung Island tarsier, Private collection

252–3: Asian grass lizard, Private collection

254: Decorator crab, Gulf Specimen Marine Laboratories, Panacea, Florida | www.gulfspecimen.org

255: Brazilian jewel tarantula, Dallas Zoo, Dallas, Texas | www.dallaszoo.com

256: Bornean peacock-pheasant, Private collection

257: Eastern aardwolf, Cincinnati Zoo, Cincinnati, Ohio | www.cincinnatizoo.org

258–9: Electric eel, Oklahoma Aquarium, Jenks, Oklahoma | www.okaquarium.org

260: Rough-throated leaf-tail gecko, Lilydale High School, Lilydale, Australia | www.lilydalehs.vic.edu.au

261: Mata mata turtle, Zoo Atlanta, Atlanta, Georgia | www.zooatlanta.org

262–3: Platypus, Healesville Sanctuary, Healesville, Australia | www.zoo.org.au/healesville

264: White-belted ruffed lemur, Plzeň Zoo, Plzeň, Czechia | www.zooplzen.cz

265: Himalayan tahr, Wildlife Reserves Singapore, Singapore | www.wrs.com.sg

266–7: Spiny tailed fairy shrimp, Alabama Aquatic Biodiversity Center, Marion, Alabama | www.outdoor alabama.com

268: Tasselled anglerfish, Dallas World Aquarium, Dallas, Texas | www.dwazoo.com

269: Leafy seadragon, Dallas World Aquarium, Dallas, Texas | www.dwazoo.com

270–71: Helmeted hornbill, Penang Bird Park, Perai, Malaysia | www.penangbirdpark.com.my

272: Caracal, Columbus Zoo, Powell, Ohio | www.columbuszoo.org

273: Brown long-eared bat, Moscow Zoo, Moscow, Russia | www.moscowzoo.su

274–5: Jackson's three-horned chameleon, Miller Park Zoo, Bloomington, Illinois | millerparkzoo.org

276: Ridged slipper lobster, Children's Aquarium at Fair Park, Dallas, Texas | www.dallasparks.org

277: Devil's flower mantis, Omaha's Henry Doorly Zoo and Aquarium, Omaha, Nebraska | www.omahazoo.com

278–9: Higgins eye pearly mussel, Genoa National Fish Hatchery, Genoa, Wisconsin | www.fws.gov/midwest/genoa

280: Ornate hawk-eagle, Sia: The Comanche Nation Ethno-Ornithological Initiative, Cyril, Oklahoma | www.comancheeagle.org

281: Black mangabey, Chattanooga Zoo, Chattanooga, Tennessee | www.chattzoo.org

282: Buck moth caterpillar, Audubon Nature Institute, New Orleans, Louisiana | www.audubonnatureinstitute.org

282: Gulf fritillary butterfly caterpillar, Audubon Nature Institute, New Orleans, Louisiana | www.audubonnatureinstitute.org

282: Saddleback moth caterpillar, Audubon Nature Institute, New Orleans, Louisiana | www.audubonnatureinstitute.org

282: African giant skipper, Wild caught, Bioko Island, Equatorial Guinea

282: Silkworm, Saint Louis Zoo, St. Louis, Missouri | www.stlzoo.org

282: Cairns birdwing caterpillar, Melbourne Zoo, Parkville, Australia | www.zoo.org.au

282: Cruiser butterfly caterpillar, Melbourne Zoo, Parkville, Australia | *www.zoo.org.au*

282: Isabella tiger moth caterpillar, Brooksdale Environmental Centre, Surrey, Canada | *www.arocha.ca*

282: Nymphalid butterfly caterpillar, Wild caught, Bioko Island, Equatorial Guinea

282: Fall webworm moth caterpillar, Big Bend Wildlife Management Area, Taylor County, Florida | *www.myfwc.com*

282: Tobacco hornworm caterpillar, Audubon Nature Institute, New Orleans, Louisiana | *www.audubonnatureinstitute.org*

282: Tussock moth caterpillar, Wild caught, Bioko Island, Equatorial Guinea

283: *Noctuidae* sp., Quinta dos Malvedos Vineyard, Castedo, Portugal | *www.grahams-port.com*

283: Yellow tussock moth caterpillar, Singapore Zoo, Singapore | *www.wrs.com.sg/en/singapore-zoo*

283: Schaus' swallowtail butterfly caterpillar, McGuire Center for Lepidoptera and Biodiversity, Gainesville, Florida | *www.floridamuseum.ufl.edu/mcguire*

283: Orange lacewing butterfly caterpillars, Melbourne Zoo, Parkville, Australia | *www.zoo.org.au*

283: Unidentified species, Wild caught, Bioko Island, Equatorial Guinea

283: Milkweed tussock moth caterpillar, Wild caught, Spring Creek Prairie, Nebraska

283: Tussock moth caterpillar, Endangered Primate Rescue Center, Cúc Phương National Park, Vietnam | *www.eprc.asia*

284–5: Red lionfish, Pure Aquariums, Lincoln, Nebraska

286: Pacific walrus, Ocean Park, Hong Kong, China | *www.oceanpark.com.hk*

287: Banded tree snail, Crocodile Lake National Wildlife Refuge, Key Largo, Florida | *www.fws.gov/refuge/Crocodile_Lake*

288–9: Arctic ground squirrel, University of Alaska Fairbanks, Fairbanks, Alaska | *www.uaf.edu/uaf*

290: Thorny devil, Melbourne Museum, Carlton, Australia | *www.museumsvictoria.com.au/melbournemuseum*

291: Siberian ibex, Wrocław Zoo, Wrocław, Poland | *www.zoo.wroclaw.pl*

292–3: Proboscis monkey, Singapore Zoo, Singapore | *www.wrs.com.sg/en/singapore-zoo*

294: Rhinoceros snake, Saint Louis Zoo, St. Louis, Missouri | *www.stlzoo.org*

295: Rhinoceros katydid, Audubon Nature Institute, New Orleans, Louisiana | *www.audubonnatureinstitute.org*

296–7: American comb duck, National Aviary of Colombia, Barú, Colombia | *www.aviarionacional.co*

298: Honeypot ant, Albuquerque BioPark, Albuquerque, New Mexico | *www.cabq.gov*

299: Long-spine porcupinefish, Nebraska Aquatic Supply, Omaha, Nebraska | *www.nebraskaaquatic.com*

300–301: Bristlenose plecostomus, Singapore Zoo, Singapore | *www.wrs.com.sg/en/singapore-zoo*

ATTITUDE

302–303: Javan leopard, Taman Safari Indonesia, Bogor, Indonesia | *www.tamansafari.com*

304: Kinkajou, Zoo New York, Watertown, New York | *www.zoonewyork.org*

306: Corsac fox, Zoopark Zájezd, Zájezd, Czechia | *www.zoopark-zajezd.cz*

307: Juruá red howler monkey, Cetas-IBAMA, Manaus, Brazil | *www.ibama.gov.br/institucional/cetas*

308–309: Southern cassowary, Gladys Porter Zoo, Brownsville, Texas | *www.gpz.org*

310: L'Hoest's monkey, Parco Natura Viva, Bussolengo, Italy | *www.parconaturaviva.it*

311: Giant katydid, Central Florida Zoo and Botanical Gardens, Sanford, Florida | *www.centralfloridazoo.org*

312: Hawaiian hawk, Sia: The Comanche Nation Ethno-Ornithological Initiative, Cyril, Oklahoma | *www.comancheeagle.org*

313: Green oropendola, Private collection

314–15: Von der Decken's sifaka, Lemuria Land, Nosy Be, Madagascar | *www.lemurialand.com*

316: Leopard gecko, Sunset Zoo, Manhattan, Kansas | *www.sunsetzoo.com*

317: Ringtail, Fort Worth Zoo, Fort Worth, Texas | *www.fortworthzoo.org*

318: Wallace's gliding tree frog, Private collection

319: Malaysian golden gliding tree frog, Private collection

320: Brushpalm crayfish, Wild caught, Okefenokee Swamp, Georgia

320: Twospot crayfish, Wild caught, Little Barren River, Kentucky

320: Brawny crayfish, Crayfish Conservation Laboratory, West Liberty, West Virginia | *www.westliberty.edu*

320: Digger crayfish, Crayfish Conservation Laboratory, West Liberty, West Virginia | *www.westliberty.edu*

320: Red swamp crayfish, Woodland Park Zoo, Seattle, Washington | *www.zoo.org*

320: Coosa River spiny crayfish, Crayfish Conservation Laboratory, West Liberty, West Virginia | *www.westliberty.edu*

320: Valley flame crayfish, Crayfish Conservation Laboratory, West Liberty, West Virginia | *www.westliberty.edu*

320: Northern clearwater crayfish, Crayfish Conservation Laboratory, West Liberty, West Virginia | *www.westliberty.edu*

320: Blue crayfish, Porte Dorée Tropical Aquarium, Paris, France | *www.palais-portedoree.fr/en/tropical-aquarium*

321: Chilean scorpion, University of Porto, Porto, Portugal | *www.up.pt*

321: Red bark scorpion, Omaha's Henry Doorly Zoo and Aquarium, Omaha, Nebraska | *www.omahazoo.com*

321: Banded flat rock scorpion, Gladys Porter Zoo, Brownsville, Texas | *www.gpz.org*

321: Amoreux's fat-tailed scorpion, University of Porto, Porto, Portugal | *www.up.pt*

321: Asian forest scorpion, Gladys Porter Zoo, Brownsville, Texas | *www.gpz.org*

321: Yellow burrowing scorpion, University of Porto, Porto, Portugal | *www.up.pt*

321: Flinders Range scorpion, Wild Life Sydney Zoo, Sydney, Australia | *www.wildlifesydney.com.au*

321: Yellow fattail scorpion, Houston Zoo, Houston, Texas | *www.houstonzoo.org*

321: Giant hairy desert scorpion, Gladys Porter Zoo, Brownsville, Texas | *www.gpz.org*

322–3: Asian small-clawed otter, Omaha's Henry Doorly Zoo and Aquarium, Omaha, Nebraska | *www.omahazoo.com*

324: Skeleton tarantula, Albuquerque BioPark, Albuquerque, New Mexico | *www.cabq.gov*

325: Southern kelp crab, California Science Center, Los Angeles, California | *www.californiasciencecenter.org*

326: Black-tailed jackrabbit, Cedar Point Biological Station, Ogallala, Nebraska | *www.cedarpoint.unl.edu*

327: Eurasian lynx, Columbus Zoo, Powell, Ohio | *www.columbuszoo.org*

328–9: Northern pintail, Sylvan Heights Bird Park, Scotland Neck, North Carolina | *www.shwpark.com*

330: Palawan stink-badger, Avilon Zoo, Rodriguez, Philippines | *www.avilonzoo.ph*

331: White-nosed coati, Fort Worth Zoo, Fort Worth, Texas | *www.fortworthzoo.org*

332: Cownose ray, Phoenix Zoo, Phoenix, Arizona | *www.phoenixzoo.org*

333: Australian owlet-nightjar, Moonlit Sanctuary Wildlife Park, Pearcedale, Australia | *www.moonlitsanctuary.com.au*

334–5: Güiña, Fauna Andina, Villarrica, Chile

336: Short-finned pilot whale, SeaWorld, Orlando, Florida | *www.seaworld.com/orlando*

337: Cooper Creek turtle, Templestowe College, Templestowe, Australia | *www.tc.vic.edu.au*

338–9: Eastern barn owl, Penang Bird Park, Perai, Malaysia | *www.penangbirdpark.com.my*

340: Barbary striped grass mouse, Budapest Zoo and Botanical Garden, Budapest, Hungary | *www.zoobudapest.com*

340: Choctawhatchee beach mouse, U.S. Fish and Wildlife Service, Panama City, Florida | *www.fws.gov/panamacity*

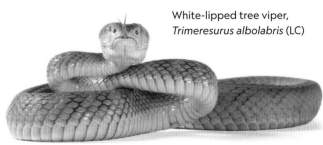

White-lipped tree viper, *Trimeresurus albolabris* (LC)

340: Northern birch mouse, Moscow Zoo, Moscow, Russia I *www.moscowzoo.su*

340: Florida cotton mouse, Wild caught, Crocodile Lake National Wildlife Refuge, Florida

340: South African spiny mouse, Plzeň Zoo, Plzeň, Czechia I *www.zooplzen.cz*

340: Desert pocket mouse, Liberty Wildlife, Phoenix, Arizona I *www.libertywildlife.org*

340: Spinifex hopping mouse, Wild Life Sydney Zoo, Sydney, Australia I *www.wildlifesydney.com.au*

340: St. Andrew beach mouse, U.S. Fish and Wildlife Service, Panama City, Florida I *www.fws.gov/panamacity*

340: Seurat's spiny mouse, Plzeň Zoo, Plzeň, Czechia I *www.zooplzen.cz*

341: North American deer mouse, Wild caught, Watertown, New York

341: Southeastern beach mouse, Wild caught, Cape Canaveral Air Force Station, Florida

341: Egyptian spiny mouse, Plzeň Zoo, Plzeň, Czechia I *www.zooplzen.cz*

341: Northern grasshopper mouse, Wild caught, Wood River, Nebraska

341: Perdido Key beach mouse, Wild caught, Kissimmee Prairie Preserve State Park, Okeechobee, Florida

341: Crete spiny mouse, Plzeň Zoo, Plzeň, Czechia I *www.zooplzen.cz*

341: Anastasia Island beach mouse, Wild caught, Florida

341: Cactus mouse, Plzeň Zoo, Plzeň, Czechia I *www.zooplzen.cz*

341: Western harvest mouse, Cedar Point Biological Station, Ogallala, Nebraska I *www.cedarpoint.unl.edu*

342: Red bald-headed uakari, Los Angeles Zoo, Los Angeles, California I *www.lazoo.org*

343: Patas monkey, Houston Zoo, Houston, Texas I *www.houstonzoo.org*

344–5: Rough-skin newt, Oregon Zoo, Portland, Oregon I *www.oregonzoo.org*

346: Mohol bushbaby, Cleveland Metroparks Zoo, Cleveland, Ohio I *www.clevelandmetroparks.com/zoo*

347: Flat-headed cat, Taiping Zoo, Taiping, Malaysia I *www.zootaiping.gov.my*

348–9: Pearse's mudskipper, Newport Aquarium, Newport, Kentucky I *www.newportaquarium.com*

350: Hippopotamus, San Antonio Zoo, San Antonio, Texas I *www.sazoo.org*

351: Northern Luzon cloud rat, Plzeň Zoo, Plzeň, Czechia I *www.zooplzen.cz*

352–3: African hawk-eagle, Zoopark Zájezd, Zájezd, Czechia I *www.zoopark-zajezd.cz*

354: Bengal slow loris, Angkor Centre for Conservation of Biodiversity, Kbal Spean, Cambodia I *www.accb-cambodia.org*

355: Tammar wallaby, Moonlit Sanctuary Wildlife Conservation Park, Pearcedale, Australia I *www.moonlitsanctuary.com.au*

356–7: Equatorial spitting cobra, Avilon Zoo, Rodriguez, Philippines I *www.avilonzoo.ph*

358: Western screech-owl, Denver Zoo, Denver, Colorado I *www.denverzoo.org*

359: Ocelot, Omaha's Henry Doorly Zoo and Aquarium, Omaha, Nebraska I *www.omahazoo.com*

360–61: Cook Strait giant wetas, Zealandia, Wellington, New Zealand I *www.visitzealandia.com*

362: Red giant flying squirrel, Private collection

363: Addax, Buffalo Zoo, Buffalo, New York I *www.buffalozoo.org*

364: Timber wolf, Zoo New York, Watertown, New York I *www.zoonewyork.org*

365: Australian sea lion, Taronga Zoo Sydney, Mosman, Australia I *www.taronga.org.au/sydney-zoo*

366–7: Nashville crayfish, Wild caught, Tennessee

368: Brownbelly leaf frog, Wild caught, Pilalo, Ecuador

369: Blue spiny lizard, Tulsa Zoo, Tulsa, Oklahoma I *www.tulsazoo.org*

370–71: Western honeybee, Wild caught, Lincoln, Nebraska

372: Goeldi's marmoset, Miller Park Zoo, Bloomington, Indiana I *www.bloomingtonparks.org/facilities/miller-park-zoo*

373: Musk ox, University of Alaska Fairbanks, Fairbanks, Alaska I *www.uaf.edu/uaf*

374–5: Texas alligator lizard, Gladys Porter Zoo, Brownsville, Texas I *www.gpz.org*

376: Philippine hanging-parrot, Private collection

376: Yellow-headed parrot, Loro Parque Foundation, Tenerife, Spain I *www.loroparque-fundacion.org*

376: Grey parrot, Jurong Bird Park, Singapore I *www.wrs.com.sg/en/jurong-bird-park.html*

376: Tanimbar eclectus, Loro Parque Foundation, Tenerife, Spain I *www.loroparque-fundacion.org*

376: Black-headed parrot, National Aviary of Colombia, Barú, Colombia I *www.aviarionacional.co*

376: Southern mealy amazon, National Zoological Park, Santo Domingo, Dominican Republic I *www.zoodom.gob.do*

376: Scarlet-chested parrot, Parrots in Paradise, Kealakekua, Hawaii I *www.parrotsinparadise.org*

376: Yellow-naped amazon parrot, Cincinnati Zoo, Cincinnati, Ohio I *www.cincinnatizoo.org*

376: Double-eyed fig parrot, Dallas Zoo, Dallas, Texas I *www.dallaszoo.com*

377: Aru Island eclectus parrot, Loro Parque Foundation, Tenerife, Spain I *www.loroparque-fundacion.org*

377: Eastern Senegal parrot, Philadelphia Zoo, Philadelphia, Pennsylvania I *www.philadelphiazoo.org*

377: Hoffmann's parakeet, Nispero Zoo, El Valle de Anton, Panama

377: Red-crowned parakeet, Nispero Zoo, El Valle de Anton, Panama

377: Large fig parrot, Prague Zoo, Prague, Czechia I *www.zoopraha.cz*

377: Red-tailed black-cockatoo, Parrots in Paradise, Kealakekua, Hawaii I *www.parrotsinparadise.org*

377: Red-vented greater bluebonnet, Loro Parque Foundation, Tenerife, Spain I *www.loroparque-fundacion.org*

377: Josephine's lorikeet, Loro Parque Foundation, Tenerife, Spain I *www.loroparque-fundacion.org*

377: Red-bellied parrot, San Antonio Zoo, San Antonio, Texas I *www.sazoo.org*

377: Blue-naped parrot, Talarak Foundation, Negros Island, Philippines I *www.talarak.org*

378: Spanish pond turtle, Parque Biológico, Vila Nova de Gaia, Portugal I *www.parquebiologico.pt*

379: Eastern hellbender, San Francisco State University, San Francisco, California I *www.sfsu.edu*

380–81: Black-tailed prairie dog, Zoo Atlanta, Atlanta, Georgia I *www.zooatlanta.org*

382: Philippine long-tailed macaque, Davao Crocodile Park, Davao City, Philippines I *www.crocodilepark.ph*

383: Florida black bear, Brevard Zoo, Melbourne, Florida I *www.brevardzoo.org*

384: Royal antelope, Los Angeles Zoo, Los Angeles, California I *www.lazoo.org*

385: Western smooth knob-tailed gecko, Private collection

386–7: Chimpanzee, Sunset Zoo, Manhattan, Kansas I *www.sunsetzoo.com*

388: Painted tree frog, Jambatu Center for Research and Conservation of Amphibians, Quito, Ecuador

389: Pale fox, Cub Creek Science Camp, Rolla, Missouri I *www.cubcreeksciencecamp.com*

391: Hausa genet, Plzeň Zoo, Plzeň, Czechia I *www.zooplzen.cz*

392: White-collared kingfisher, Jurong Bird Park, Singapore I *www.wrs.com.sg/en/jurong-bird-park.html*

393: Ecuadorian monkey frog, Jambatu Center for Research and Conservation of Amphibians, Quito, Ecuador

394: Giant Malay fruit bat, Negros Forest Park, Bacolod, Philippines I *www.talarak.org/negros-forest-park*

395: White-lipped tree viper, Houston Zoo, Houston, Texas I *www.houstonzoo.org*

396: Andean white-eared opossums, Quito Zoo, Quito, Ecuador I *www.quitozoo.org*

397: Red-billed firefinch, Tulsa Zoo, Tulsa, Oklahoma I *www.tulsazoo.org*

398: Gray-tailed mustached monkey, Park Assango, Libreville, Gabon

Andean white-eared opossums, *Didelphis pernigra* (LC)

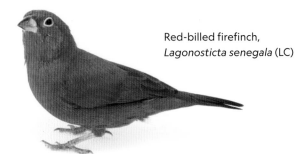

Red-billed firefinch,
Lagonosticta senegala (LC)

IUCN DESIGNATIONS

The International Union for Conservation of Nature (IUCN) is a global group dedicated to protecting biodiversity. The IUCN Red List of Threatened Species is a comprehensive collection of animal and plant species that have been analyzed according to their risk of extinction. Once evaluated, a species is placed into one of several categories. Throughout this book, each species' current IUCN status appears alongside its common and scientific names.

EX | EXTINCT There is no reasonable doubt that the last individual of a species has died.

EW | EXTINCT IN THE WILD Individuals of a species are known only to survive in captivity or as a naturalized population, well outside the former range.

CR | CRITICALLY ENDANGERED The best available evidence indicates that a species faces an extremely high risk of extinction in the wild.

EN | ENDANGERED The best available evidence indicates that a species faces a very high risk of extinction in the wild.

VU | VULNERABLE The best available evidence indicates that a species faces a high risk of extinction in the wild.

NT | NEAR THREATENED A species has been evaluated and does not currently qualify for one of the previous categories, but is close to qualifying.

LC | LEAST CONCERN A species has been evaluated but does not qualify for any of the categories above.

DD | DATA DEFICIENT Not enough information is available to fully evaluate a species for its risk of extinction.

NE | NOT EVALUATED A species has not yet been evaluated for its risk of extinction.

Since 1888, the National Geographic Society has funded more than 14,000 research, conservation, education, and storytelling projects around the world. National Geographic Partners distributes a portion of the funds it receives from your purchase to National Geographic Society to support programs, including the conservation of animals and their habitats.

Get closer to National Geographic Explorers and photographers, and connect with our global community. Join us today at nationalgeographic.com/join

For rights or permissions inquiries, please contact National Geographic Books Subsidiary Rights: bookrights@natgeo.com

Library of Congress Cataloging-in-Publication Data

Names: Sartore, Joel, author.
Title: Photo ark wonders : celebrating diversity in the animal kingdom / Joel Sartore.
Description: Washington, D.C. : National Geographic, [2021] I Includes bibliographical references and index. I Summary: "Joel Sartore, on a mission to photograph all the animal species in human care, now features photographs selected to represent the amazing diversity of the world's animals, highlighting the fascinating shapes, patterns, and expressions of animals both familiar and little known"-- Provided by publisher.
Identifiers: LCCN 2021011538 I ISBN 9781426221910 (hardcover)
Subjects: LCSH: Animals--Pictorial works. I Photography of animals. I Wildlife photography.
Classification: LCC TR727 .S375 2021 I DDC 779/.32--dc23
LC record available at https://lccn.loc.gov/2021011538

Printed in China

21/PPS/1

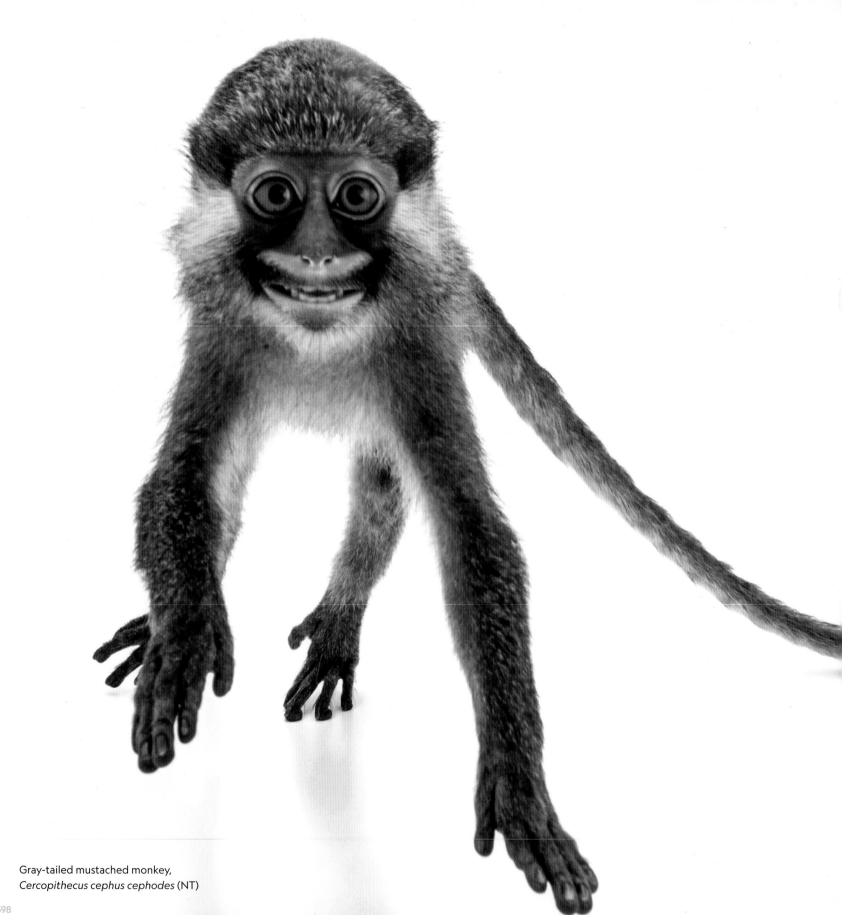

Gray-tailed mustached monkey,
Cercopithecus cephus cephodes (NT)